modern means

modern means | continuity and change in art, 1880 to the present | HIGHLIGHTS FROM THE MUSEUM OF MODERN ART

Deborah Wye | Wendy Weitman

with an essay by David Elliott

The Museum of Modern Art, New York | in association with | **Mori Art Museum, Tokyo**

Published in conjunction with the exhibition MODERN MEANS: CONTINUITY AND CHANGE IN ART, 1880 TO THE PRESENT, HIGHLIGHTS FROM THE MUSEUM OF MODERN ART, organized by Deborah Wye, The Abby Aldrich Rockefeller Chief Curator, and Wendy Weitman, Curator, Department of Prints and Illustrated Books, of The Museum of Modern Art, New York, under the auspices of the Museum's International Council and in collaboration with David Elliott, Director, and Sunhee Kim, Curator, Mori Art Museum, Tokyo, April 28 to August 1, 2004.

This exhibition is presented in Tokyo in association with the **Asahi Shimbun** and **tv asahi corporation**.

Prudential 🌀 **Financial** Generous support has been provided by **Gibraltar Life Insurance Co., Ltd.** and **Prudential Life Insurance Company, Ltd.**

 Additional funding has been provided by **World Co., Ltd.**, **Obayashi Corporation**, and **Shinko Securities Co., Ltd.**

This exhibition is supported by **Japan Airlines**, with additional assistance from **Ruinart (Takara Shuzo Co., Ltd.)**, **Bombay Sapphire**, and **Okunomatsu Sake Brewery Co., Ltd.**, and is shown under the patronage of the United States Embassy in Tokyo.

Produced by the Department of Publications
The Museum of Modern Art, New York

Edited by **Joanne Greenspun** and **David Frankel**
Designed by **Amanda Washburn**
Production by **Marc Sapir** and **Elisa Frohlich**

Printed and bound by **Toppan Printing**, Tokyo

This book is typeset in **bayer universal**, folio, and **Twentieth Century**
The paper is 128 gsm Shiraoi matte

© 2004 The Museum of Modern Art, New York
Copyright credits for illustrations are cited on page 206.
All rights reserved.

Library of Congress Control Number: 2004103380
ISBN: 0-87070-453-2 (MoMA)
ISBN: 0-87070-454-0 (Mori Art Museum)

Published by The Museum of Modern Art
11 West 53 Street
New York, New York 10019
www.moma.org

Distributed in the United States and Canada by
D.A.P., New York
Distributed outside the United States and Canada by
Thames & Hudson Ltd., London
Front cover:
andy warhol | MARILYN MONROE (MARILYN). 1967
One from a portfolio of ten screenprints,
comp. and sheet: 36 x 36" (91.5 x 91.5 cm)
Publisher: Factory Additions, New York
Printer: Aetna Silkscreen Products, New York
Edition: 250
Gift of Mr. David Whitney

Back cover:
cindy sherman | UNTITLED #188 (detail). 1989
Chromogenic color print,
43½ x 65½" (110.5 x 166.4 cm)
Gift of the Dannheisser Foundation

Inside front flap:
el lissitzky | NEW MAN (detail), from FIGURINES: THE THREE-DIMENSIONAL DESIGN OF THE ELECTRO-MECHANICAL SHOW "VICTORY OVER THE SUN." 1920–21, published 1923
One from a portfolio of ten lithographs, sheet:
21 x 17 13/16" (53.3 x 45.4 cm). Publisher and printer:
Leunis & Chapman, Hannover, Germany. Edition: 75
Purchase

Inside back flap:
henri matisse | BATHER. Summer 1909
Oil on canvas, 36½ x 29⅛" (92.7 x 74 cm)
Gift of Abby Aldrich Rockefeller

Page 6:
ernst ludwig kirchner | STREET, BERLIN (detail). 1913
Oil on canvas, 47½ x 35⅞" (120.6 x 91.1 cm)
Purchase

Page 8:
pablo picasso | PAINTER AND MODEL (detail). 1928
Oil on canvas, 51⅛ x 64¼" (129.8 x 163 cm)
The Sidney and Harriet Janis Collection

Page 10:
jacques de la villeglé | 122 RUE DU TEMPLE (detail). 1968
Torn and collaged painted and printed paper on linen,
62⅝" x 6' 10¾" (159.2 x 210.3 cm)
Gift of Joachim Aberbach (by exchange)

Page 14:
bruce nauman | HANGING HEADS #2 (BLUE ANDREW WITH PLUG/WHITE JULIE, MOUTH CLOSED) (detail). 1989
Wax and wire, two heads, 10¾ x 9½ x 7¾"
(27.3 x 24.2 x 19.7 cm) and 10½ x 8¾ x 7¼"
(26.7 x 22.2 x 18.4 cm)
Acquisition from the Werner Dannheisser Testamentary Trust

Printed in Japan

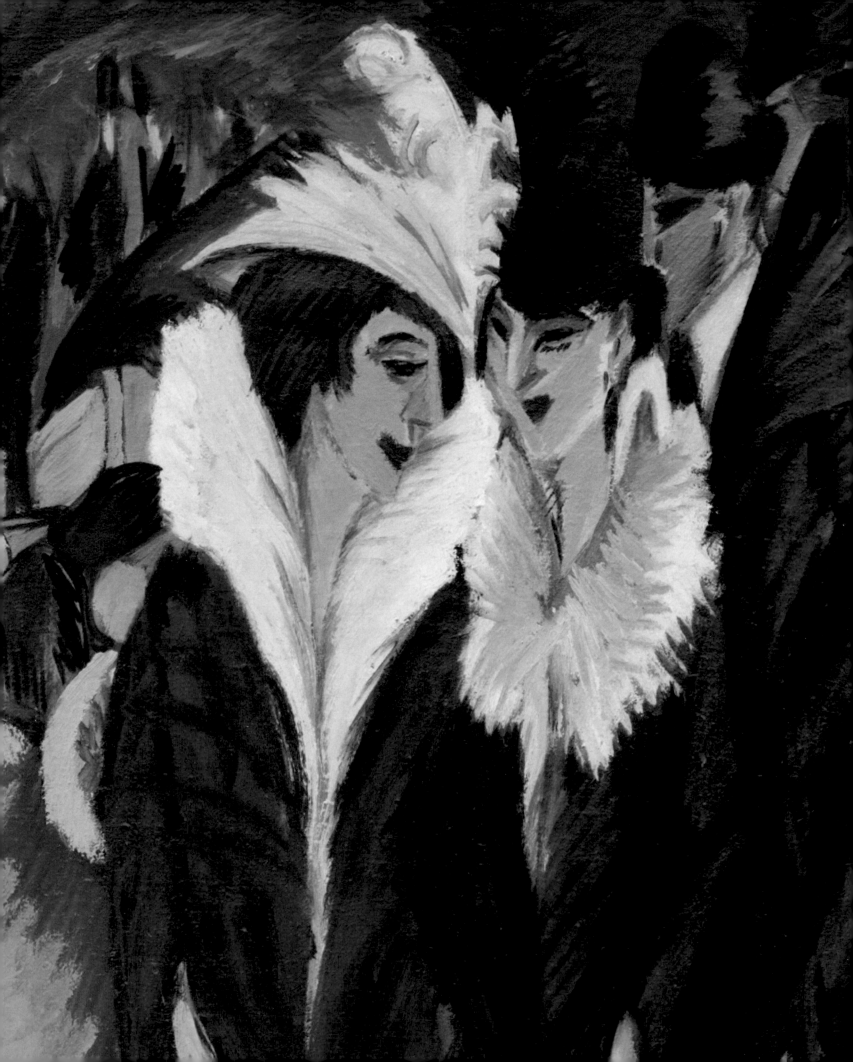

foreword

Glenn D. Lowry
Director
The Museum of Modern Art
New York

MODERN MEANS is The Museum of Modern Art's first collaborative project with the Mori Art Museum, an institution with which we are delighted to have been affiliated since its very inception. Minoru and Yoshiko Mori, who have long been part of the Museum's International Council, asked us for advice as they began to plan their museum in 1996. It was the perfect moment for such a collaboration since we were about to start the expansion of our own building and had been studying in detail many of the issues involving museum planning and construction that were of particular interest to Mr. and Mrs. Mori. We also helped them organize an international advisory committee for the project. During the last few years it has been our great pleasure to watch David Elliott and his staff bring the ambitious plans for the museum to an impressive realization. We feel privileged to have been a part of this process, which has created such a vital new institution in the Asian art world.

MODERN MEANS is meant to provoke innovative ideas and a fresh understanding of the history of art in the modern period. The Museum of Modern Art's synoptic holdings across disciplines from architecture and design to photography to film and video, in addition to the more traditional areas of painting and sculpture, drawings, and prints, allow for an exciting and uniquely integrated study of modernism's watershed aesthetic breakthroughs. Organized around four broadly chronological themes, this exhibition reveals that history is a fluid phenomenon and that ideas rooted in one period have endured and remain vital impulses to artists throughout the modern era, uniting historical precedents with contemporary developments.

I encourage and applaud such creative perspectives on the Museum's unparalleled collection. I entrusted Deborah Wye, The Abby Aldrich Rockefeller Chief Curator, and Wendy Weitman, Curator, Department of Prints and Illustrated Books, with the challenging task of exploring our holdings for this project. They have approached it with their customary intelligence and imagination and created a superb exhibition that has made even those of us thoroughly familiar with the collection think about it in new ways.

An exhibition of this magnitude and complexity draws on resources across the Museum, and many on the staff deserve special mention. Jay Levenson, Director, International Program, has been intimately involved in our collaboration with the Mori Art Museum from the outset. Jennifer Russell, Deputy Director for Exhibitions and Collections Support, has brought her breadth of talents to this monumental undertaking despite her other considerable responsibilities. Even with all the preliminary activities necessary to plan and open our own expanded building, the team preparing **MODERN MEANS** has done an outstanding job during an extraordinary time in our Museum's history. As this impressive project draws to fruition, we look forward to many future interactions between our institutions.

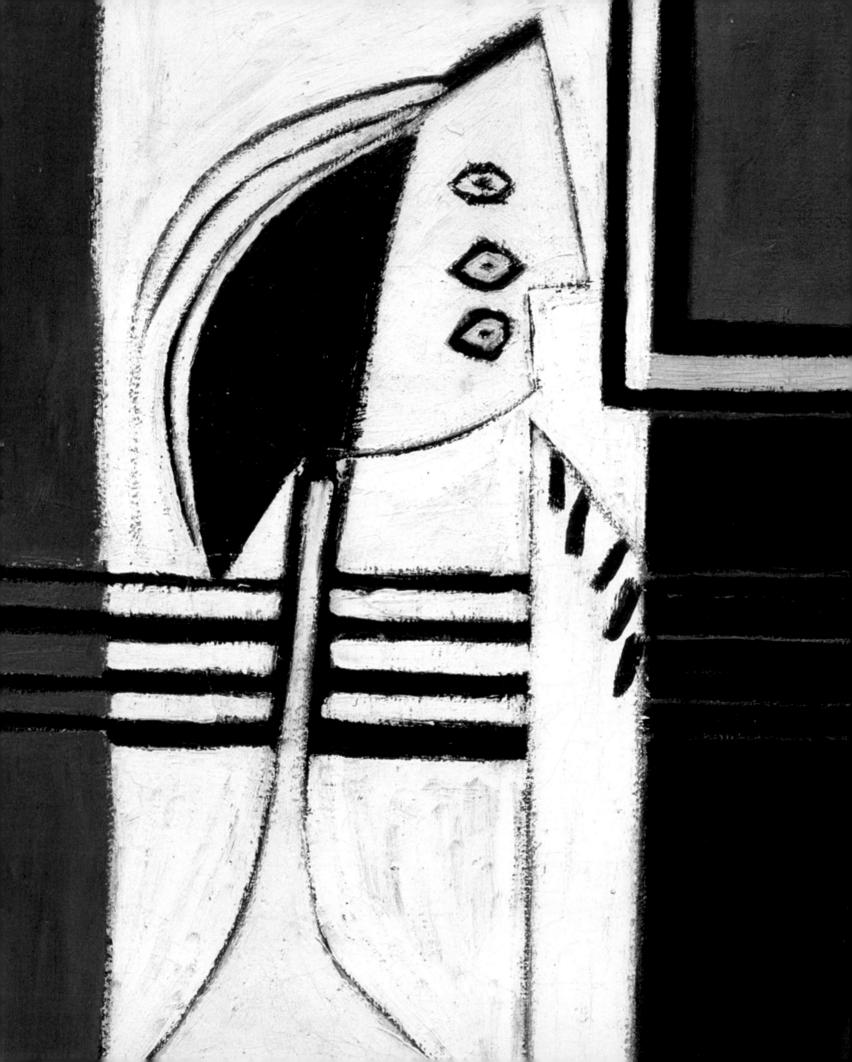

preface

Minoru Mori
Founder

Yoshiko Mori
Chairperson

Mori Art Museum
Tokyo

Eighteen years ago, when we first envisioned Roppongi Hills, we wanted it to become the cultural heart of Tokyo. In all major world cities there are museums that offer outstanding exhibitions which attract many people nationally and from overseas. The Museum of Modern Art in New York is a prime example of a world-renown museum. We have always wanted to build such a museum in Japan, particularly in Tokyo.

In 1996, at the introduction of Senator John D. Rockefeller, we had the opportunity to meet Mr. Glenn Lowry, the then newly appointed director of The Museum of Modern Art. When we explained our idea of building an art museum and asked for his support, he responded passionately: "I believe that it is vitally important for The Museum of Modern Art to work with colleagues around the world to encourage interest in modern and especially contemporary art." The Museum at that time was beginning to embark on an expansion of its facilities, and we agreed to work together to explore the future role of a museum and to determine what kinds of activities it should pursue. This marked the beginning of a fruitful collaboration between The Museum of Modern Art and the Mori Art Museum.

Since then the two museums have worked together to present **MODERN MEANS**, a unique exhibition based on The Museum of Modern Art's collection, that we will present in conjunction with the celebration of the first anniversary of Roppongi Hills. Many of the works shown here have never been seen in Japan and present a new and fascinating perspective on the development of modern art to the present day.

In undertaking this huge task, we, along with David Elliott, Director, Mori Art Museum, are particularly grateful to Mr. Lowry, who encouraged this project from the outset, as well as to Deborah Wye and Wendy Weitman, the organizing curators, who took the initial brief and developed it in imaginative ways that have greatly enriched our understanding of modern art. Many other Museum staff, unfortunately too numerous to mention here, have also helped bring this project to a successful conclusion.

Lastly we would like to give a particular word of thanks to Gibraltar Life Insurance Co., Ltd., and Prudential Life Insurance Company, Ltd., the exhibition's main sponsors, as well as to World Co., Ltd., Obayashi Corporation, and Shinko Securities Co., Ltd., whose generous support has enabled us to present this exhibition.

We greatly hope that a large number of visitors from both home and abroad will visit this exhibition as part of the cultural heart of Tokyo that Roppongi Hills represents. For us, such an outpouring of interest would mean the true achievement of our goal, set more than a decade ago.

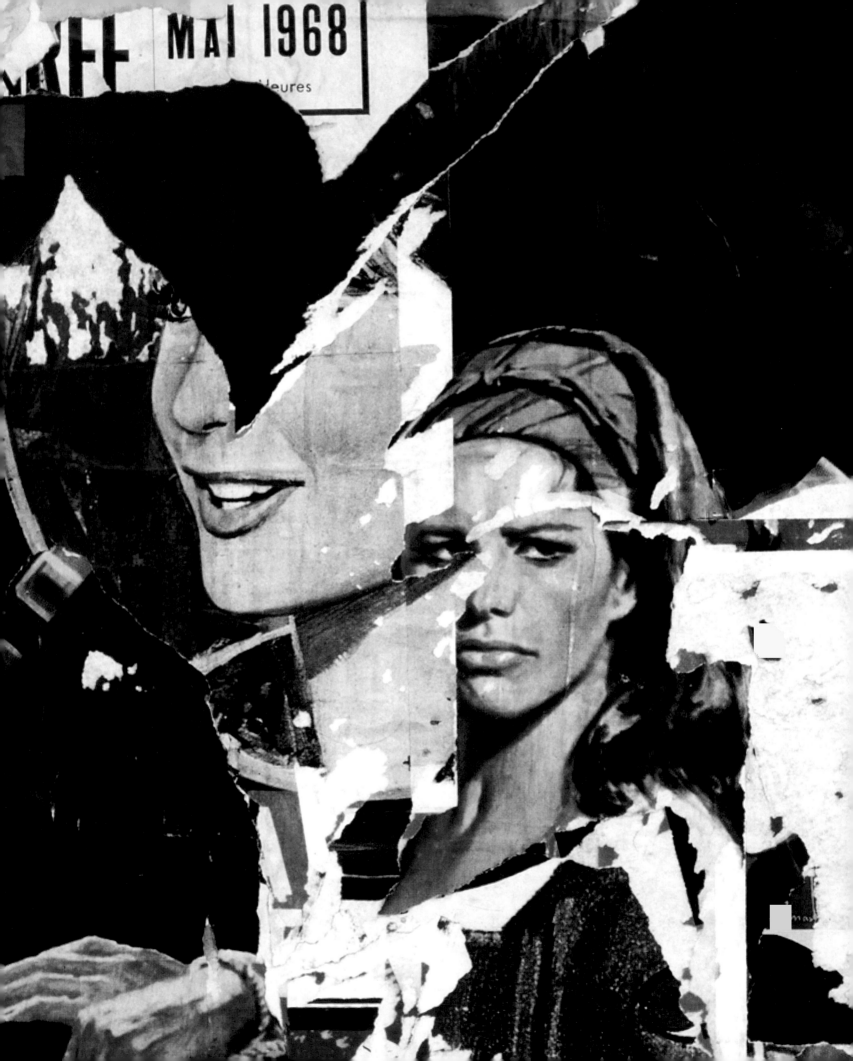

what is "modern"?

David Elliott
Director
Mori Art Museum
Tokyo

How much do the words we use to describe art affect our ways of looking at it? Do our ways of looking at art remain the same, regardless of the time in which we live? These questions, and the need to find the right words, the right meanings, for today, lie at the heart of **MODERN MEANS**. Art is formed by, reflects, and may even come to represent the time in which it is made, but if it is any good it will also transcend that time and be valued, perhaps for different reasons, in the future. Words, too, can be ambiguous, and among their various meanings some may be inconsistent. How do we reflect this in the frameworks we create to think about and exhibit art?

Many people have consigned the idea of "modern" art to the past, feeling that it reflects a Western belief in progress that has been superseded by the more flexible categories of "postmodern" and "contemporary." Meanwhile, speed of communication has shrunk our sense of the world's size while also, to some, making it seem a larger, more unsettling place, since the West no longer dominates it in the same way; something similar holds true in the world of art. Why, then, should we seek to revalidate "modern art" here? Perhaps it is not as closed a category as its detractors claim? Perhaps "postmodern" and "contemporary" art extend its intellectual and cultural heritage as much as they break away from it? Without ignoring the limitations of the idea of the modern, this exhibition's thematic presentation of painting and sculpture, prints and drawings, photography, design, and architecture from the late nineteenth century to the present proposes a more inclusive approach to it—one that reflects more than just the formal ideas and impulses with which modern artists have been concerned.

The history of modernity has been written as a story of progress, a linear narrative in which each successive development inevitably leads to the next. But the discontinuous, chaotic, and polyvalent activity of artmaking has never supported this view. The dissolution of the idea of progress is perhaps one of the most important contributions of postmodernism. Into its place has gone an idea of history and culture as a field or matrix in which many different links can be made across time and space.

Today, when the digital revolution is having as large an impact as the industrial revolution did in the eighteenth century, when "diversity," "pluralism," the "multicultural," and the "global" are the latest hip terms—in a "postmodern," "post-Soviet," "postcolonial" world—we struggle to find the right words and concepts to describe the ways in which our culture has changed. To complicate the matter further, the idea of the postmodern, with its reference to previous systems of power, has been replaced in some circles by the more open and flexible category of the "contemporary," which can be used to refer to all art made in the present and the relatively recent past.[1] Clearly, when art, our understanding of its history, and its reception are all in flux, the institutions that collect, preserve, and present it must be equally dynamic and reactive in their turn. This need has had an impact on the modern art museum in its many different incarnations across the world. Some aspire to be temples for the converted, aloof from the crowd; some resemble the treasure house, intent on protecting and displaying their precious hoards; some are more like theme parks or malls for the "consumption" of art; some are didactic, some are unashamedly partisan, and yet others seem to be more valued for their shell—their architecture—than for what they do or hold. But if the museum is not to become a museum piece itself, it must be able to adapt the frameworks through which it considers and displays art to reflect changing perspectives, circumstances, and meanings.

1. There is no consensus about when "contemporary art" begins. Although the term is often applied to art of the present and recent past, it may, particularly with regard to collections of museums of contemporary art, refer to art since the early 1960s or even, in some cases, to the period since World War II.

It was not always like this. Seventy-five years ago, when the founders of The Museum of Modern Art, New York, appointed the twenty-seven-year-old Alfred H. Barr, Jr., as its first director, the history of modern art and its institutions was in its infancy. In 1929, the Museum pioneered in creating a framework for displaying and thinking about art. Following the model of the Bauhaus, the German school that made links among all of the visual arts, Barr set up a multidepartmental museum that covered film, photography, architecture and design, as well as painting, sculpture, and works on paper. His aim was to research, exhibit, collect, and promote the most advanced and "best" art being made at the time. Barr and his staff were essentially connoisseurs of objects in a new field of which they had to make sense, creating some kind of relative order. The educational and constructive role of the museum was stressed from the outset.

Modernity then was not the problematic or historical concept it is seen as today, but its meaning was still slippery, and Barr realized from the outset that as a term it was both "ambiguous and flexible."[2] There has never been complete agreement about what the modern is (or was) and when it began, but in broad social terms the phrase has often been applied to the period since the European Enlightenment. The eighteenth and subsequent centuries saw enormous intellectual, political, social, and cultural ferment. In terms of government they witnessed the widespread replacement of monarchy and the idea of divine right with elective democracy based on ideas of individual responsibility, autonomy, and freedom. This change, mirrored by the rise of the nation state, was accompanied socially by the effects of the industrial revolution, dramatic population growth, and the appropriation of undeveloped lands for profit and power. Underwriting all this was a firm belief in Western civilization and progress, supported by specific discoveries in science and technology and more generally by faith in the power of rational thought.

Barr was a child of the modern culture to which these transformations gave rise. He was not inclined to extend the new macro-category of modern art as far back as the eighteenth century, however, because until the middle of the nineteenth century, art was widely accepted, by collectors, museums, and the public alike. Barr was more interested in the kind of modern art that had emerged out of the avant-garde, and had not yet been absorbed into American culture.

The avant-garde—the word was taken over from radical politics, and before that from the military— both anticipated and ran parallel to vast changes in cultural consciousness throughout the nineteenth and twentieth centuries. One of modernity's main engines of regeneration, it combined vital elements of both continuity, in that it was self-renewing, and change, in that it acted as both a focus and a generator of radical approaches, each one superseding the last. The avant-garde drove culture forward. In art history its different manifestations subsequently came to be identified with "modernism"—a kind of collective academy of the avant-garde. But from the last decades of the nineteenth century the words "modern" and "modernist" have often been confused, and at times have even been understood to mean the same thing.[3]

By the 1880s—more or less the starting point for Barr's museum—ideas about realism in art had moved away from the historical or literal desire to show the world as it was, or should be, toward an oppositional and aesthetic concern with individual feelings and consciousness on the one hand and with collective interest in inner structures or relationships on the other. For artists as for scientists and philosophers, the realization had dawned that reality lay below the surface, and had more to do with relativity (the relationship of one element to another), consciousness (different, subjective, potentially competing modes of

2. Alfred H. Barr, "Modern and 'Modern,'" *Bulletin of The Museum of Modern Art*, May 1934, reprinted in *Defining Modern Art: Selected Writings of Alfred H. Barr, Jr.*, ed. Irving Sandler and Amy Newman (New York: Harry N. Abrams, 1986), pp. 82–83.

3. The term "avant-garde" came into common use in reference to art toward the end of the

nineteenth century, but as a phenomenon it had existed earlier in the century, in the counterculture of the *vie de Bohème*. How much the avant-garde was ahead of its times, as its name suggests, or against them, as proposed in the idea of a "counterculture," has long been a moot point. The word "modernist" came into use in the 1880s as a synonym for "modern." It was not until after World War I

that the term "modernism" began to be used to describe avant-garde artistic development after mid-nineteenth-century realism. The term is commonly regarded as extending until the early 1970s, when the idea of perpetual innovation by a series of successive "movements" was superseded by the pluralistic and historicist strategies of postmodernism.

thought or perception), and sensibility (emotion, compulsion, or conviction). In MODERN MEANS, by focusing on basic ideas or impulses that over time have driven artists to make a variety of different kinds of art, we have tried to reflect these approaches in the organization of the works in the exhibition.

Barr captured the art of his times and then tried to fit it into history, but his perspectives, inevitably, were challenged by both more conservative and more radical artists and critics. Famously, he characterized his new museum metaphorically as a kind of artwork in itself: a torpedo surging forward, cutting through time and space. Two seminal exhibitions, CUBISM AND ABSTRACT ART (1936) and FANTASTIC ART, DADA AND SURREALISM (1936–37), laid out his understanding of the development of modern art to that time. On the dust jacket of the book accompanying CUBISM AND ABSTRACT ART, a diagram placed artists such as Seurat, Cézanne, Gauguin, and van Gogh as the forerunners of the opposing tendencies of Cubism and Fauvism, which themselves were then traced down through other styles to the emergence of geometrical and nongeometrical abstract art. For Barr and for many others, abstraction in one form or another seemed to be an inevitable endpoint of modern art. In this approach Barr was adapting traditional stylistic and chronological methods of art-historical analysis while consigning the subject of the work to a secondary position. He was influenced here by the British critics Roger Fry and Clive Bell, who stressed the significance of form, yet he was also very much aware of art's political meanings and affiliations and wrote on them extensively throughout his long career, reflecting in a dispassionate and evenhanded way the changing perspectives of the prewar and Cold War years.

Although MODERN MEANS maintains Barr's Bauhaus-inspired synthesis of the traditional visual arts with architecture, photography, and design, and his starting point in the late nineteenth century, the thematic categories that form its backbone are of a very different kind from the ones he would have known. Abstraction is no longer an end in itself but purely a means some artists use. The categories here have no pretension to be definitive, universal, or even consistent (good art can never be confined), only to provide complex yet accessible ways of looking at the development of modern and contemporary art by relating it to basic ideas that we can all recognize.

The exhibition's two opening sections examine the fundamental desire to strip things back to an essential core; the last two are more concerned with alchemy, focusing on the ways in which art transforms reality. The first, **Primal**, centers on the strategy of finding energy in the primitive forces of nature and the unconscious human mind. **Reductive** traces the impulse to strip away inessential elements of form to uncover the "purity" of what lies underneath. **Commonplace** considers ways in which art has absorbed mass culture and media, finding new forms of beauty in them and changing their nature in the process, sometimes with socially critical intent. **Mutable**, the show's final section, looks at the transforming power of art, its ability to make familiar things strange and endow them with new significance, sometimes with positive but more often with profoundly disturbing results.

Several impulses have encouraged this approach. First, in response to the feeling that contemporary art is alienated from modern art, we have simply asked whether the modern and the contemporary really belong to such different worlds, and to what extent modern art anticipates contemporary culture and consciousness. Second, to counteract the impression that both modern and contemporary art are difficult languages to learn, we wanted to construct straightforward but open-ended groupings of work that make sense visually, intuitively, and conceptually. Finally, although this is mainly an exhibition of Western art, an effort has been made to broaden it. Barr's early program reflected his global interests, but the changed climate of the years around World War II and after, the success of the Museum itself, and the rise of the New York School led to a greater concentration on American and European modernism. Now, in a world no longer so dominated by Western values, there is little doubt that exhibitions like MODERN MEANS will in the future contain many more non-Western works—indeed they will have to, if they are to reflect the ways in which our world and its art continue to change.

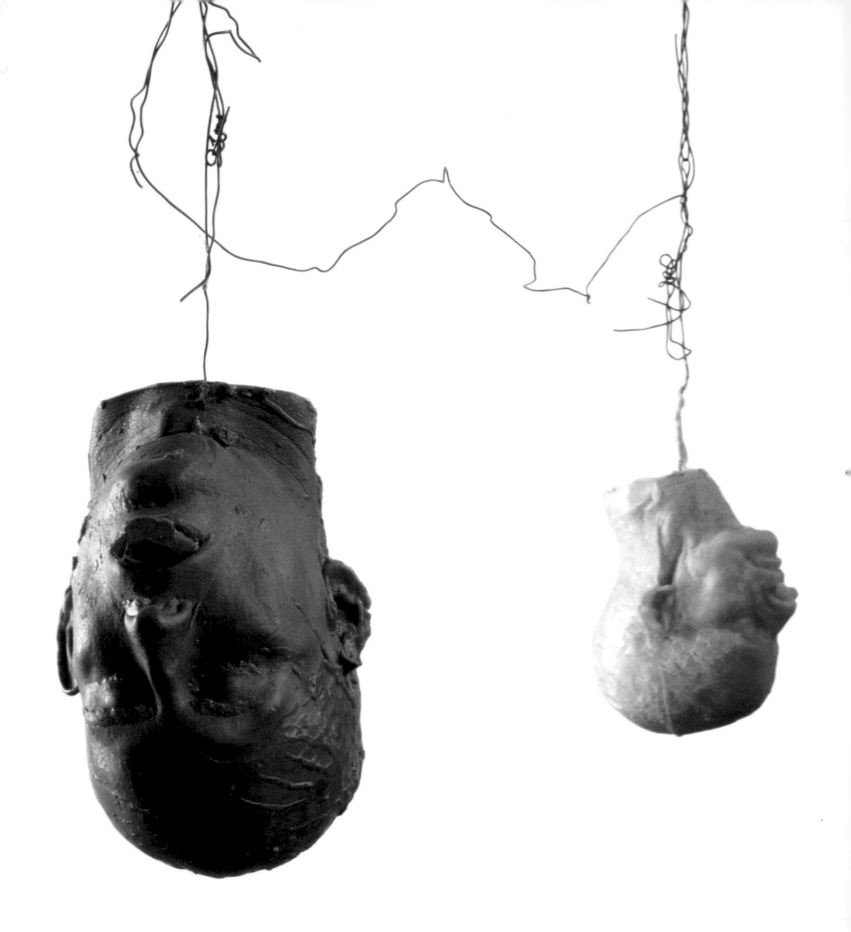

a synoptic view

Deborah Wye
The Abby Aldrich Rockefeller
Chief Curator

Wendy Weitman
Curator

Department of Prints
and Illustrated Books
The Museum of Modern Art
New York

What are the "means" that modern artists use to express their aesthetic concerns? For decades, the standard approach to modern art was to examine its unfolding movements as a linear progression of formal developments, each one leading to the next. In recent years, however, thematic studies have gained authority, and many scholars have examined art through its sociopolitical context in its time and place. Still others have focused on the artist's biography, psychology, and gender. MODERN MEANS: CONTINUITY AND CHANGE IN ART, 1880 TO THE PRESENT finds its own way to tell this complex story. What methods have artists used to address their concerns, and what does "modern" signify in art? This exhibition blends formal and thematic perspectives to answer such questions, even while its chronological core identifies the zeitgeists of historical moments. Each of the exhibition's four zones focuses on a concern of a specific period; history, however, is fluid and amorphous, and MODERN MEANS charts recurrences of these themes throughout modernity, acknowledging both their historical variations and their enduring nature. It demonstrates a constant exchange of ideas and, in particular, the strong tie between contemporary thinking and the past.

The exhibition's first section, **Primal**, covers the years 1880 to 1920, the fin-de-siècle period of the nineteenth century and the turbulent early decades of the twentieth. Here, works by such artists as Paul Gauguin and Edvard Munch, redolent with mystery, examine such subjects as anxiety, loneliness, sexuality, and death. These basic human issues, however, are constant concerns in art, as later works by Jackson Pollock and Louise Bourgeois show.

The next section, **Reductive**, follows the development, between 1920 and 1950, of an abstract visual language, and particularly of a geometric art sharing rational principles with a core of spirituality and idealism—as, for example, in the paintings of Piet Mondrian and the architecture and design of Gerrit Rietveld. The period also fostered an organic, nature-derived abstraction, seen here in works by Georgia O'Keeffe and Constantin Brancusi. Cubism offers a notable precedent for abstract reduction, which continues to appear today in the spare and ethereal paintings of Robert Ryman and Agnes Martin.

Commonplace, the exhibition's third section, covers the years 1950 to 1970, which saw an explosion of commercial imagery in art, inspired by and addressing the burgeoning media of mass communication and advertising. Precedents appear in the collages of Kurt Schwitters and the photographs of Walker Evans, but this section centers on Pop art, which shocked public and critics alike with its confrontational imagery and bold presentation. Certain artists today, including Andreas Gursky and Jeff Koons, sustain this preoccupation with the concerns of daily life.

Finally, **Mutable** looks at the recent and contemporary period, beginning around 1970, and underscores themes of disequilibrium, transformation, and metamorphosis, whether in the "social sculpture" of Joseph Beuys or the cryptic universe of Matthew Barney. A similar sense of disorienting flux had appeared much earlier in the amorphous compositions of Jean Arp and Joan Miró, who parsed the conscious and unconscious realms as interchangeable.

The range of art in MODERN MEANS is broad, not only in theme but in form—not just painting and sculpture but drawing, photography, printmaking, architecture, design, and electronic media, brought together here in synthetic juxtaposition. This range is possible because of the structure of The Museum of Modern Art's collection. It was a basic premise of the Museum's founding director, Alfred H. Barr, Jr., that the modern spirit pervaded all disciplines. In enlarging the collection and maintaining its currency, later curators kept Barr's principle in mind, and amassed a body of art encompassing all of the mediums exhibited here. These resources allow a synoptic view of the multifaceted richness, myriad nuances, and dazzling inventiveness of modern art, which innovated aesthetically while keeping the timeless issues of human life in view.

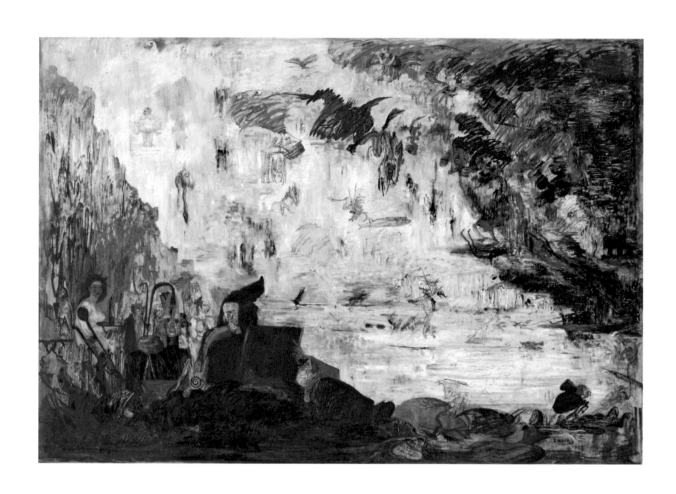

james ensor | Belgian, 1860–1949
TRIBULATIONS OF ST. ANTHONY. 1887
Oil on canvas, 46⅜ x 66"
(117.8 x 167.6 cm)
Purchase

primal

Elemental aspects of life—relationships to the natural world and to the cosmos, struggles with loneliness, love, and sexuality, the meanings of illness, suffering, and death—have always been subjects of art, not least in the modern period. In Western art in the late-nineteenth and early-twentieth centuries, however, these were dominant concerns, appearing in remarkable concentration in a variety of mediums. In the visual arts, an array of formal equivalents gave definition to such subject matter. Enveloping atmospheres and muted colors provided a sense of mystery, while intense hues reverberated with energy and vitality. Distortions evoked tension and anxiety, as sinuous lines patterned after vegetation suggested regeneration. Simplification conveyed essence rather than narrative.

Likeminded artists form alliances and critics comment on art of their day, and such tendencies inevitably lead to artists' groups and identifying terminology. In the 1880s and 1890s, the designation most widely applied to primal subjects was "Symbolism." Romantic in nature, Symbolist art favored emotion and subjectivity over intellect and reason, and can be seen as a reaction against Western society's encroaching industrialization and embrace of science. This meant turning away from the studies of light that had so fascinated Impressionist painters and searching instead for interior truths, however deeply concealed. This art was intended to evoke and suggest rather than state. It is noteworthy that Sigmund Freud began to publish his work on the unconscious during these decades; THE INTERPRETATION OF DREAMS appeared in 1900.

After the turn of the century, such concerns found expression in the work of artists' groups like BRÜCKE (Bridge), in Germany. Seeking unadulterated feeling through bright, clashing colors and spontaneous brushwork, BRÜCKE artists railed against prevailing taste. Among their motifs were the female nude, performers in cabarets, and prostitutes parading city streets, rendered with jarring angularity or bold rhythms. Similarly dissonant qualities appear in the art of the Viennese Secession group, which was also reacting against the conservatism of established practice. The tortured eroticism in the work of those artists contrasts vividly with that of the Fauves in France, so named for their strident colors and agitated paint-handling (*fauve* is French for "wild beast"), but whose art, with its Arcadian sensuality, expresses joy in life.

Encompassing the concerns of such groups, as well as singular figures, are certain pervasive thematic investigations. One consistently finds, for instance, an attempt to acknowledge the existence of a hidden realm lurking beneath the surface of everyday life. A mood of enigma is manifested even in representations of mundane aspects of city life, as in Giacomo Balla's STREET LIGHT (1909), which suggests supernatural power through emanating

rays of electric light. Similarly, the ominous architectural settings in Giorgio de Chirico's haunting paintings conjure up an uneasy silence that suggests the domain of dreams more than any recognizable time or place. Figural studies too explore this strange imaginary world, as seen in the disquieting melancholy of Odilon Redon's ethereal SILENCE (c. 1911), or in Edward Steichen's muted MIDNIGHT—RODIN'S BALZAC (1908), which likens the ponderous sculpture to a mysterious emanation of nature.

Claude Monet painted THE JAPANESE FOOTBRIDGE late in his life, about 1920–22, when his eyesight was failing and he was beset by depression. Although the central motif in this churning, fiery scene is the bridge in his garden at Giverny, France, the image is inexplicable in terms of any specific site; the work is dominated instead by mood, even suggesting a primordial state. A similarly poetic interpretation of landscape is found in Steichen's evocative photograph MOONRISE—MAMARONECK, NEW YORK (1904), with its dramatic painterly effects. Hector Guimard's furnishings, as well, with tendrillike elements, suggest organic forces of nature, typifying the Art Nouveau aesthetic of the turn of the century.

The enduring relevance of such subject matter is demonstrated by Arshile Gorky's DIARY OF A SEDUCER, from 1945, the period of Abstract Expressionism in the United States. With its darkened tonalities and biomorphic forms, this unsettling scene suggests writhing microorganisms interacting at an early evolutionary stage. Curvilinear lines

show the influence of Surrealist automatic drawing, which aimed to bypass standard representation by uncovering secrets buried in the unconscious. In the early 1950s, a period still affected by post–World War II traumas, Francis Bacon continued this search for meaning behind the facade of convention, stating that he wished to "unlock the valves of feeling." In NUMBER VII from EIGHT STUDIES FOR A PORTRAIT (1953), Bacon transforms the pope, a premier symbol of religious faith, from a figure of grandeur (based on a painting by Diego Velázquez) to the embodiment of inner torment. Such a thematic investigation relates directly back to James Ensor's menacing work TRIBULATIONS OF ST. ANTHONY of 1887.

Yet another thematic focus is sexuality, whether rendered as natural and affirming, raw and unbridled, or anxious and troubled. In the first decade of the century, artists like Fauvists André Derain and Henri Matisse saw sexual impulses as rhythmic components of nature. The female bodies in Derain's BATHERS (1907) merge with their environment of water and trees to sway and gesture in a tableau of uninhibited harmony. A gentle, calming sensation also appears in Matisse's MUSIC (SKETCH) (1907), in which even gender differentiation is subsumed within larger notions of tranquility and accord with earth and sky. In Pablo Picasso's WOMAN PLAITING HER HAIR (1906), the soft, pink female form seems to emerge from some embryonic source as the essence of fertility, her flowing hair epitomizing sensuality.

Yet female hair has opposite connotations as well, signaling male/female encounters that are suffocating, and equating the erotic with the dangerous. In the disquieting prints of Edvard Munch,

tresses turn to frightening tentacles as female figures become *femmes fatales*. Such tensions also appear in the work of Ernst Ludwig Kirchner and Emil Nolde. Kirchner's painting STREET, BERLIN (1913) captures an atmosphere of seduction and menace through strident color and syncopated angularity. His glamorous women of the night become birds of prey. In Nolde's prints entitled YOUNG COUPLE of the same year, fluid, organic forms signal instinctual sexual behavior. Through changing colors, Nolde implies emotions ranging from incipient attraction to violent revulsion.

Tribal objects, with radical simplifications and an aura of magic, were a major source of power and energy for sexual motifs. The most renowned of those artists who sought elemental feeling and an unrestrained sexuality in faraway cultures is Paul Gauguin. Although Tahiti did not provide all that he had hoped, his vivid woodcuts representing its exotic motifs include female subjects that merge with nature as well as cosmic deities. These prints in turn influenced the use of woodcut by Munch and, later, the BRÜCKE artists. Erich Heckel's boldly simplified FRÄNZI RECLINING (1910), for example, captures the awkwardness of an adolescent girl and turns this young model into an abstracted sign of incipient sexuality. Her masklike face in particular shows the influence of tribal art. Such qualities are also evident in Picasso's HEAD OF A SLEEPING WOMAN of 1907, and later in Alberto Giacometti's sculptural totems from the 1920s.

The fusion of tension and eroticism is best exemplified by the figural studies of Egon Schiele. His NUDE WITH VIOLET STOCKINGS (1912) presents a female coiled as if to spring, while the tortured, arched body in STANDING MALE NUDE WITH ARM RAISED (1910) seems plagued by physical impulses that must be endured rather than enjoyed. Oskar Kokoschka goes even farther in his depiction of ungainliness in the brutal nakedness of NUDE WITH BACK TURNED (c. 1907). The figure's pose is a blatant contradiction of the idealized nude in classical tradition.

Disturbing views of sexuality and specifically of the female body continue in later years, as in the monumental WOMAN, II, painted with savage brushwork in 1952 by Willem de Kooning. This ferocious portrayal is part overpowering fertility symbol and part lustful, devouring female. Striking interpretations of the body are also found in recent art. Louise Bourgeois, Kiki Smith, and Kara Walker are represented here by dramatic large-scale prints of figures who are vulnerable rather than threatening. Bourgeois's STE SEBASTIENNE (1992) is under attack from forces outside herself, while Smith's figure (drawn from an outline of her own body) curls into a fetal position, and Walker's silhouette, set in perpetual free-fall, confronts us as a victim of race-based abuse. These female depictions contrast with those created by the male artists mentioned here, but stand no less as evidence of the enduring sensitivity and nuance of the artistic vision in posing questions of primal concern for the human condition.

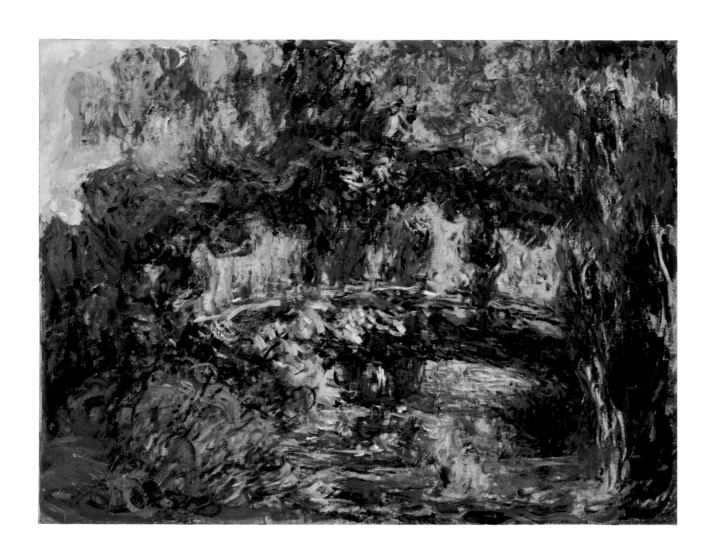

claude monet | French, 1840–1926
THE JAPANESE FOOTBRIDGE. c. 1920–22
Oil on canvas, 35¼ x 45⅞" (89.5 x 116.3 cm)
Grace Rainey Rogers Fund

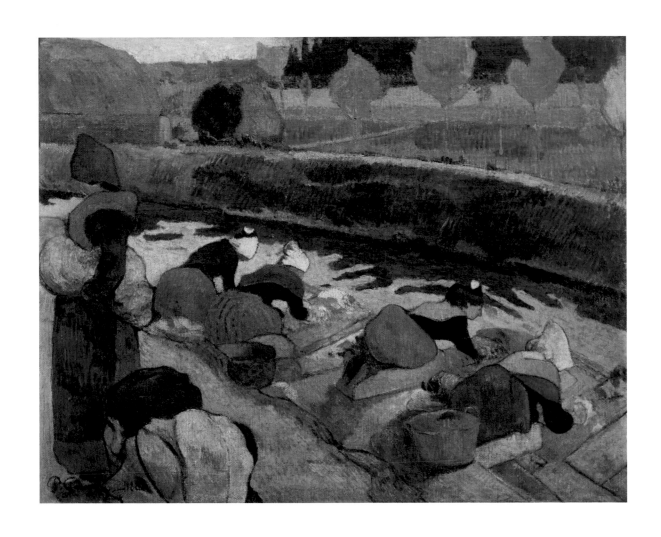

paul gauguin | French, 1848–1903
WASHERWOMEN. 1888
Oil on canvas, 29⅞ x 36¼" (75.9 x 92.1 cm)
The William S. Paley Collection

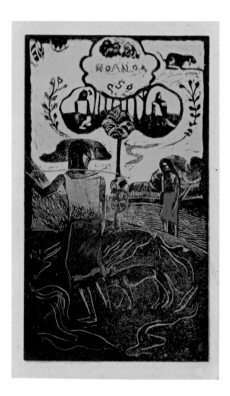

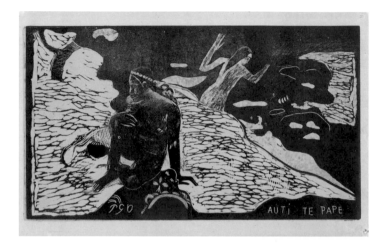

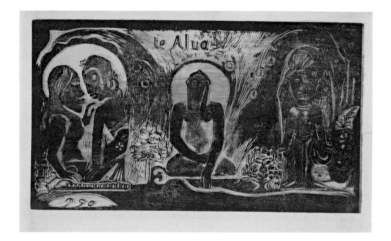

Above left:

paul gauguin | French, 1848–1903

NOA NOA (FRAGRANCE)

from NOA NOA (FRAGRANCE). 1893–94

One from a series of ten woodcuts,

comp.: 14 x 8 1/16" (35.5 x 20.5 cm)

Publisher: the artist, Paris. Printer: Louis Roy, Paris

Edition: 25–30

Lillie P. Bliss Collection

Above right:

paul gauguin

AUTI TE PAPE (WOMEN AT THE RIVER)

from NOA NOA (FRAGRANCE). 1893–94

One from a series of ten woodcuts,

comp.: 8 1/16 x 14" (20.5 x 35.5 cm)

Publisher: the artist, Paris. Printer: Louis Roy, Paris

Edition: 25–30

Gift of Abby Aldrich Rockefeller

Below right:

paul gauguin

TE ATUA (THE GODS)

from NOA NOA (FRAGRANCE). 1893–94

One from a series of ten woodcuts,

comp.: 8 1/16 x 14" (20.5 x 35.5 cm)

Publisher: unpublished. Printer: the artist, Paris

Edition: proof before edition of 25–30

Gift of Abby Aldrich Rockefeller

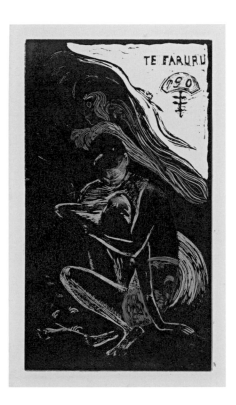 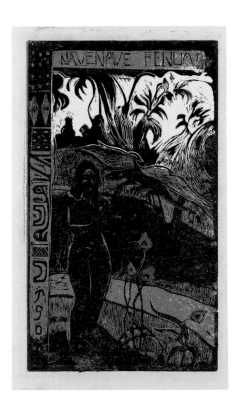

paul gauguin
TE FARURU (HERE WE MAKE LOVE)
from NOA NOA (FRAGRANCE). 1893–94
One from a series of ten woodcuts,
comp.: 14 1⁄16 x 8 1⁄16" (35.7 x 20.5 cm)
Publisher: the artist, Paris. Printer: Louis Roy, Paris
Edition: 25–30
Gift of Abby Aldrich Rockefeller

paul gauguin
NAVE NAVE FENUA (FRAGRANT ISLE)
from NOA NOA (FRAGRANCE). 1893–94
One from a series of ten woodcuts,
comp.: 14 x 8 1⁄16" (35.5 x 20.5 cm)
Publisher: the artist, Paris. Printer: Louis Roy, Paris
Edition: 25–30
Gift of Abby Aldrich Rockefeller

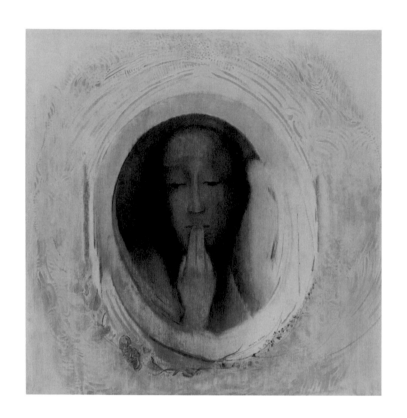

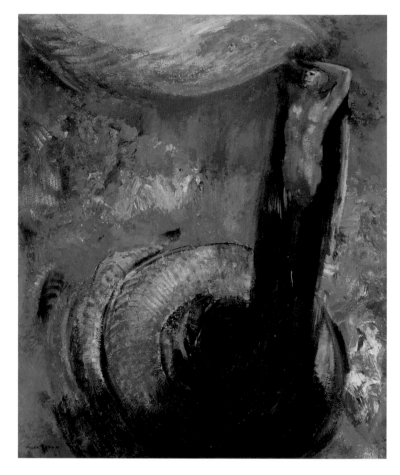

odilon redon | French, 1840–1916
SILENCE. c. 1911
Oil on gesso on paper, 21¼ x 21½" (54 x 54.6 cm)
Lillie P. Bliss Collection

odilon redon
GREEN DEATH. c. 1905
Oil on canvas, 21⅝ x 18¼" (54.9 x 46.3 cm)
Louise Reinhardt Smith Bequest

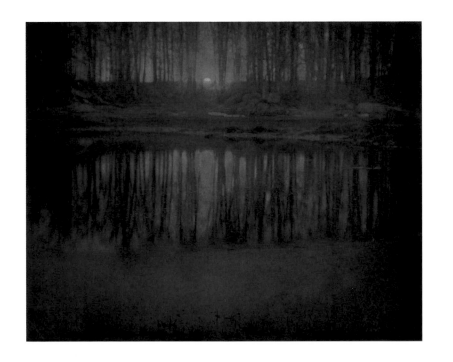

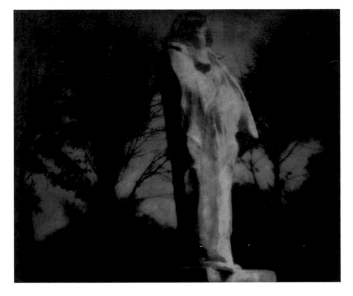

edward steichen | American, born Luxembourg. 1879–1973
MOONRISE—MAMARONECK, NEW YORK. 1904
Platinum and ferroprussiate print, 15¼ x 19"
(38.7 x 48.2 cm)
Gift of the photographer

edward steichen
MIDNIGHT—RODIN'S BALZAC. 1908
Pigment print, 12⅛ x 14⅝" (30.8 x 37.1 cm)
Gift of the photographer

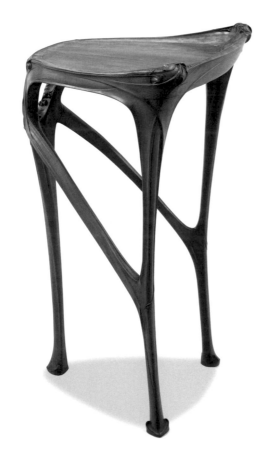

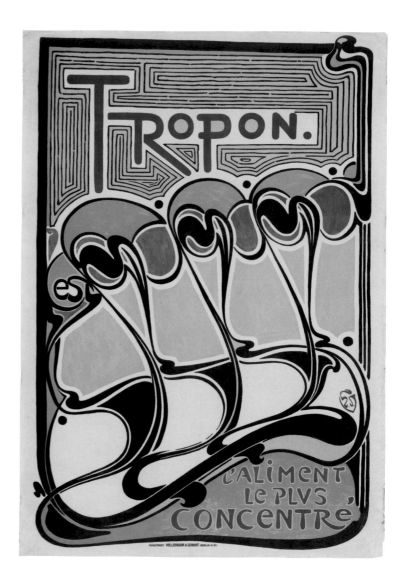

hector guimard | French, 1867–1942
Side Table. c. 1904–07
Pear wood, 29⅞ x 20½ x 17⅞"
(75.9 x 52.1 x 45.4 cm)
Gift of Madame Hector Guimard

henry clemens van de velde | Belgian,
1863–1957
TROPON, L'ALIMENT LE PLUS CONCENTRÉ. 1899
Lithograph, 44 x 30⅜" (111.8 x 77.2 cm)
Arthur Drexler Fund

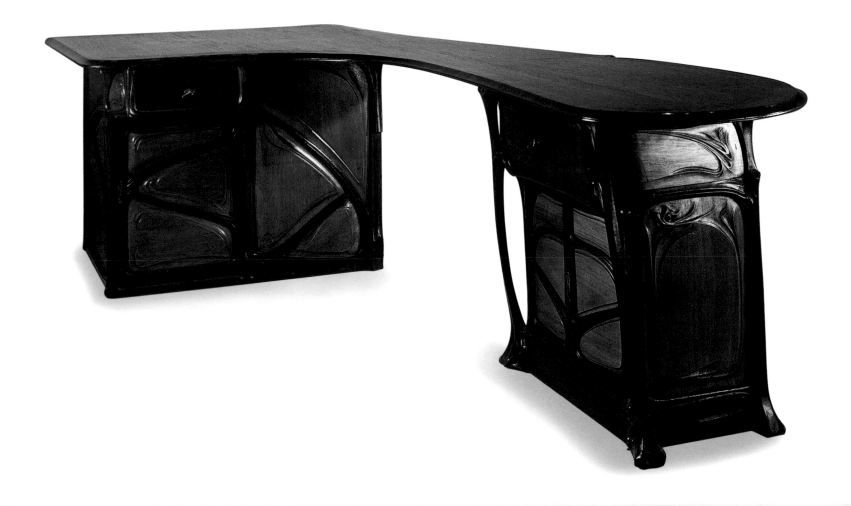

hector guimard
Desk. c. 1899
Olive wood with ash panels, 28¾" x 8' 5" x 47¾"
(73 x 256.5 x 121.3 cm)
Gift of Madame Hector Guimard

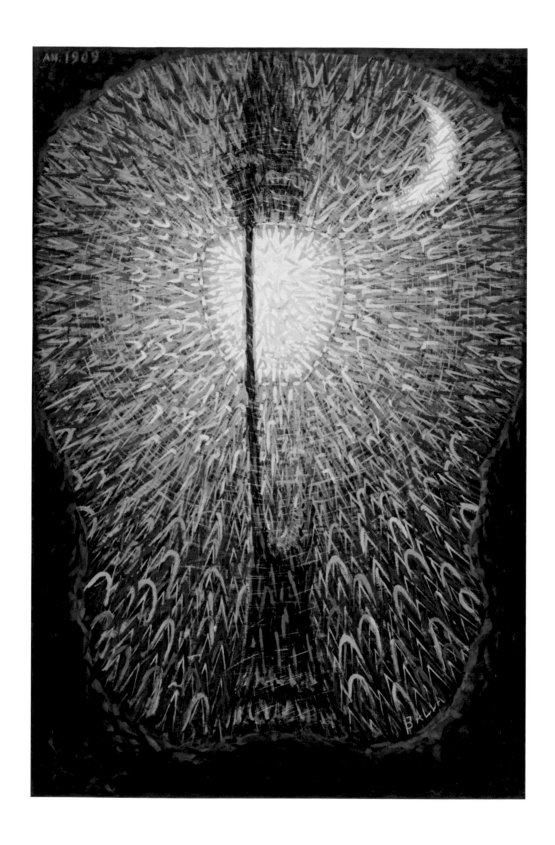

giacomo balla | Italian, 1871–1958
STREET LIGHT. Dated by the artist 1909
Oil on canvas, 68¾ x 45¼" (174.7 x 114.7 cm)
Hillman Periodicals Fund

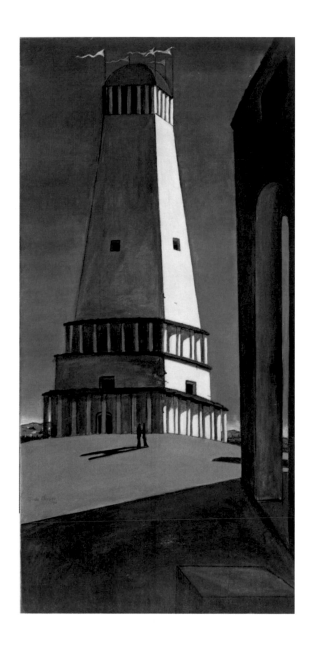

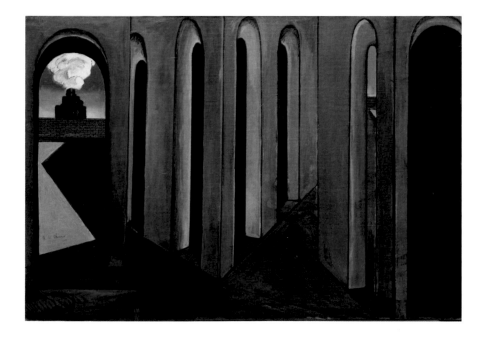

giorgio de chirico | Italian, born Greece.
1888–1978
THE NOSTALGIA OF THE INFINITE. 1913–14?;
dated on painting 1911
Oil on canvas, 53¼ x 25½" (135.2 x 64.8 cm)
Purchase

giorgio de chirico
THE ANXIOUS JOURNEY. 1913
Oil on canvas, 29¼ x 42" (74.3 x 106.7 cm)
Acquired through the Lillie P. Bliss Bequest

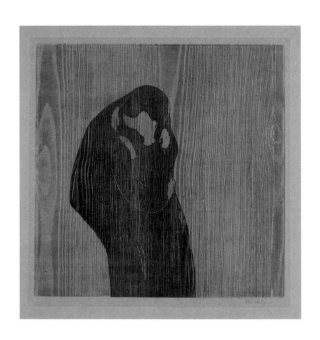

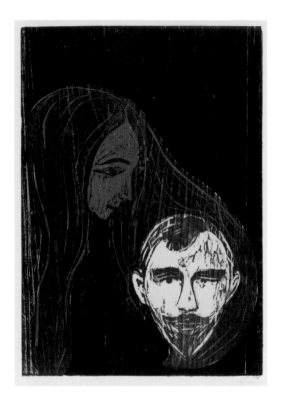

edvard munch | Norwegian, 1863–1944
THE KISS IV. 1897–1902
Woodcut, comp.: 18⅜ x 18⁵⁄₁₆" (46.7 x 46.4 cm)
Publisher: the artist. Printer: M. W. Lassally, Berlin,
or the artist. Edition: 50–100 in several variations
Gift of Abby Aldrich Rockefeller

edvard munch
MAN'S HEAD IN WOMAN'S HAIR. 1896
Woodcut, comp.: 21⅝ x 15" (55 x 38.2 cm)
Publisher: the artist. Printer: M. W. Lassally, Berlin
Edition: approx. 100 in several variations
The William B. Jaffe and Evelyn A. J. Hall Collection

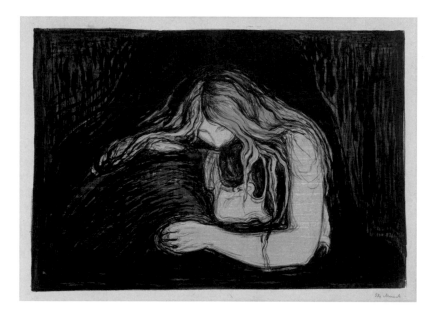

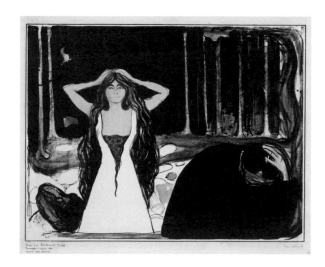

edvard munch

VAMPIRE II. 1895–1902

Lithograph and woodcut, comp.: 15 x 21¾"
(38.1 x 55.3 cm)

Publisher: the artist. Printer: M. W. Lassally, Berlin

Edition: 150–200 in several variations

The William B. Jaffe and Evelyn A. J. Hall Collection

edvard munch

ASHES II. 1899

Lithograph with watercolor additions,
comp.: 13¹⁵⁄₁₆ x 18" (35.4 x 45.7 cm)

Publisher: the artist. Printer: Petersen & Waitz,
Kristiania (now Oslo). Edition: 50–100
in several variations

The William B. Jaffe and Evelyn A. J. Hall Collection

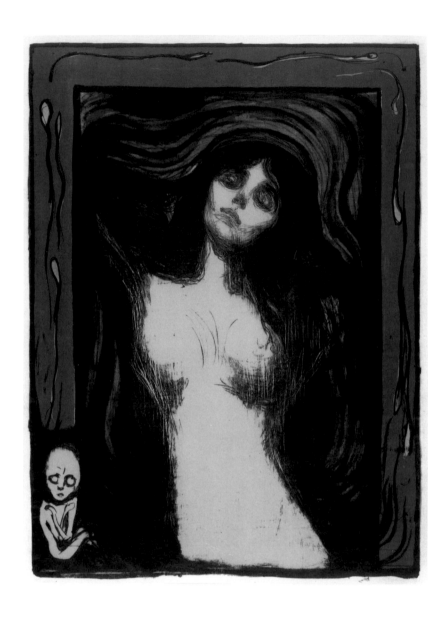

edvard munch | Norwegian, 1863–1944
MADONNA. 1895–1902
Lithograph, comp.: 23¾ x 17½" (60.5 x 44.5 cm)
Publisher: the artist. Printer: M. W. Lassally, Berlin
Edition: approx. 150 in several variations
The William B. Jaffe and Evelyn A. J. Hall Collection

Opposite top left:
egon schiele | Austrian, 1890–1918
NUDE WITH VIOLET STOCKINGS. 1912
Watercolor, pencil, and brush and ink on paper,
12⅝ x 18⅝" (32 x 47.3 cm)
Mr. and Mrs. Donald B. Straus Fund

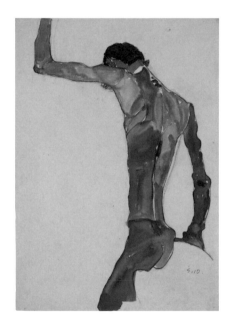

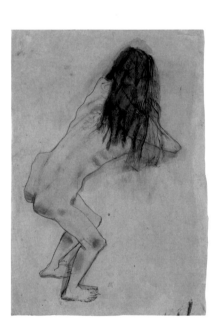

Above right:
erich heckel | German, 1883–1970
FRÄNZI RECLINING. 1910
Woodcut, comp.: 8¹⁵⁄₁₆ x 16½" (22.7 x 41.1 cm)
Publisher: unpublished. Printer: the artist, Dresden
Edition: unknown
Gift of Mr. and Mrs. Otto Gerson

Below left:
oskar kokoschka | British, born Austria.
1886–1980
NUDE WITH BACK TURNED. c. 1907
Pen and ink, gouache and chalk on buff paper,
17¾ x 12¼" (45.1 x 31.1 cm)
Rose Gershwin Fund

Below right:
egon schiele
STANDING MALE NUDE WITH ARM RAISED. 1910
Watercolor and charcoal on paper, 17½ x 12¼"
(44.5 x 30.8 cm)
Gift of Jo Carole and Ronald S. Lauder

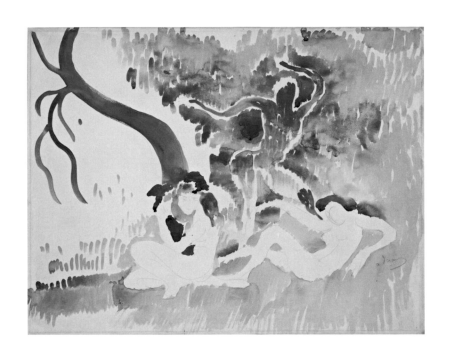

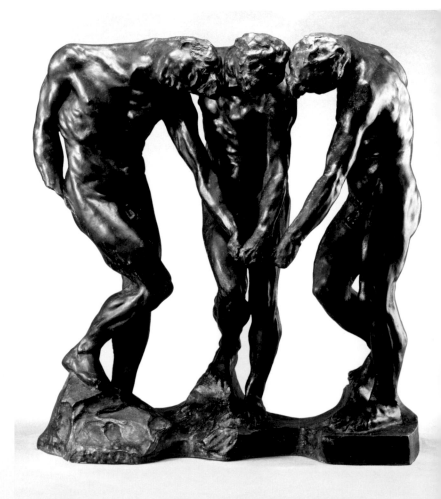

andré derain | French, 1880–1954
BACCHIC DANCE. 1906
Watercolor and pencil on paper, 19½ x 25½"
(49.5 x 64.8 cm)
Gift of Abby Aldrich Rockefeller

34 **primal**

Opposite:
auguste rodin | French, 1840–1917
THE THREE SHADES. 1881–86
Bronze, 38⅜ x 36⅜ x 19½" (97.3 x 92.2 x 49.5 cm)
Mary Sisler Bequest

andré derain
BATHERS. 1907
Oil on canvas, 52 x 6' 4¾" (132.1 x 195 cm)
William S. Paley and Abby Aldrich Rockefeller Funds

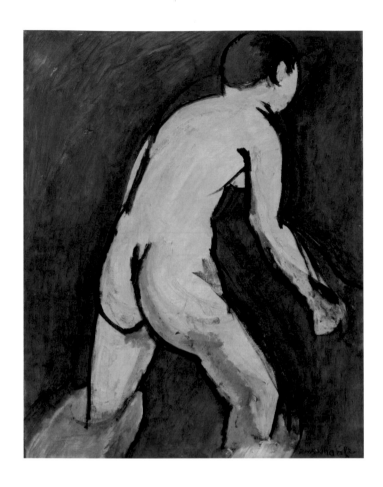

henri matisse | French, 1869–1954
BATHER. Summer 1909
Oil on canvas, 36½ x 29⅛" (92.7 x 74 cm)
Gift of Abby Aldrich Rockefeller

henri matisse
MUSIC (SKETCH). June–July 1907
Oil and charcoal on canvas, 29 x 24"
(73.4 x 60.8 cm)
Gift of A. Conger Goodyear in honor of
Alfred H. Barr, Jr.

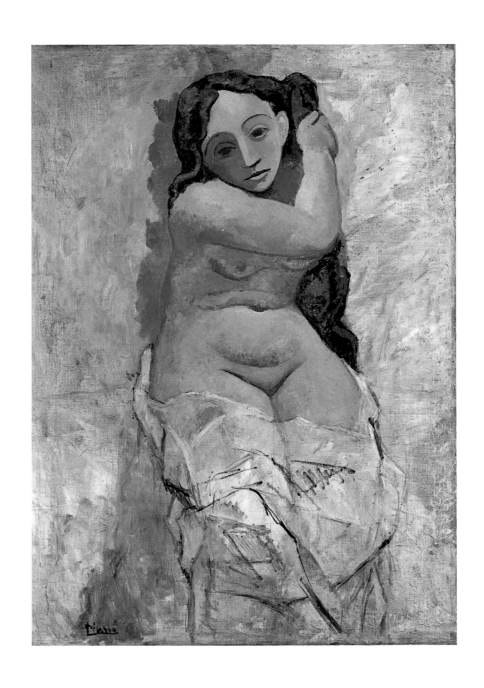

pablo picasso | Spanish, 1881–1973
WOMAN PLAITING HER HAIR. 1906
Oil on canvas, 50 x 35¾" (127 x 90.8 cm)
Florene May Schoenborn Bequest

emil nolde | German, 1867–1956
CHRIST AMONG THE CHILDREN. 1910
Oil on canvas, 34⅛ x 41⅞" (86.8 x 106.4 cm)
Gift of Dr. W. R. Valentiner

κäthe κollwitz | German, 1867–1945
THE PARENTS from SEVEN WOODCUTS
ABOUT WAR. 1921–22, published 1924
One from a portfolio of seven woodcuts,
comp.: 13¾ x 16¾" (34.9 x 42.6 cm)
Publisher: Emil Richter, Dresden. Printer: probably
Fritz Voigt, Berlin. Edition: two editions of 100 each
Gift of the Arnhold Family in memory of
Sigrid Edwards

κäthe κollwitz
THE WIDOW I from SEVEN WOODCUTS
ABOUT WAR. 1921–22, published 1924
One from a portfolio of seven woodcuts,
comp.: 14⅝ x 9¼" (37.2 x 23.5 cm)
Publisher: Emil Richter, Dresden. Printer: probably
Fritz Voigt, Berlin. Edition: two editions of 100 each
Gift of the Arnhold Family in memory of
Sigrid Edwards

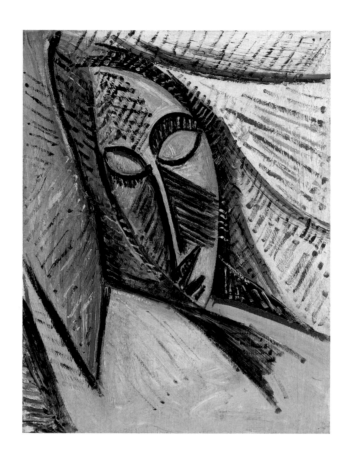

pablo picasso | Spanish, 1881–1973
HEAD OF A SLEEPING WOMAN. Summer 1907
Oil on canvas, 24¼ x 18¾" (61.4 x 47.6 cm)
Estate of John Hay Whitney

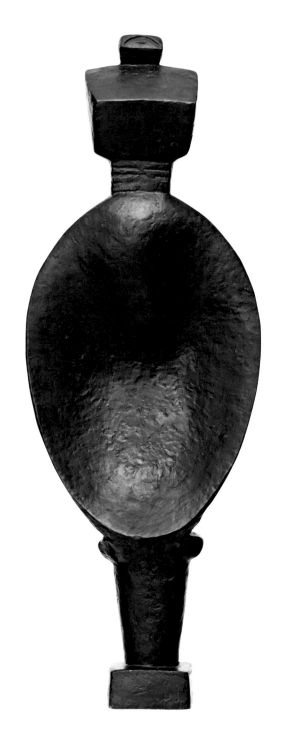

alberto giacometti | Swiss, 1901–1966
THE COUPLE. 1926
Bronze, 23⅜ x 14⅞ x 14⅝" (59.6 x 38 x 37.1 cm)
Blanchette Rockefeller Fund

alberto giacometti
SPOON WOMAN. 1926–27
Bronze, 57 x 20¼ x 8¼" (144.8 x 51.4 x 21 cm)
Acquired through the Mrs. Rita Silver Fund in honor
of her husband Leo Silver and in memory of her son
Stanley R. Silver, and the Mr. and Mrs. Walter
Hochschild Fund

41

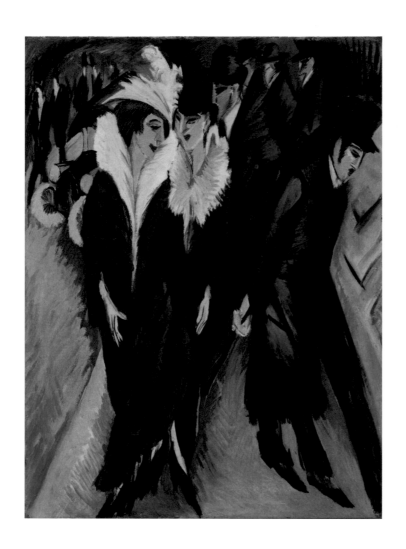

ernst ludwig kirchner | German, 1880–1938
STREET, BERLIN. 1913
Oil on canvas, 47½ x 35⅞" (120.6 x 91.1 cm)
Purchase

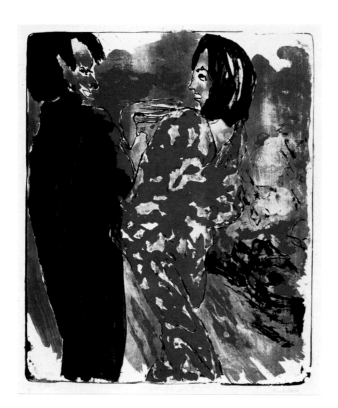 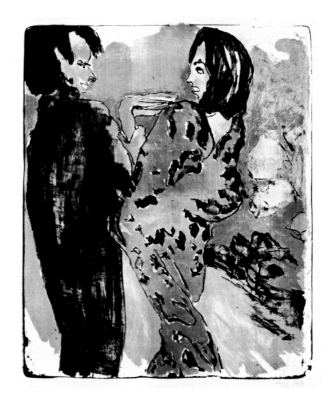

emil nolde | German, 1867–1956
YOUNG COUPLE. 1913
Lithograph, comp.: 24⁷⁄₁₆ x 20" (62.1 x 50.9 cm)
Publisher: the artist. Printer: Westphalen, Flensburg,
Germany. Edition: 121 in 69 color variations
Purchase

emil nolde
YOUNG COUPLE. 1913
Lithograph, comp.: 24½ x 19¹⁵⁄₁₆" (62.2 x 50.6 cm)
Publisher: the artist. Printer: Westphalen, Flensburg,
Germany. Edition: 121 in 69 color variations
Purchase

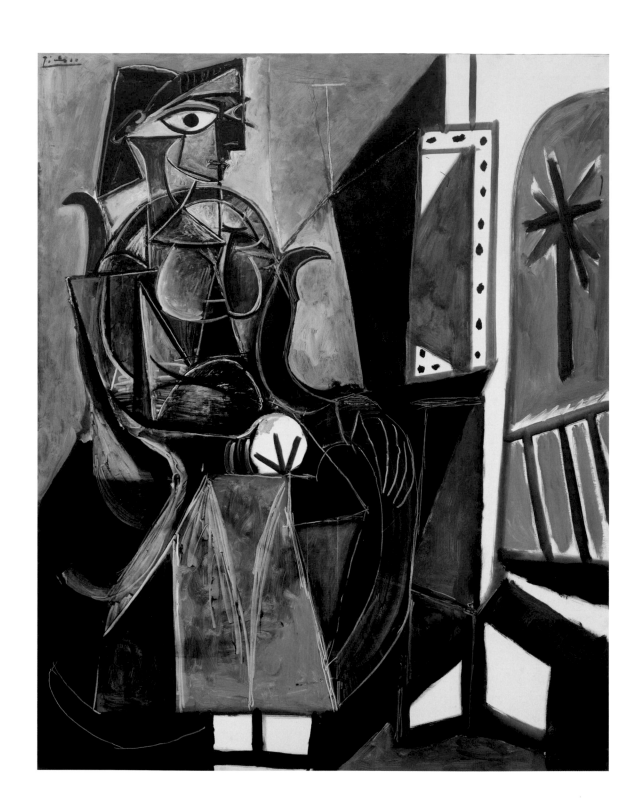

pablo picasso | Spanish, 1881–1973
WOMAN BY A WINDOW. June 1956
Oil on canvas, 63¾ x 51¼" (162 x 130 cm)
Mrs. Simon Guggenheim Fund

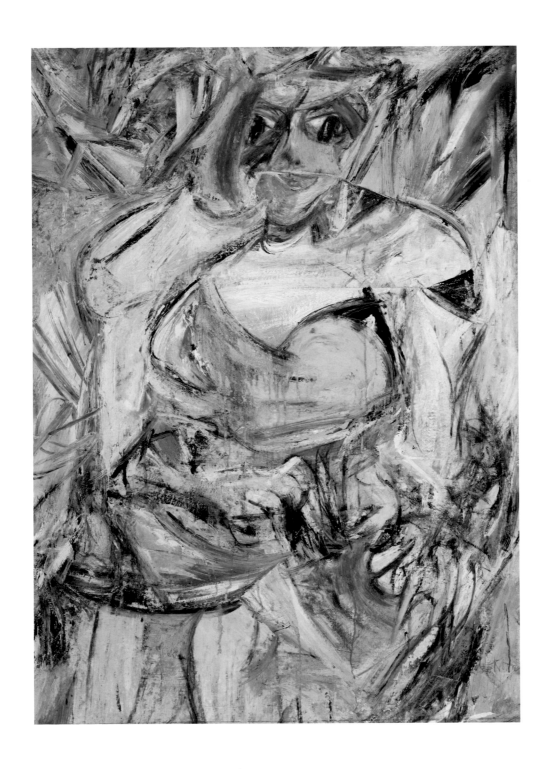

willem de kooning | American, born
The Netherlands. 1904–1997
WOMAN, II. 1952
Oil on canvas, 59 x 43" (149.9 x 109.3 cm)
Gift of Mrs. John D. Rockefeller 3rd

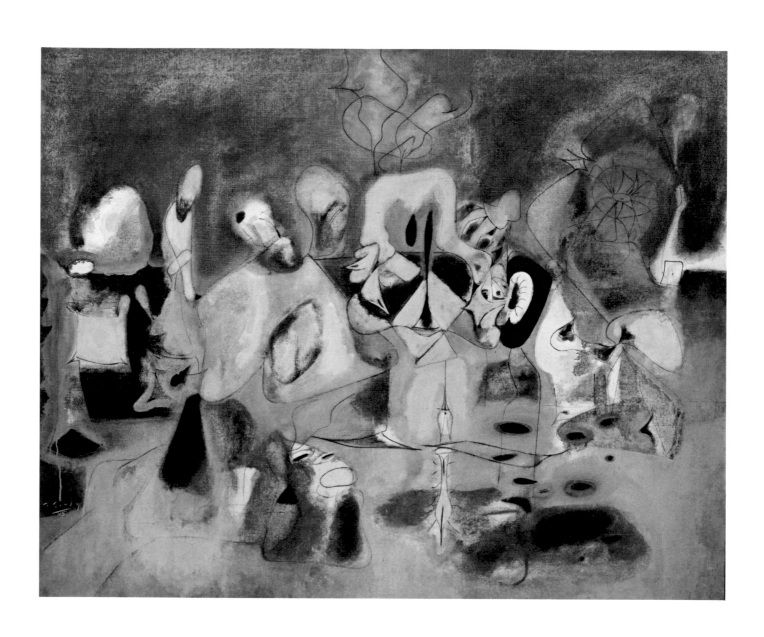

arshile gorky (vosdanig manoog adoian)
American, born Armenia. 1904–1948
DIARY OF A SEDUCER. 1945
Oil on canvas, 49⅞ x 62" (126.7 x 157.5 cm)
Gift of Mr. and Mrs. William A. M. Burden

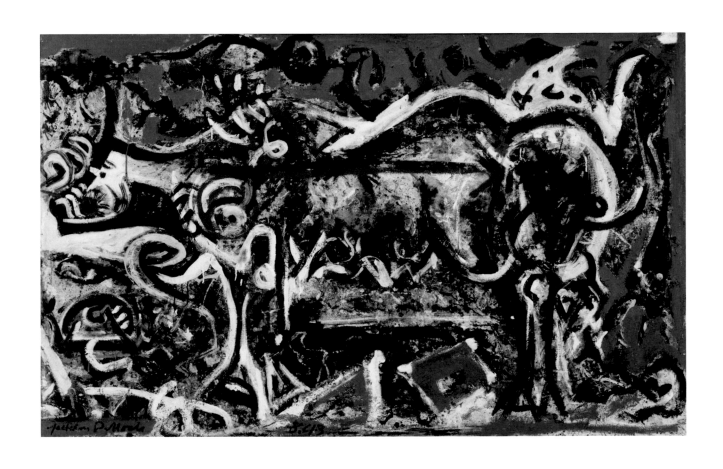

jackson pollock | American, 1912–1956
THE SHE-WOLF. 1943
Oil, gouache, and plaster on canvas, 41⅞ x 67"
(106.4 x 170.2 cm)
Purchase

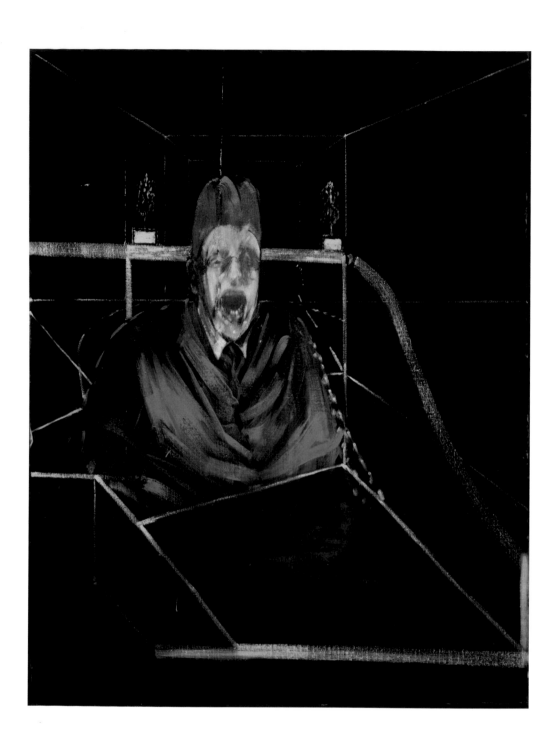

francis bacon | British, born Ireland. 1909–1992
NUMBER VII from EIGHT STUDIES FOR
A PORTRAIT. 1953
Oil on linen, 60 x 46⅛" (152.3 x 117 cm)
Gift of Mr. and Mrs. William A. M. Burden

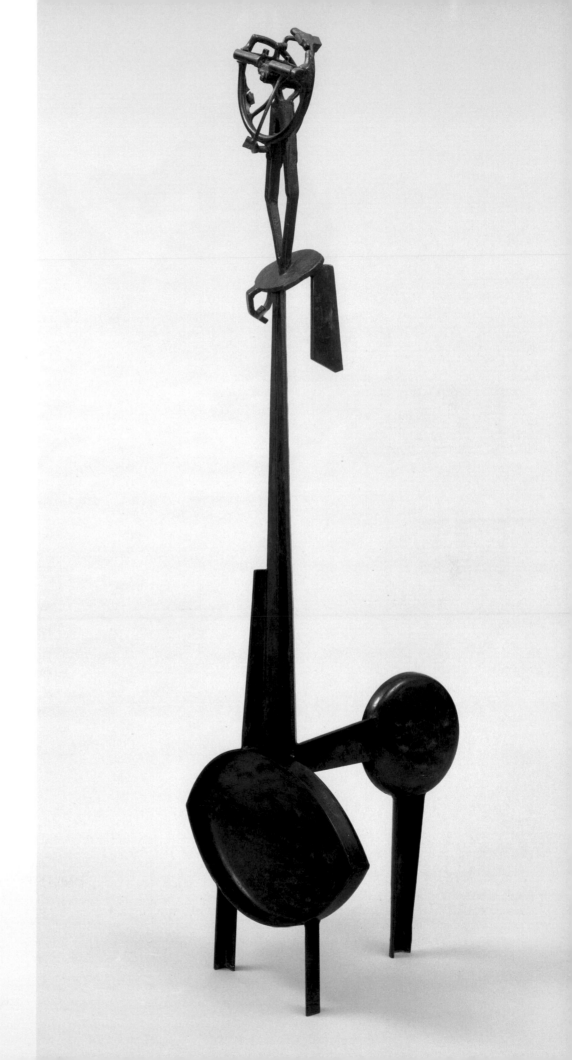

david smith | American, 1906–1965
HISTORY OF LEROY BORTON. 1956
Forged steel, 7' 4¼" x 26¾ x 24½"
(224.1 x 67.9 x 62.2 cm)
Mrs. Simon Guggenheim Fund

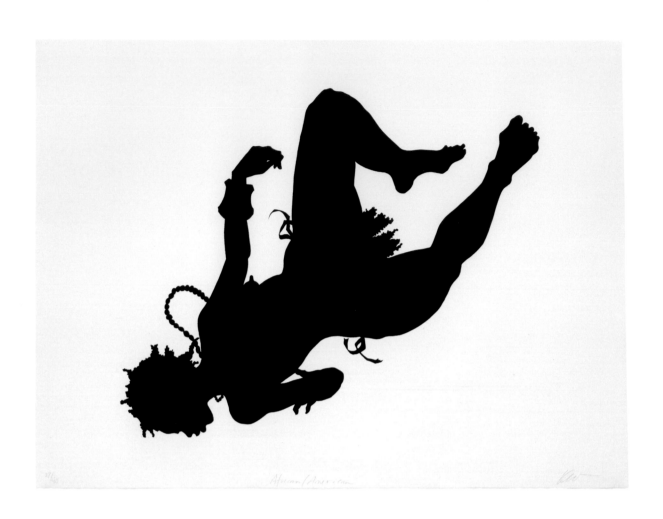

kara walker | American, born 1969
AFRICAN/AMERICAN. 1998
Linoleum cut, sheet: 46¼ x 60½" (117.5 x 153.7 cm)
Publisher and printer: Landfall Press, Chicago
Edition: 40
Ralph E. Shikes Fund

nancy spero | American, born 1926
TO THE REVOLUTION XI. 1981
Zinc cut, sheet: 20¼" x 9' 2⅜" (51.4 x 280.4 cm)
Publisher: unpublished. Printer: the artist, New York
Edition: unique
John B. Turner Fund

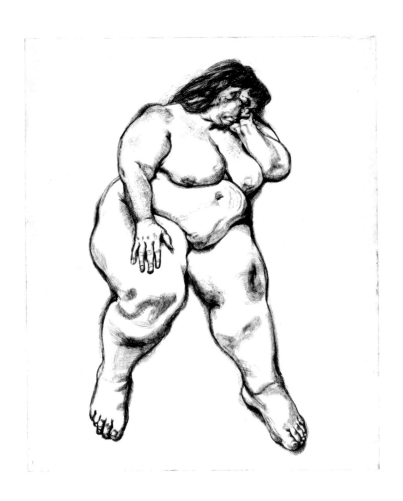

Above:
lucian freud | British, born Germany, 1922
BENEFITS SUPERVISOR SLEEPING. 1995
Etching, plate: 28¹¹⁄₁₆ x 23⅜" (72.9 x 59.4 cm)
Publisher: Matthew Marks Gallery, New York
Printer: Studio Prints, London. Edition: 36
Alexandra Herzan Fund and Linda Barth
Goldstein Fund

51

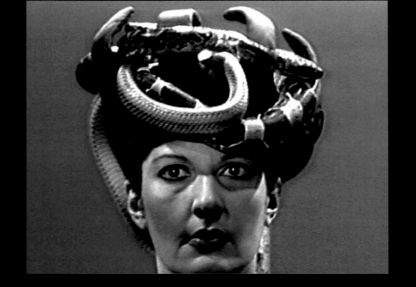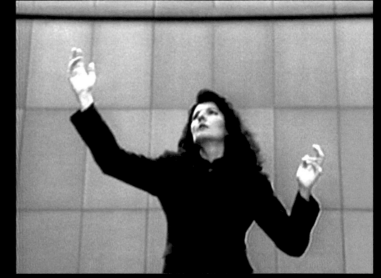

marina abramovic | Yugoslavian, born 1946
and **charles atlas** | American, born 1944
SSS. 1989
DVD, color, sound, 6 minutes
Produced by IMATCO/ATANOR for Television
Espanola S.A. El Arte del Video.
Gift of Barbara Wise

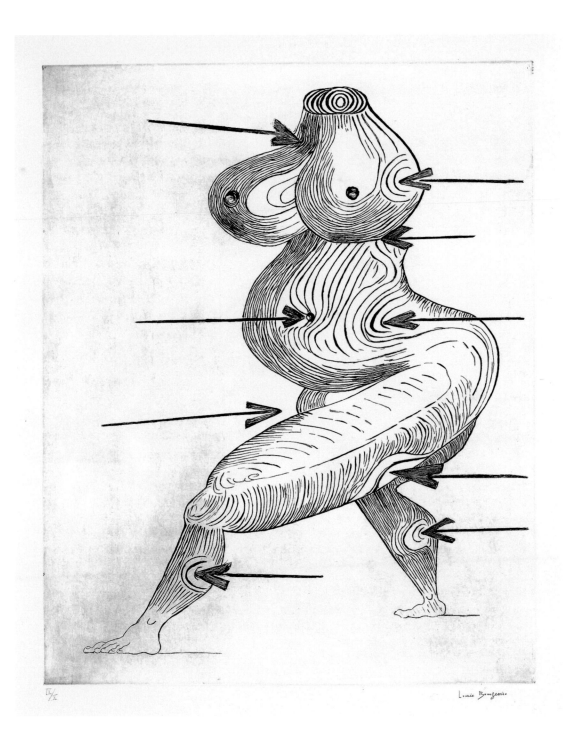

louise bourgeois | American, born France, 1911
STE SEBASTIENNE. 1992
Drypoint, plate: 38¹⁵⁄₁₆ x 30⅞" (98.9 x 78.4 cm)
Publisher: Peter Blum Edition, New York
Printer: Harlan & Weaver, New York
Edition: 50
Gift of the artist

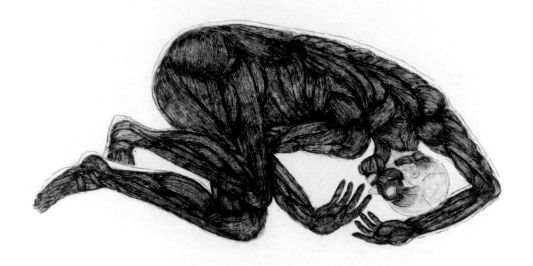

kiki smith | American, born Germany, 1954
SUEÑO. 1992
Etching and aquatint, sheet: 41¹³⁄₁₆ x 6' 5¹⁄₁₆"
(106.2 x 195.8 cm)
Publisher and printer: Universal Limited
Art Editions, West Islip, N.Y. Edition: 33
Gift of Emily Fisher Landau

Opposite:
anselm kiefer | German, born 1945
GRANE. 1980–93
Woodcut with paint and collage additions,
on thirteen sheets, mounted on linen,
sheet: 9' 1¹⁄₁₆" x 8' 2½" (277.1 x 250.2 cm)
Publisher: unpublished. Printer: the artist,
Buchen, Germany
Edition: unique

Purchased with funds given in honor of Riva
Castleman by the Committee on Painting and
Sculpture, the Associates Fund, Molly and Walter
Bareiss, Nelson Blitz, Jr. with Catherine Woodard
and Perri and Allison Blitz, Agnes Gund, The Philip
and Lynn Straus Foundation, Howard B. Johnson,
Mr. and Mrs. Herbert D. Schimmel, and the Riva
Castleman Endowment Fund

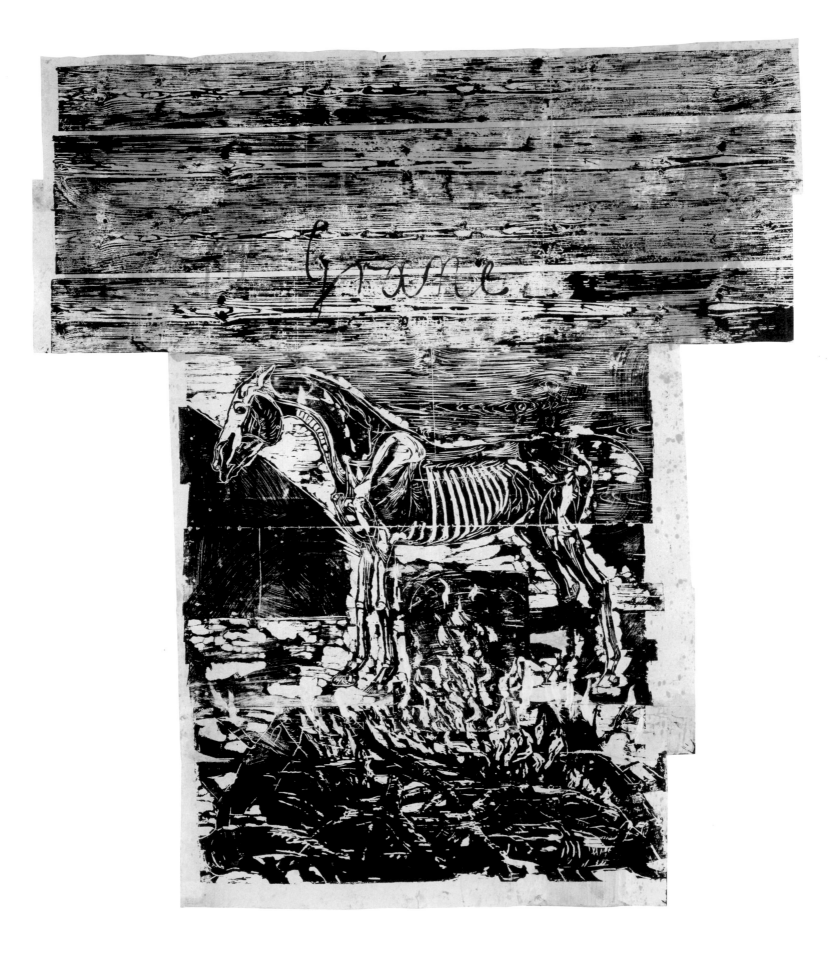

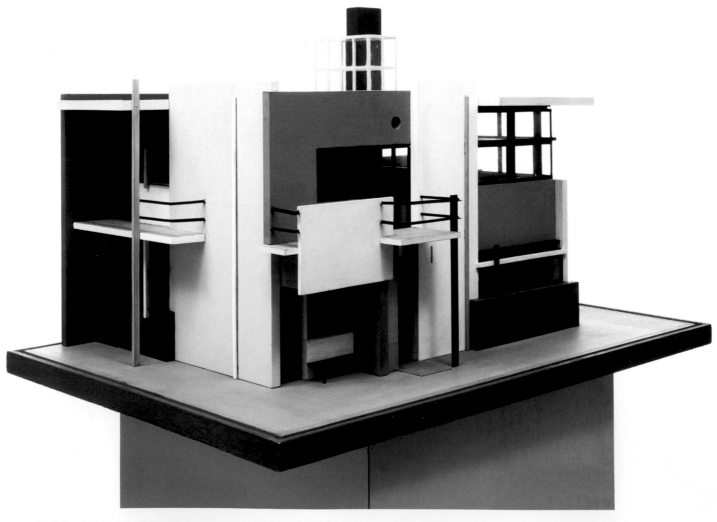

gerrit rietveld | Dutch, 1888–1964
Schröder House, Utrecht, The Netherlands. 1924
Model date: 1965
Wood, 19 x 30³⁄₁₆ x 21³⁄₁₆" (48.3 x 76.7 x 53.8 cm)
Gift of Mrs. Phyllis B. Lambert

reductive

While the impulse for simplification and abstraction is basic to human thinking, and appears in art of many cultures and epochs, the modern West experienced a flowering of such an artistic vocabulary beginning roughly in 1910 and extending to the present. Variations in abstraction can include the gestural and expressionist, as well as the measured and contemplative, but the focus here is on reductive forms, sometimes manifested in organic shapes derived from nature, but most often based on geometric principles of rationality and order. The years of and around the 1920s may have seen the fullest expression of such a vocabulary, yet there were other moments of concentration as well.

The dictum "less is more," formulated by architect Ludwig Mies van der Rohe, has come to stand for a widespread search for clarity of vision and a focus on the essences of materials and forms. For many artists, such abstraction also represented cosmic harmonies and universal truths. A search for harmony and order was certainly among the responses to the devastation of World War I, and this quest may have found its quintessential embodiment in architecture. Requiring tenets of mathematical reasoning, buildings also provided an aesthetic environment in which to encompass utopian ideas. Gerrit Rietveld's Schröder House (1924) provides such a model with its rectilinear planes, interlocking spaces, and primary colors emphasizing structural elements, as well as interior furnishings of similar design. Projects like this reflect the desire for an equilibrium in art and life at that time and can be seen as leading eventually to the architectural phenomenon known as the International Style, flourishing worldwide until the 1950s. Unadorned skyscrapers of steel, concrete, and transparent glass, based on the axiom of form following function, expressed a faith in technology, efficiency, and progress.

The story of reductive geometric abstraction begins earlier, however, foreshadowed in works like Gustav Stickley's Armchair (1907) and Frank Lloyd Wright's clerestory windows from the Avery Coonley Playhouse (1912), but gaining momentum with the unfolding of Cubism. Cubist painters analyzed still life, portraiture, and cityscape and landscape subjects, each from simultaneous points of view and composed of rectilinear facets and fragmented planes that acknowledged the flat surface of their canvas supports. Piet Mondrian, who forged his artistic language through Cubism, said in 1914, "I wish to approach truth as closely as is possible, and therefore I abstract everything until I arrive at the fundamental quality of objects." Mondrian eventually limited his compositional elements to horizontals and verticals and his palette to the primary colors, black, white, and gray, developing what he called "a universal structuring system." Pictorially reduced as it was, this work reflected a preoccupation with dynamic balance and harmony, and was rooted in the mystical philosophy of theosophy.

Fernand Léger, meanwhile, exploited abstraction for very different ends, addressing the dynamism of the machine age. "If pictorial expression has changed," Léger said, "it is because modern life has necessitated it." In the United States, the photographers Charles Sheeler and Margaret Bourke-White, commissioned by the automotive giants Ford and Chrysler, framed architectural motifs as authoritative geometric compositions that glorified modern industry. Their pictures burnished the public images of these manufacturing companies by emanating power, grandeur, and positive aspects of technological progress.

Russian artists of the 1920s were caught up in a comparable idealism about the future, although their hopes rested not on the machinery of capitalism, whether literal or managerial, but on the power of the proletariat and of the state. In the teens, they, too, had explored the visual possibilities of abstraction in painting, most notably in the work of Kazimir Malevich. Like Mondrian, Malevich wanted his art to express universal harmonies, and evolved for this purpose a philosophy and visual syntax he called Suprematism. His canvases suggested endless space and spiritual transcendence, yet the ingredients were simply geometric shapes against white backdrops.

With the Revolution of 1917, however, Russian artists turned in a new direction. They abandoned easel painting, now considered an indulgent art form designed for the bourgeois consumer, and took up practical projects—posters, book covers, textiles, ceramics—that could be mass-produced for a vast audience. These projects adapted the visual language of Suprematism and employed a color scheme of red, black, and white. Optimistic about

their own roles in the new society, artists believed that their simplified compositions would be universally understood. Beginning in the late 1920s, however, these goals met the resistance of Joseph Stalin, who began to suppress abstract art as elitist, decreeing in 1934 that only Socialist Realism, a style that glorified the Soviet state and his own regime, would be tolerated.

Before Stalin's aesthetic repressions set in, links had developed between the Russian and Western European avant-gardes. The Russian El Lissitzky, for example, whose work encompassed architecture, graphic design, and photography, traveled extensively back and forth, so that Russian Constructivist ideas merged with those of both the Dutch de Stijl movement, led by Mondrian and Theo van Doesburg, and the Bauhaus art school in Germany. Lissitzky invented a visual form called "Proun" that united concepts of painting and architecture, and that he adapted for characters in his portfolio FIGURINES: THE THREE-DIMENSIONAL DESIGN OF THE ELECTRO-MECHANICAL SHOW "VICTORY OVER THE SUN" (1923). His book designs include OF TWO SQUARES: A SUPREMATIST TALE IN SIX CONSTRUCTIONS (1922), meant to indoctrinate children into the superiority of the new Soviet order (symbolized by a red square) over the old (symbolized by a black square).

The Bauhaus, established by Walter Gropius in 1919, was envisioned to unite the fine and the applied arts, art and technology. In its various

locations (first Weimar, then Dessau, and briefly Berlin, before closing in 1933), the Bauhaus brought artists and craftspeople together. The emphasis was on practical forms for everyday environments, and the dominant style was geometric. Students worked with mass production in mind, displacing the unique, hand-crafted object. Furnishings created at the Bauhaus include chairs and tables by Marcel Breuer and Mies van der Rohe. Breuer's furniture introduced the use of tubular steel, a product immediately suggesting machinery. Frames were reduced to essentials, expressing clarity and simplicity, and concepts like "integrity" and "honesty" figured prominently as design precepts. A chair, for example, instead of being bulky like an old-fashioned stuffed sofa, would be pared down to its skeleton, revealing only its structural essence.

Josef Albers, who filled many roles at the Bauhaus as both student and teacher, demonstrated the uses of geometric shapes in both the practical and fine arts. His fruit bowl of 1924 and tea glass with saucer and stirrer of 1925, seen here, are two examples from the Bauhaus metal shops. When Albers emigrated to the United States, in 1933, he brought these ideas with him, continuing his role as influential artist and teacher. His **HOMAGE TO THE SQUARE** series, begun in 1950 and exploring the effects of color within strictly defined nesting squares, resulted in more than one thousand permutations in paintings and prints.

Even at the height of the Abstract Expressionist movement in the 1950s, figures like Yves Klein in France and Ellsworth Kelly in the United States pursued abstraction with geometric components that gave color a primary role. Kelly used the shape of the canvas itself as a source of compositional structure and often based his forms on elements of the natural world, such as plants or cast shadows. Klein tried to approach spirituality through monochromatic color. He so favored one particular shade of blue that he named it "International Klein Blue," or "IKB," believing it a measure of infinity and "an open window to freedom."

The Minimalism movement emerging in the United States in the 1960s marks yet another aesthetic embrace of simplification and order in art. Donald Judd, Sol LeWitt, and others based their work on logical systems and machine-made materials. Their objects inhabited space in ways that called attention to it: ceilings, walls, and floors were seen as interacting with the artworks, echoing environmental implications discussed earlier. Similarly, the paintings of Agnes Martin and Robert Ryman evoke a sense of transcendence that clearly descends from the cosmic strivings of Mondrian and Malevich, although neither would state their aims in such terms. The reverence of such ideals, in fact, can be fodder for Conceptual-art manipulation, as seen in Allan McCollum's **40 PLASTER SURROGATES** (1982–84), a work that immediately evokes the squares and rectangles of Suprematism more than a half century earlier, but that challenges the faith once imbued in such abstraction with irony and humor.

frank lloyd wright | American, 1867–1959
Clerestory Windows from
Avery Coonley Playhouse, Riverside, Illinois. 1912
Colored and clear leaded glass,
each: 18⁵⁄₁₆ x 34³⁄₁₆" (46.5 x 86.8 cm)
Joseph H. Heil Fund

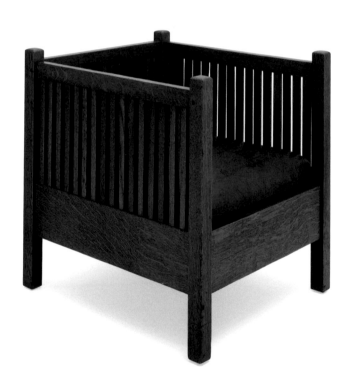

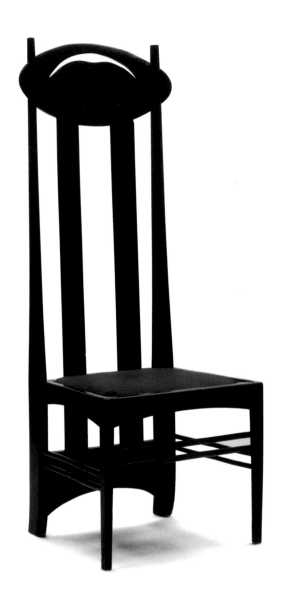

gustav stickley | American, 1858–1942
Armchair. 1907
Oak and leather, 29 x 26 x 27⅝"
(73.6 x 66 x 70.2 cm)
Gift of John C. Waddell

charles rennie mackintosh | British, 1868–1928
Side Chair. 1897
Oak and silk, 54⅜ x 20 x 18" (138.1 x 50.8 x 45.7 cm),
seat h. 17" (43.2 cm)
Gift of the Glasgow School of Art

juan gris | Spanish, 1887–1927
STILL LIFE. 1911
Oil on canvas, 23½ x 19¾" (59.7 x 50.2 cm)
Acquired through the Lillie P. Bliss Bequest

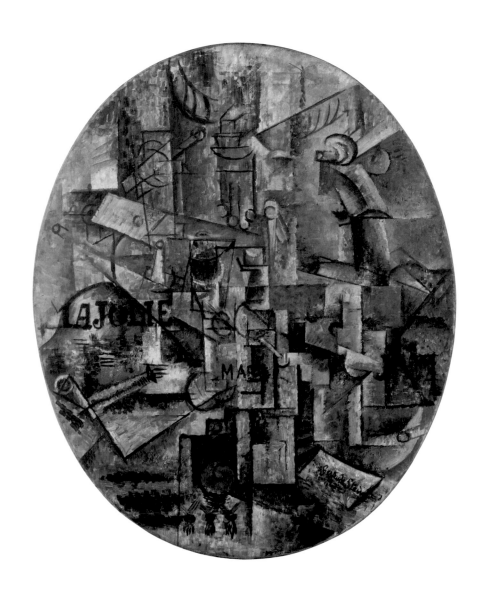

pablo picasso | Spanish, 1881–1973
THE ARCHITECT'S TABLE. Early 1912
Oil on canvas mounted on oval panel,
28⅝ x 23½" (72.6 x 59.7 cm)
The William S. Paley Collection

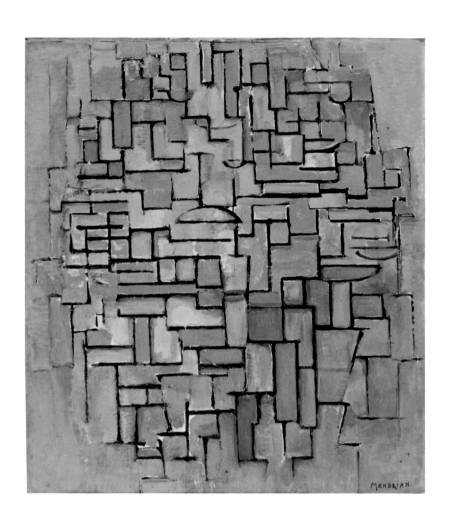

piet mondrian | Dutch, 1872–1944
COMPOSITION IN BROWN AND GRAY. 1913–14
Oil on canvas, 33¾ x 29¾" (85.7 x 75.6 cm)
Purchase

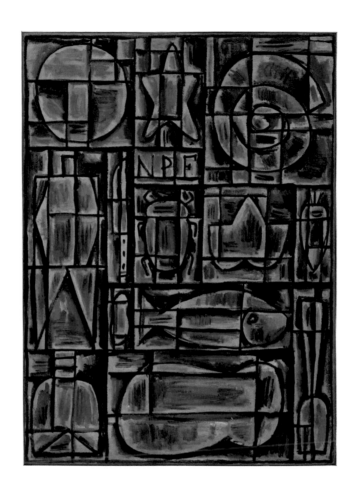

joaquín torres-garcía | Uruguayan, 1874–1949
CONSTRUCTIVE PAINTING. c. 1931
Oil on canvas, 29⅝ x 21⅞" (75.2 x 55.4 cm)
The Sidney and Harriet Janis Collection

fernand léger | French, 1881–1955
THE MIRROR. 1925
Oil on canvas, 51 x 39¼" (129.6 x 99.6 cm)
Nina and Gordon Bunshaft Bequest

Opposite:
fernand léger
MURAL PAINTING. 1924
Oil on canvas, 71 x 31¼" (180.3 x 79.2 cm)
Given anonymously

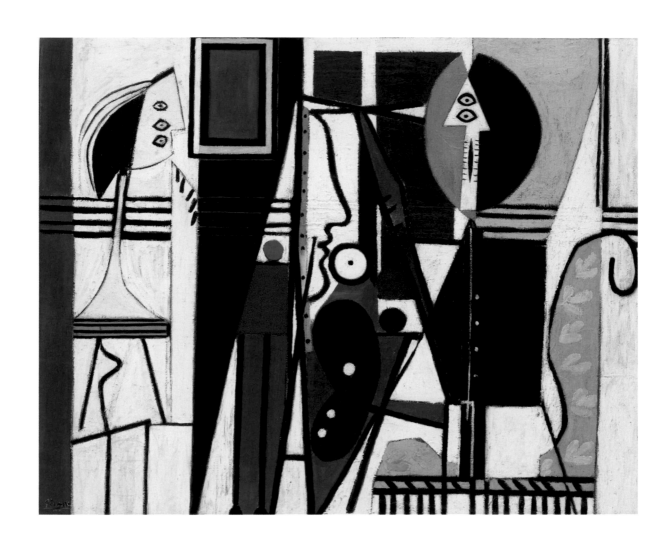

pablo picasso | Spanish, 1881–1973
PAINTER AND MODEL. 1928
Oil on canvas, 51⅛ x 64¼" (129.8 x 163 cm)
The Sidney and Harriet Janis Collection

pablo picasso
THE KITCHEN. November 1948
Oil on canvas, 69" x 8' 2½" (175.3 x 250 cm)
Acquired through the Nelson A. Rockefeller Bequest

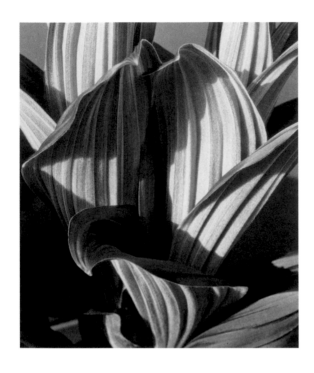

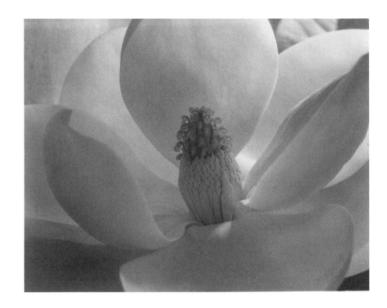

imogen cunningham | American, 1883–1976
GLACIAL LILY. 1927
Gelatin silver print, 8⅜ x 7¼" (21.3 x 18.4 cm)
Gift of Albert M. Bender

imogen cunningham
MAGNOLIA BLOSSOM. c. 1925
Gelatin silver print, 6¾ x 8½" (17.1 x 21.6 cm)
Gift of Albert M. Bender

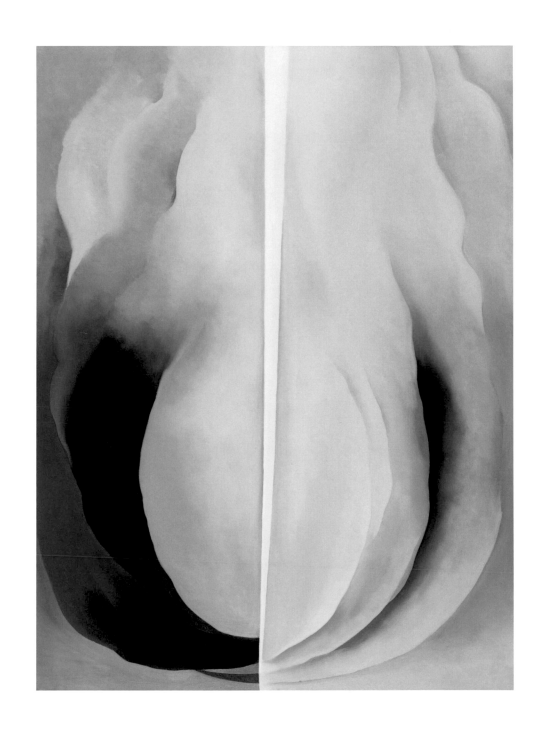

georgia o'keeffe | American, 1887–1986
ABSTRACTION BLUE. 1927
Oil on canvas, 40¼ x 30" (102.1 x 76 cm)
Acquired through the Helen Acheson Bequest

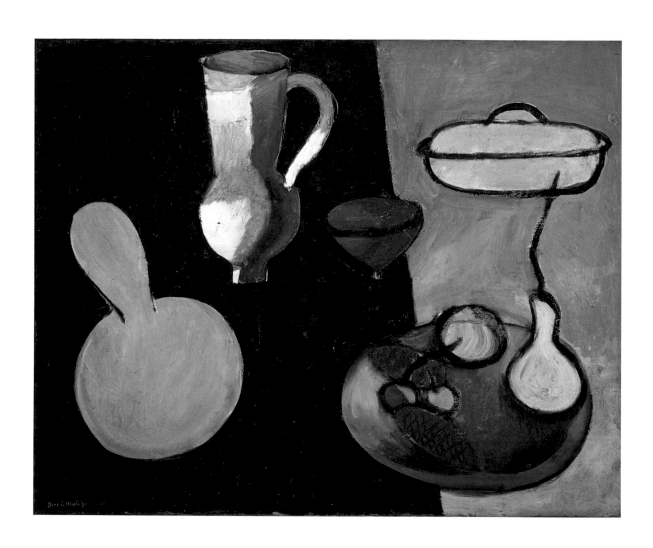

henri matisse | French, 1869–1954
GOURDS. 1915–16; dated 1916
Oil on canvas, 25⅝ x 31⅞" (65.1 x 80.9 cm)
Mrs. Simon Guggenheim Fund

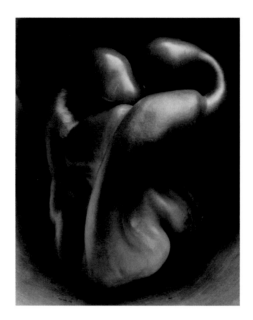

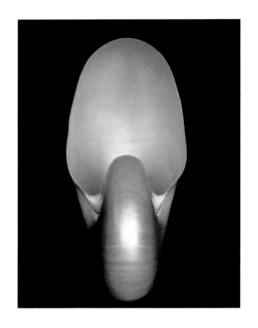

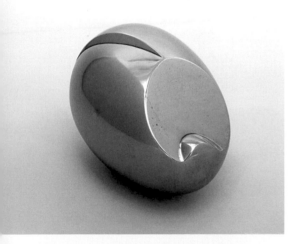

constantin brancusi | French, born Romania.
1876–1957
THE NEWBORN. version I, 1920
(close to the marble of 1915)
Bronze, 5¾ x 8¼ x 5¾" (14.6 x 21 x 14.6 cm)
Acquired through the Lillie P. Bliss Bequest

edward weston | American, 1886–1958
PEPPER NO. 30. 1930
Gelatin silver print, 9⁷⁄₁₆ x 7½" (24 x 19 cm)
Gift of David H. McAlpin

edward weston
NAUTILUS. 1927
Gelatin silver print, 9⅜ x 7⁵⁄₁₆" (23.8 x 18.6 cm)
Gift of Merle Armitage

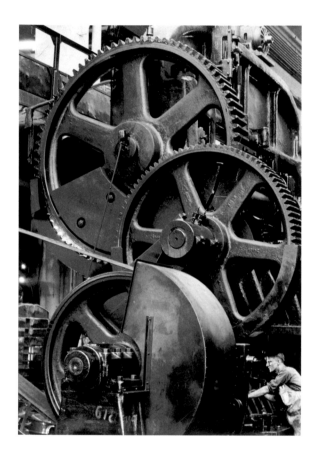

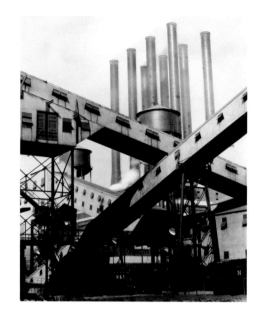

Above left:

margaret bourke-white | American, 1904–1971
CHRYSLER CORPORATION. 1929
Gelatin silver print, 13 x 9" (33 x 22.9 cm)
Gift of the photographer

Above right:

charles sheeler | American, 1883–1965
CRISS-CROSSED CONVEYORS, FORD PLANT,
DETROIT. 1927
Gelatin silver print, printed 1941, 9⅜ x 7½"
(23.9 x 19 cm)
Gift of Lincoln Kirstein

Below right:

margaret bourke-white
BLAST FURNACES,
FORD MOTOR COMPANY. c. 1930
Gelatin silver print, 9 x 13¼" (22.9 x 33.7 cm)
Gift of the photographer

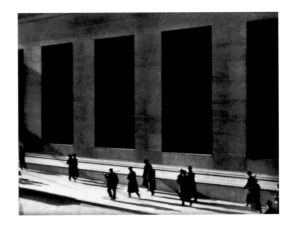

aleksandr rodchenko | Russian, 1891–1956
BALCONIES. 1925
Gelatin silver print, 11⁷⁄₁₆ x 9¹⁄₁₆" (29 x 23 cm)
Gift of the Rodchenko family

paul strand | American, 1890–1976
WALL STREET. 1915
Photogravure, 5 x 6⁷⁄₁₆" (12.8 x 16.3 cm)
Anonymous gift

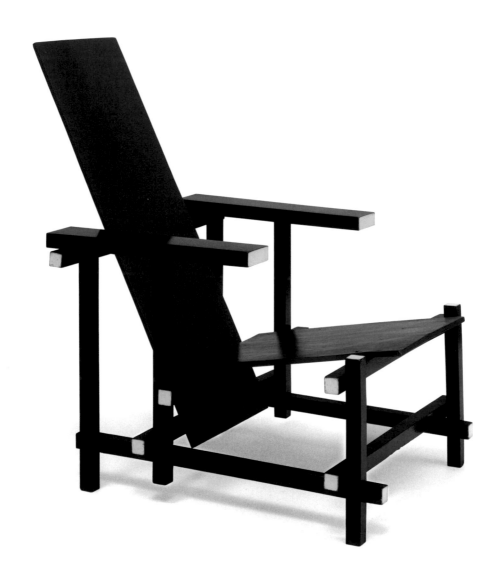

gerrit rietveld | Dutch, 1888–1964
Red Blue Chair. c. 1923
Painted wood, 34⅛ x 26 x 33" (86.7 x 66 x 83.8 cm)
Gift of Philip Johnson

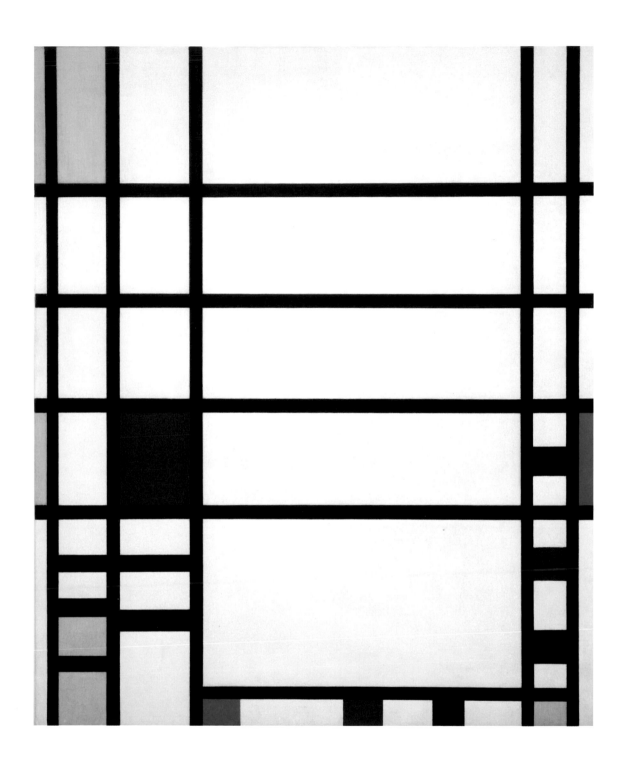

piet mondrian | Dutch, 1872–1944
TRAFALGAR SQUARE. 1939–43
Oil on canvas, 57¼ x 47¼" (145.2 x 120 cm)
Gift of Mr. and Mrs. William A. M. Burden

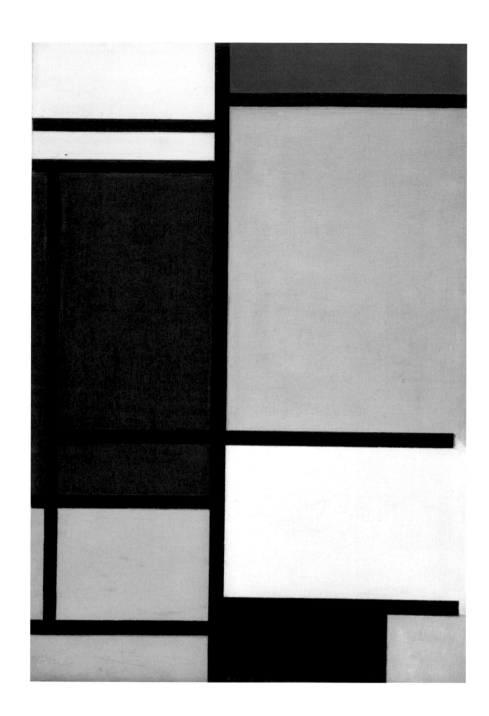

piet mondrian | Dutch, 1872–1944
COMPOSITION. 1921
Oil on canvas, 29⅞ x 20⅝" (76 x 52.4 cm)
Gift of John L. Senior, Jr.

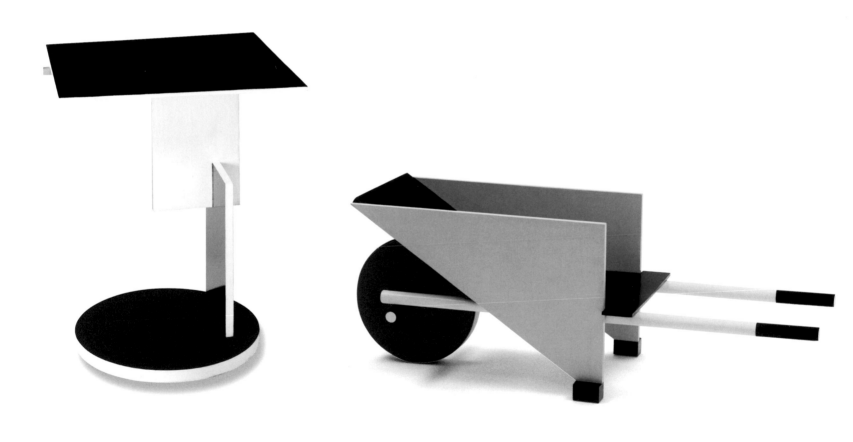

gerrit rietveld | Dutch, 1888–1964
Side Table. 1923
Wood, 23⅝ x 20⅜ x 19¾"
(60 x 51.8 x 50.2 cm)
Gift of Manfred Ludewig

gerrit rietveld
Child's Wheelbarrow. 1923
Painted wood, 12½ x 11⅜ x 33½"
(31.8 x 28.9 x 85.1 cm)
Gift of Jo Carole and Ronald S. Lauder

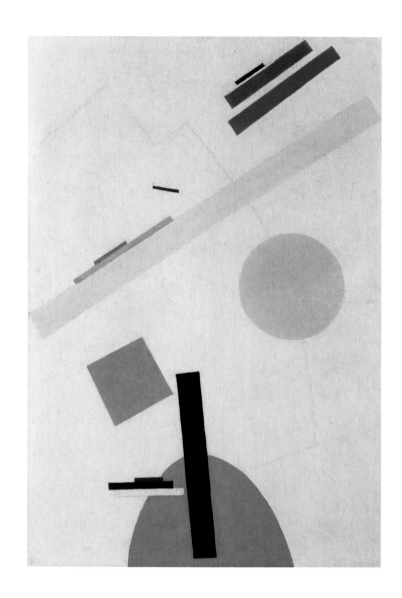

кazimir malevich | Russian, born Ukraine.
1878–1935
SUPREMATIST PAINTING. 1916–17
Oil on canvas, 38½ x 26⅛" (97.8 x 66.4 cm)
Acquisition confirmed in 1999 by agreement with the
Estate of Kazimir Malevich and made possible with
funds from the Mrs. John Hay Whitney Bequest
(by exchange)

80 reductive

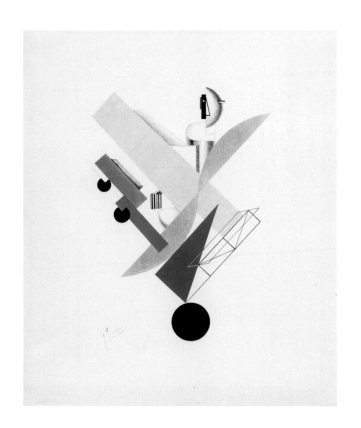

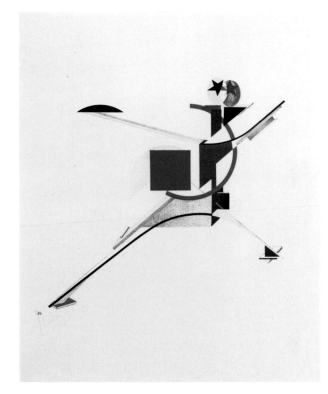

el lissitzky (lazar markovich lissitzky)
Russian, 1890–1941
THE GLOBETROTTER, from FIGURINES: THE THREE-
DIMENSIONAL DESIGN OF THE ELECTRO-
MECHANICAL SHOW "VICTORY OVER THE SUN"
1920–21, published 1923
One from a portfolio of ten lithographs, sheet:
21 x 18" (53.3 x 45.7 cm). Publisher and printer:
Leunis & Chapman, Hannover, Germany. Edition: 75
Purchase

el lissitzky
NEW MAN, from FIGURINES: THE THREE-
DIMENSIONAL DESIGN OF THE ELECTRO-
MECHANICAL SHOW "VICTORY OVER THE SUN"
1920–21, published 1923
One from a portfolio of ten lithographs, sheet:
21 x 17¹³⁄₁₆" (53.3 x 45.4 cm). Publisher and printer:
Leunis & Chapman, Hannover, Germany. Edition: 75
Purchase

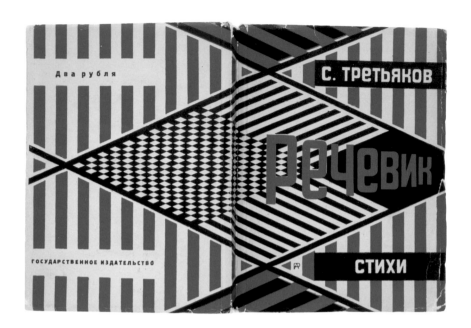

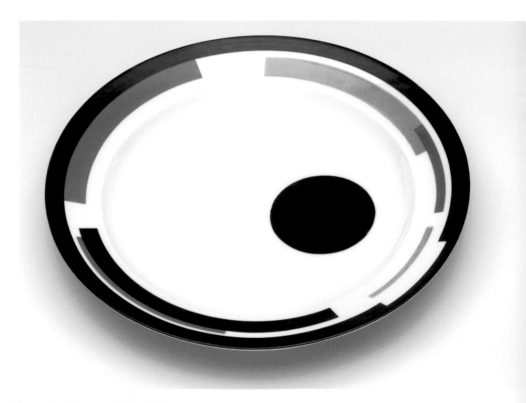

aleksandr rodchenko | Russian, 1891–1956
Wraparound cover for **ORATOR: VERSE** by
Sergei Tret'iakov. 1929
Letterpress, page: 6¹¹⁄₁₆ x 4¹⁵⁄₁₆" (17 x 12.6 cm)
Publisher: State Publishing House, Moscow-
Leningrad. Printer: unknown. Edition: 2,000
Gift of The Judith Rothschild Foundation

nikolai suetin | Russian, 1897–1954
Plate. c. 1923
Porcelain with overglaze painted decoration,
1⅝" (4.1 cm), 11¼" (28.5 cm) diam.
Estée and Joseph Lauder Design Fund

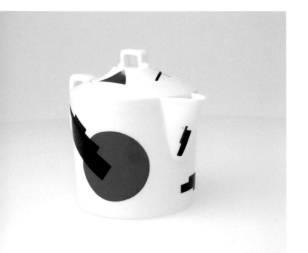

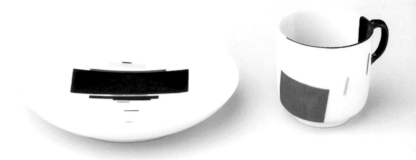

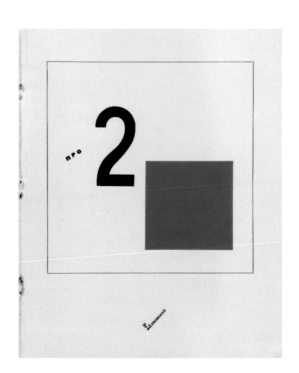

nikolai suetin
Teapot. c. 1923
Porcelain with overglaze painted decoration,
5½" (14 cm), 4½" (11.4 cm) diam.
Estée and Joseph Lauder Design Fund

el lissitzky (lazar markovich lissitzky)
Russian, 1890–1941
OF TWO SQUARES: A SUPREMATIST TALE IN SIX
CONSTRUCTIONS by El Lissitzky. 1922
Illustrated book with letterpress cover and six letter-
press illustrations, page: 10¹⁵⁄₁₆ x 8⅞" (27.9 x 22.5 cm)
Publisher: Skify, Berlin. Printer: unknown
Edition: unknown
Gift of The Judith Rothschild Foundation

nikolai suetin
Demitasse Cup and Saucer. 1923
Porcelain with overglaze painted decoration,
(cup): 2⁵⁄₁₆" (5.9 cm), 2⁵⁄₁₆" (5.9 cm) diam.
(saucer): 1" (2.5 cm), 5⁹⁄₁₆" (14.2 cm) diam.
Gift of Mottahedah & Co., Inc.

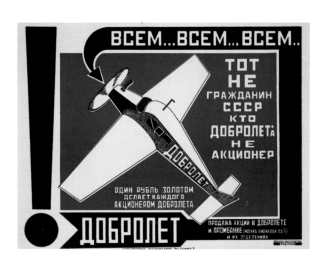

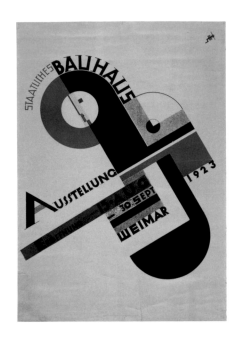

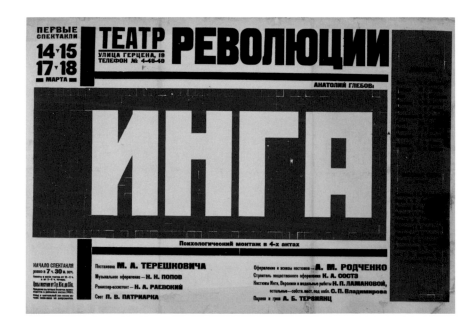

Above left:
aleksandr rodchenko | Russian, 1891–1956
DOBROLET. 1923
Offset lithograph, 13¾ x 17⅞" (35 x 45.4 cm)
Given anonymously

Above right:
joost schmidt | German, 1893–1948
STAATLICHES BAUHAUS AUSSTELLUNG. 1923
Lithograph, 26¼ x 18⅝" (66.7 x 47.3 cm)
Gift of Walter Gropius

Below right:
aleksandr rodchenko
INGA, THEATER OF THE REVOLUTION. c. 1929
Letterpress, 28¾ x 41¾" (73 x 106.1 cm)
Gift of Jay Leyda

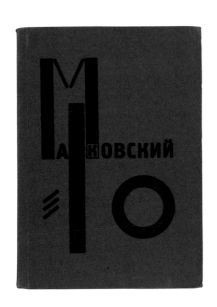

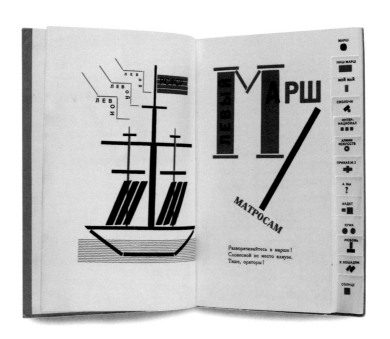

el lissitzky (lazar markovich lissitzky)
Russian, 1890–1941
FOR THE VOICE by Vladimir Mayakovsky. 1923
Illustrated book with twenty-four letterpress
illustrations, page: 7 3/8 x 4 15/16" (18.7 x 13 cm)
Publisher: State Publishing House, Moscow-Berlin
Printer: State Printing House, Moscow-Berlin
Edition: 2,000–3,000
Gift of The Judith Rothschild Foundation

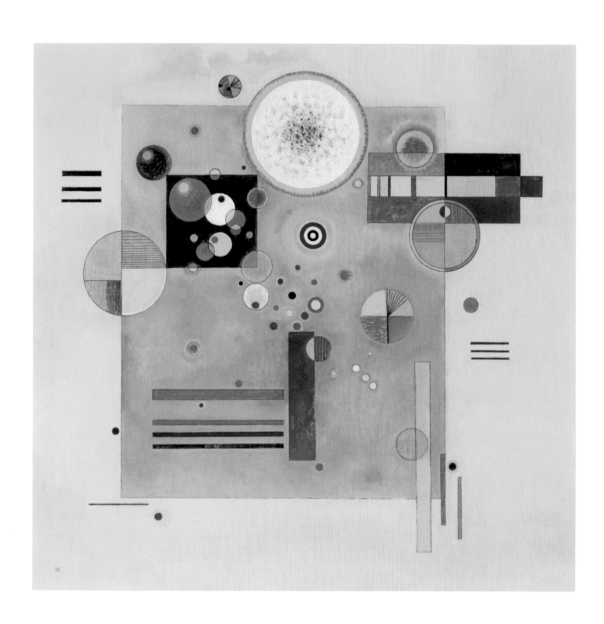

vasily kandinsky | French, born Russia. 1866–1944
SOFT PRESSURE. 1931
Oil on plywood, 39¼ x 39" (99.5 x 99 cm)
The Riklis Collection of McCrory Corporation

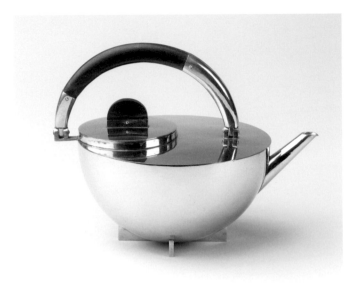

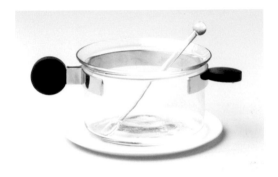

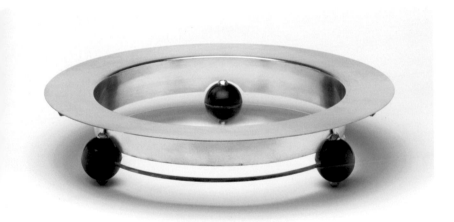

josef albers | American,
born Germany. 1888–1976
Fruit Bowl. 1924
Silver-plated metal, glass, and wood,
3⅝" (9.2 cm), 16¾" (42.5 cm) diam.
Gift of Walter Gropius

marianne brandt | German, 1893–1983
Teapot. 1924
Nickel silver and ebony, 7 x 9" (17.8 x 22.8 cm),
3¼" (8.3 cm) diam.
Phyllis B. Lambert Fund

josef albers
Tea Glass with Saucer and Stirrer. 1925
Heat-resistant glass, chrome-plated steel, ebony, and
porcelain, (cup): 2 x 5½ x 3½" (5.1 x 14 x 8.9 cm);
(saucer): 4⅛" (10.5 cm) diam.;
(stirrer): 4¼ x ⅟₁₆" (10.8 x 1.1 cm)
Gift of the designer

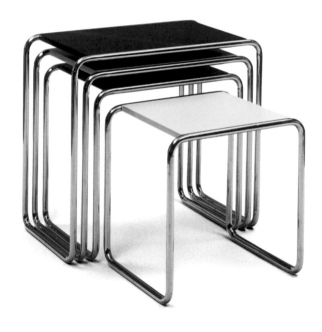

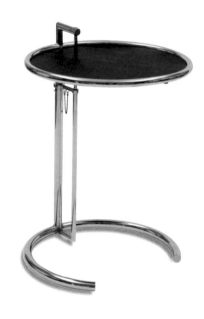

marcel breuer | American, born Hungary.
1902–1981
Nesting Tables (model B9). 1925–26
Tubular steel and lacquered plywood
Various dimensions, largest:
23⅞ x 26 x 15¼" (60.7 x 66 x 38.7 cm)
Gift of Dr. Anny Baumann

eileen gray | British, born Ireland. 1879–1976
Adjustable Table. 1927
Manufacture date: 1976
Polished chromium-plated tubular steel frame and
satin black stove-enameled sheet steel top: variable:
21¼" to 36½" x 20" (54 to 93 x 50.8 cm) diam.
Philip Johnson Fund and Aram Designs Ltd., London

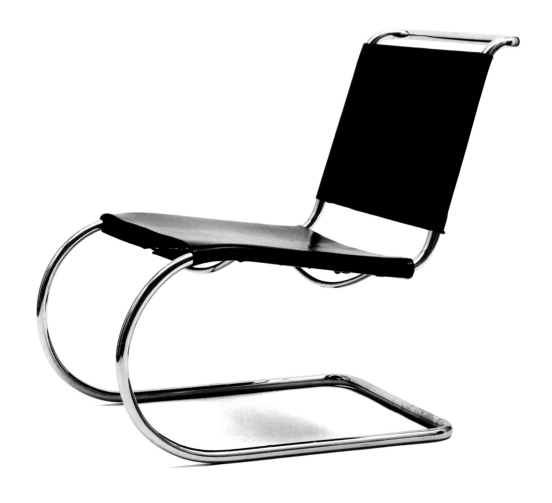

ludwig mies van der rohe | American,
born Germany. 1886–1969
MR Side Chair. 1927
Chrome-plated steel tubing and leather,
30½ x 22½ x 33½" (77.4 x 57.1 x 85.1 cm)
Gift of Philip Johnson

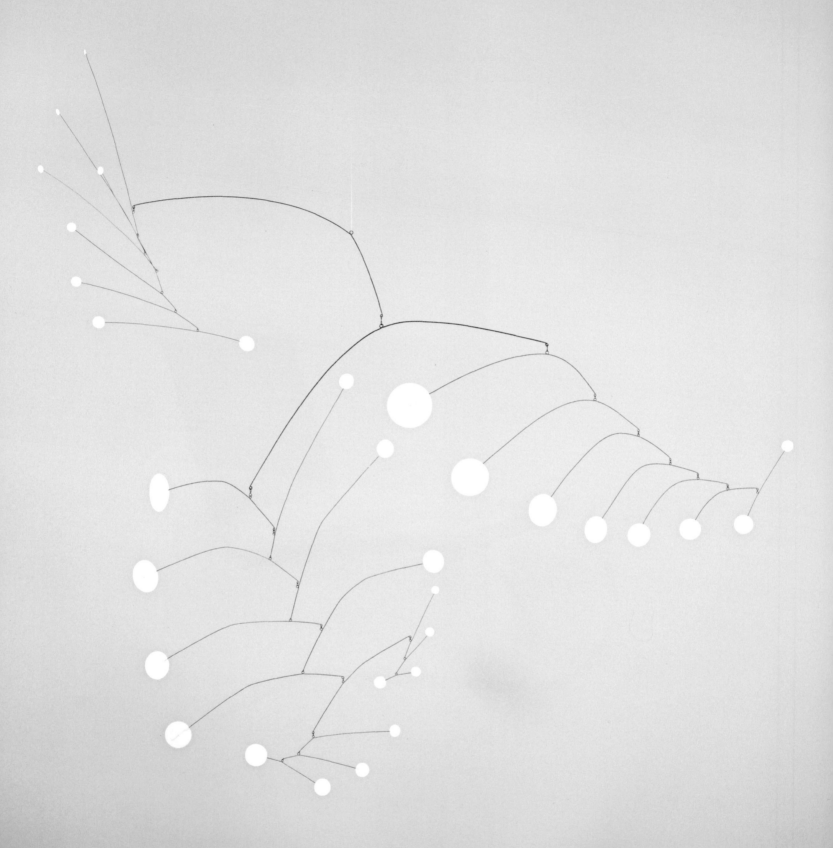

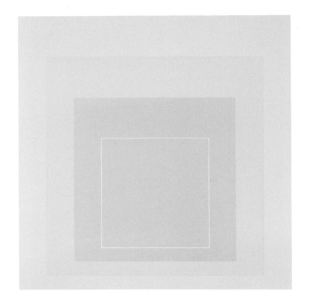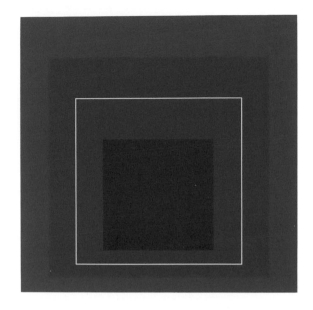

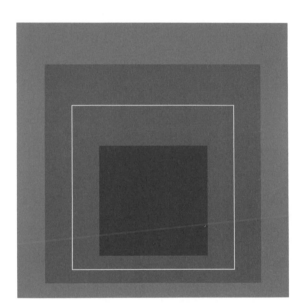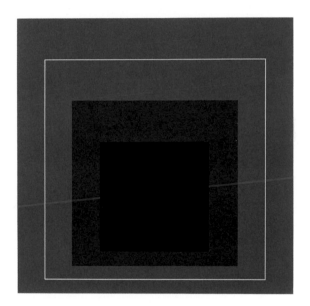

Top left:

josef albers | American, born Germany. 1888–1976
WHITE LINE SQUARE I from
WHITE LINE SQUARES (SERIES I). 1966
One from a portfolio of eight lithographs,
comp.: 15¹¹⁄₁₆ x 15¹¹⁄₁₆" (39.9 x 39.9 cm)
Publisher and printer: Gemini G.E.L., Los Angeles
Edition: 125
John B. Turner Fund

Top right and bottom row:

josef albers
WHITE LINE SQUARE XV, IX, and **XIII** from
WHITE LINE SQUARES (SERIES II). 1966
Three from a portfolio of eight lithographs,
comp.: 15¹¹⁄₁₆ x 15¹¹⁄₁₆" (39.9 x 39.9 cm)
Publisher and printer: Gemini G.E.L., Los Angeles
Edition: 125
Gift of Gemini G.E.L. Ltd.

ʏᴠᴇs ᴋʟᴇɪɴ | French, 1928–1962
BLUE MONOCHROME. 1961
Dry pigment in synthetic polymer medium on cotton
over plywood, 6' 4⅞" x 55⅛" (195.1 x 140 cm)
The Sidney and Harriet Janis Collection

ellsworth kelly | American, born 1923
YELLOW ORANGE. 1968
Oil on two canvases, 58⅜ x 62" (148.2 x 157.5 cm)
The Riklis Collection of McCrory Corporation

donald judd | American, 1928–1994
UNTITLED. 1967
Stainless steel, 6⅛ x 36⅛ x 26⅛"
(15.5 x 91.6 x 66.2 cm)
Gift of Philip Johnson

robert ryman | American, born 1930
PACE. 1984
Synthetic polymer paint on fiberglass on wood with
aluminum, 59½ x 26 x 28" (151.2 x 66 x 71.1 cm)
Gift of anonymous donor and gift of Ronald S. Lauder

agnes martin | American, born Canada, 1912
UNTITLED NUMBER 1. 1981
Gesso, synthetic polymer paint, and pencil on
canvas, 6' x 6' ⅛" (183 x 183.4 cm)
Gift of the American Art Foundation

gego (gertrude goldschmidt) | Venezuelan,
born Germany. 1912–1994
UNTITLED. 1966
Lithograph, sheet: 22 3/16 x 22 3/16" (56.3 x 56.3 cm)
Publisher and printer: Tamarind Lithography
Workshop, Los Angeles. Edition: 10
Gift of Kleiner, Bell & Co.

gego
UNTITLED. 1966
Lithograph, sheet: 22 1/8 x 22 1/16" (56.2 x 56.1 cm)
Publisher and printer: Tamarind Lithography
Workshop, Los Angeles. Edition: 20
Gift of Kleiner, Bell & Co.

sol lewitt | American, born 1928
CUBIC CONSTRUCTION: DIAGONAL 4,
OPPOSITE CORNERS 1 AND 4 UNITS. 1971
White painted wood, 24½ x 24¼ x 24¼"
(62.2 x 61.6 x 61.6 cm)
The Riklis Collection of McCrory Corporation

brice marden | American, born 1938
AVRUTUN. 1971
Oil and wax on canvas, 6' x 36" (182.9 x 91.4 cm)
Gift of Werner and Elaine Dannheisser

allan mccollum | American, born 1944
40 PLASTER SURROGATES. 1982–84
Enamel on hydrostone, forty panels ranging from
5 x 4⅛" (12.8 x 10.2 cm) to 20¼ x 16¼"
(51.3 x 41.1 cm), overall 64" x 9' 2" (162.5 x 279.4 cm)
Robert and Meryl Meltzer and Robert F. and
Anna Marie Shapiro Funds

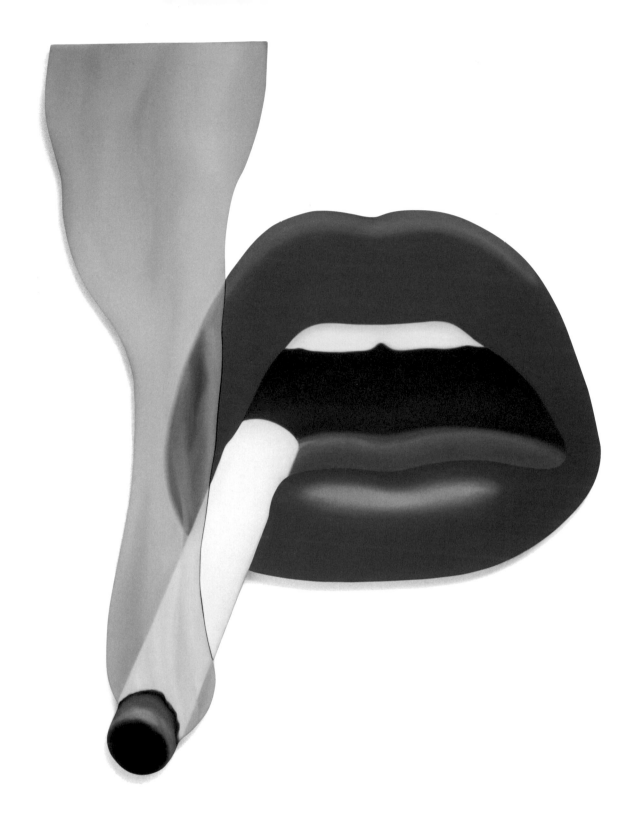

tom wesselmann | American, born 1931
SMOKER, 1 (MOUTH, 12). 1967
Oil on shaped canvas, in two parts,
overall: 9' ⅞" x 7' 1" (276.6 x 216 cm)
Susan Morse Hilles Fund

commonplace

The vanguard artists of the 1950s and 1960s reacted against the previous generation's deeply personal, emotion-laden abstractions and turned to the world around them for fresh approaches. The trappings of the period's unprecedented economic prosperity were on continual display in the rapidly ballooning commercial media, and artists responded to this visual bombardment with a vocabulary of crisply depicted everyday objects and a new reliance on photography. This populist art, whose brazen imagery and bold presentation shocked and captivated critics and public alike, swept across the industrialized world. The impulse to represent commonplace, commercially driven culture remained a vital trend into the 1970s and beyond, and continues today with an edgier, more ironic sensibility.

In Europe and the United States in the 1950s, artists termed Nouveaux Réalistes and Neo-Dada began to make assemblages and collages incorporating the litter of their surroundings. The work of Armand P. Arman, Christo, and Jacques de la Villeglé in Paris, and of Jim Dine, Robert Indiana, and Robert Rauschenberg in New York, set the stage for the explosion of commercial imagery in the work of Andy Warhol, Roy Lichtenstein, Sigmar Polke, and others, that characterized the movement that became known as Pop art. In an exhibition in Paris in 1954, Arman had discovered the work of the German Dadaist Kurt Schwitters, whose collages of printed ephemera inspired him to consider commonplace objects as valid artistic choices. Arman made what he called "accumulations"—collections of identical readymade objects in plexiglass boxes, given new meaning by the works' ironic titles. In BOOM! BOOM! (1960), a potent critique of contemporary consumerism and violence, Arman reduced guns to elements in an allover pattern. The so-called *affichistes*, such as Villeglé, restricted their materials to printed scrap, ripping thick layers of superimposed posters off city walls and reassembling them on canvas. Villeglé's *décollages*, or "unpastings," bore witness to the life of Parisian neighborhoods. He underscored their street history by titling them with the addresses from which they were peeled. The mélange of movie stars, newsprint, and gleaming bullets in 122 RUE DU TEMPLE (1968) reflects Villeglé's interest in advertising, filmmaking, and social criticism.

Rauschenberg too borrowed heavily from the media, making several printed series inspired by commercial photographs, and drawing on themes from America's modern history and popular culture. In works such as the HOARFROST series of the mid-1970s, Rauschenberg created printed veils of diaphanous unstretched fabrics, evoking a ghostlike remembrance of or tribute to contemporary life.

Rauschenberg and others of the period relied heavily on the collage tradition begun over thirty years earlier by Pablo Picasso and Georges Braque, and developed in the innovative work of Schwitters,

as seen in PICTURE WITH A LIGHT CENTER (1919). In the disillusioned aftermath of World War I, Schwitters created collages and reliefs out of cast-off materials and printed ephemera—newspapers and postcards, ticket stubs and postage stamps. His term for these objects, "*Merz*"—derived from the German word "*Kommerz*"—for him symbolized renewal, the creation of fresh art from urban discards. Artfully juxtaposed in arrangements often overpainted with colorful brushstrokes, these fragments, in Schwitters's hands, became dynamic compositions resembling Cubist *papiers collés* (works made from found printed media), and reflecting his interest in the integration of art and life, a concept that would prove fundamental for future generations. At nearly the same moment, the American artist Stuart Davis, also inspired by Cubist collage, painted some of the earliest images of American consumer products. Davis saw advertising and packaging as critical elements of the new visual culture, a language whose syncopations he compared to the rhythms of jazz. An ardent smoker, Davis was drawn to cigarette packaging for its colorful wrappers and contemporary sensibility. LUCKY STRIKE of 1921 is among his breakthrough works on this theme.

More than any other twentieth-century artist, it was Warhol who brought the everyday into art, and who illuminated the pervasiveness of advertising and consumer packaging in contemporary life. Trained as a commercial artist, Warhol used the signature logos and labels of manufacturers like Campbell's and Heinz, makers of mundane food products, in works of near-total verisimilitude. His sculptures of cartons, handmade out of wood and paint, shockingly simulated their ephemeral cardboard models, right down to their installation, piled on the floor. Claes Oldenburg's sculptures, by contrast, while inspired by commonplace items, treat them humorously and playfully through the use of monumental scale, pliable materials, and crude colors. FLOOR CONE (GIANT ICE-CREAM CONE) was included in the 1962 rendering of THE STORE, Oldenburg's watershed installation/performance piece in which he set himself up in a storefront for several weeks where he sold art objects depicting everyday household items.

The cult of celebrity fueled by the mass media was another important theme of Pop art. British painter and printmaker Richard Hamilton was a pioneer in creating a visual language that explored the influence of the mass media and related issues of perception. Drawing on his early experience in advertising, he often appropriated fragments from magazines and newspapers. Commercial techniques like screenprint also played an important role in his attempts to fuse high and low art forms. SWINGEING LONDON 67 (c. 1968–69) is based on a newspaper photograph showing Hamilton's art dealer Robert Fraser handcuffed to Rolling Stone Mick Jagger in the back of a police car. The impact of this "rock star" photograph, and the media

frenzy surrounding the event, are Hamilton's real subjects here; press distortions have been a persistent theme of his long career.

Similarly, Warhol created art from photographs of film stars, politicians, and heads of state, as did Gerhard Richter in West Germany. They both appropriated traditionally commercial mediums as well. In his **MARILYN MONROE** series of screenprints (1967), based on a publicity shot, Warhol magnified Monroe's iconic face and depicted it in lurid neon tones, equating the movie star's tragic persona with the inanimate objects of consumer culture. Similarly, in **MAO** (1968), Richter usurped a newspaper image of the Chinese leader, bleeding the looming head off the edges of the sheet to give this portrait of contemporary power a posterlike immediacy. Unlike Warhol, Richter chose subdued tones of black and gray, provoking further perceptual conundrums concerning the artistic image and its popular source.

The art of the 1980s and 1990s revealed a fresh interest in the commonplace. No artist is a truer heir to the commercial aspect of Pop art than the American Jeff Koons, who unapologetically brought his background on Wall Street to his approach to art; early works such as **NEW SHELTON WET/DRY DOUBLEDECKER** (1981) enshrine bourgeois possessions—here, a pair of vacuum cleaners—with a strangely antiseptic vulgarity. By placing such objects in lighted vitrines resembling showroom displays, Koons elevated them into valuable specimens of the everyday.

European sculptors too were inspired by the iconography of Pop and appropriated utilitarian objects for their work. Through scale, materials, and color, Katharina Fritsch of Düsseldorf painstakingly transforms objects of ordinary life into austere, often eerie tableaux, imbued with the disquieting stillness of Surrealism. At first glance, **BLACK TABLE WITH TABLE WARE** (1985) appears familiar and mundane. On inspection, however, one notices that the dishes on this table bear an image identical to the tableau of furniture and crockery that we are seeing, but with identical twins on two of the chairs. Meanwhile the sculpture's mat-black surfaces radiate an ominous aura. With her precise attention to shape and form, Fritsch is not so much commenting on the indulgences of the 1980s as subverting the idea of mass production in hypnotic stylizations of the everyday.

Both Fritsch's magic and Koons's vulgarity build on the still-life tradition, which was revolutionized in the modern period through the introduction of actual commonplace objects and materials into art. Whether critically or from a neutral vantage, countless artists have sought to integrate the domains of art and reality since Picasso first glued a piece of newsprint onto a drawing in the 1910s. With the explosion of commercialism during the affluent period following World War II, however, this aesthetic tendency came to define the entire culture, not merely its art, as "popular."

Above left:
berenice abbott | American, 1898–1991
ZITO'S BAKERY, BLEECKER STREET. c. 1948
Gelatin silver print, 9½ x 7½" (24.1 x 19 cm)
Anonymous gift

Above right:
berenice abbott
NEWSSTAND, EAST 32ND STREET AND THIRD
AVENUE, MANHATTAN. November 19, 1935
Gelatin silver print, 7⁹⁄₁₆ x 9⅝" (19.3 x 24.4 cm)
Gift of Connecticut Valley Boys School

Below right:
walker evans | American, 1903–1975
ROADSIDE STAND NEAR BIRMINGHAM. 1936
Gelatin silver print, 7¼ x 7½" (18.4 x 19 cm)
Purchase

margaret bourke-white | American, 1904–1971
AT THE TIME OF THE LOUISVILLE FLOOD. 1937
Gelatin silver print, 9¾ x 13⅛" (24.7 x 33.4 cm)
Gift of the photographer

walker evans
SIDEWALK AND SHOPFRONT, NEW ORLEANS. 1935
Gelatin silver print, 9⁵⁄₁₆ x 6¹⁵⁄₁₆" (23.6 x 17.7 cm)
Purchase

lucian bernhard | American, born Germany.
1883–1972
STILLER. 1908
Lithograph, 27⅛ x 37½" (69 x 95.2 cm)
Gift of The Lauder Foundation, Leonard and Evelyn
Lauder Fund

lucian bernhard
OSRAM AZO. c. 1910
Lithograph, 27⅝ x 37⅜" (70 x 95 cm)
Purchase Fund

lucian bernhard

MANOLI. 1910
Lithograph, 28 x 37¼" (71 x 94.5 cm)
Don Page Fund

kurt schwitters | British, born Germany.
1887–1948
PICTURE WITH A LIGHT CENTER. 1919
Cut-and-pasted colored and printed papers,
watercolor, oil and pencil on cardboard,
33¼ x 25⅞" (84.5 x 65.7 cm)
Purchase

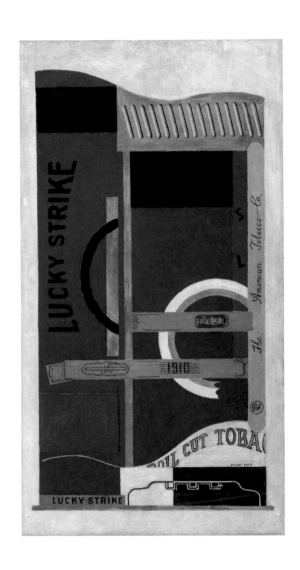

stuart davis | American, 1892–1964
LUCKY STRIKE. 1921
Oil on canvas, 33¼ x 18" (84.5 x 45.7 cm)
Gift of The American Tobacco Company, Inc.

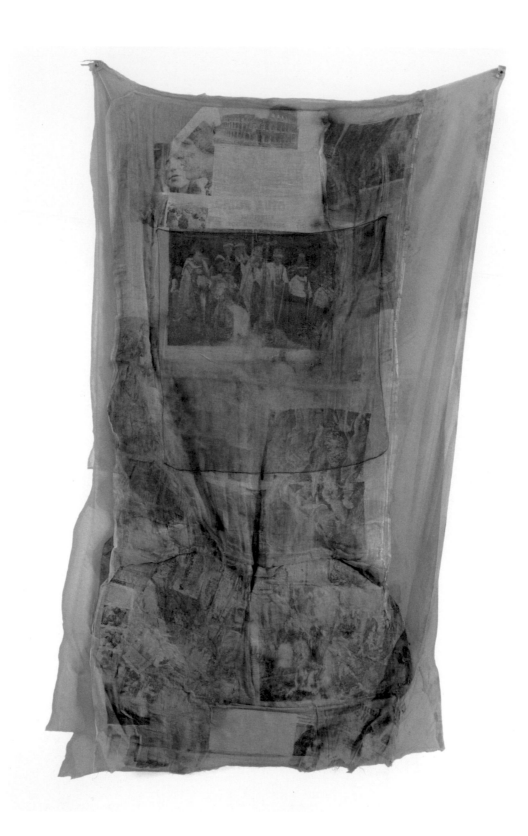

robert rauschenberg | American, born 1925
MINT from the HOARFROST series. 1974
Ink (transfer image) on unstretched silk and cotton
with additional synthetic fabric, paper, polyvinyl
acetate emulsion glue, 6' 6" x 45⅞"
(198.1 x 116.6 cm) (irreg.)
Mr. and Mrs. Walter Hochschild and
Kay Sage Tanguy Funds

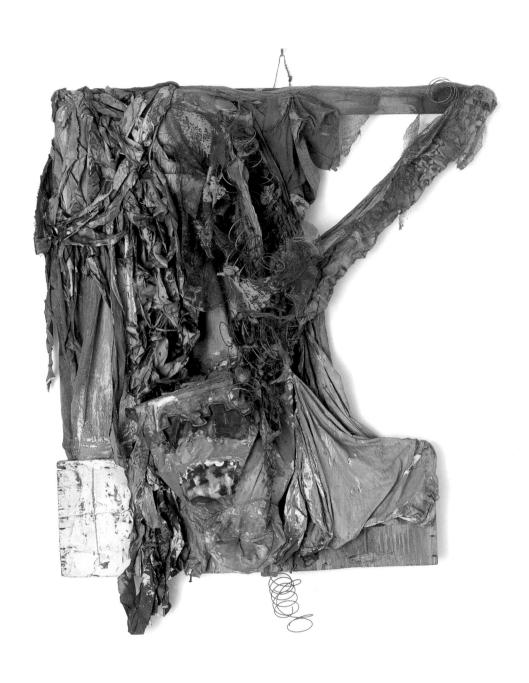

jim dine | American, born 1935
HOUSEHOLD PIECE. 1959
Assemblage: wood, canvas, cloth, iron springs, oil
and bronze paint, sheet copper, brown paper
bag, mattress stuffing, and plastic, 54¼ x 44¼ x 9¼"
(137.7 x 112.4 x 23.5 cm)
Gift of John W. Weber

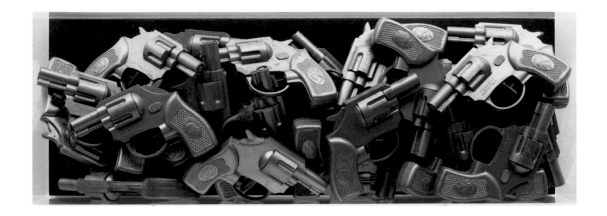

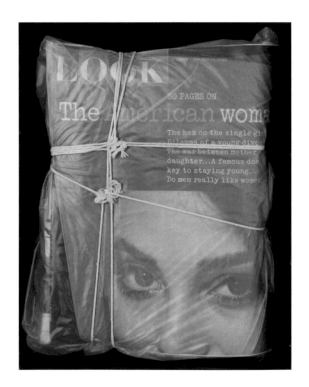

armand p. arman | American, born France, 1928
BOOM! BOOM! 1960
Assemblage of plastic water pistols in plexiglass
case, 8 ¼ x 23¼ x 4½" (21 x 59 x 11.2 cm)
Gift of Philip Johnson

christo (christo javacheff) | American,
born Bulgaria, 1935
WRAPPED *LOOK* MAGAZINE. 1965
Magazine over foam, wrapped in polyethylene
and cord, on wood support, 22⅛ x 18 x 3¼"
(56 x 45.6 x 8.2 cm)
Publisher: Édition MAT, Galerie Der Spiegel,
Cologne. Fabricator: the artist. Edition: 100
Lee and Ann Fensterstock Fund

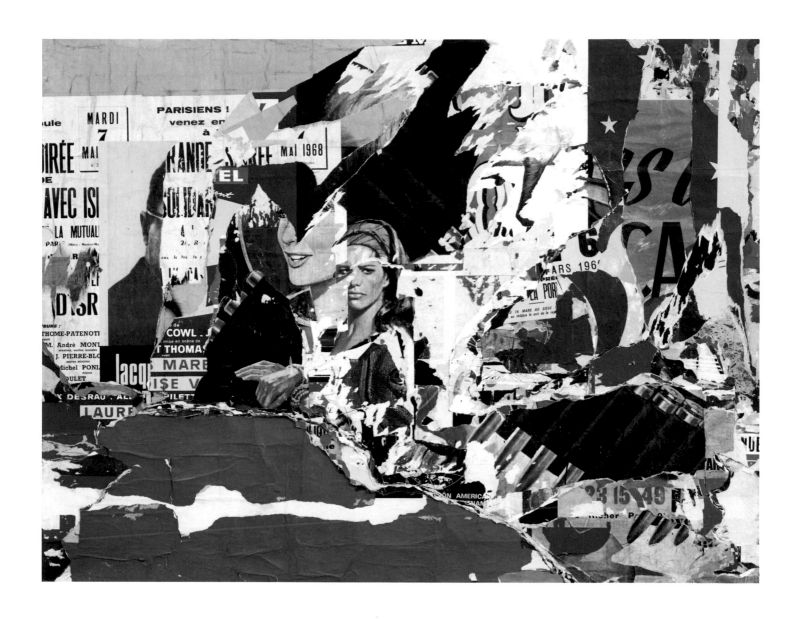

jacques de la villeglé | French, born 1926
122 RUE DU TEMPLE. 1968
Torn and collaged painted and printed paper on
linen, 62⅝" x 6' 10¾" (159.2 x 210.3 cm)
Gift of Joachim Aberbach (by exchange)

mokuma kikuhata | Japanese, born 1935
ROULETTE: NUMBER FIVE. 1964
Assemblage: wood boards, sheet metal with circular
cutouts, cans, iron pipe, baseball, pencil, enamel
paint, etc., 42⅛ x 25⅜ x 8½" (107 x 64.5 x 21.6 cm)
Daphne Hellman Shih Fund

eduardo paolozzi | British, born 1924
N° 3 HORIZON OF EXPECTATIONS, collage study
for UNIVERSAL ELECTRONIC VACUUM. 1967
Cut-and-pasted papers on graph paper,
41 x 28" (104.1 x 71.1 cm)
Gift of Mrs. Alexander Keiller

eduardo paolozzi
N° 4 PROTOCOL-SENTENCES, collage study for
UNIVERSAL ELECTRONIC VACUUM. 1967
Cut-and-pasted papers on graph paper,
41 x 28" (104.1 x 71.1 cm)
Gift of Mrs. Alexander Keiller

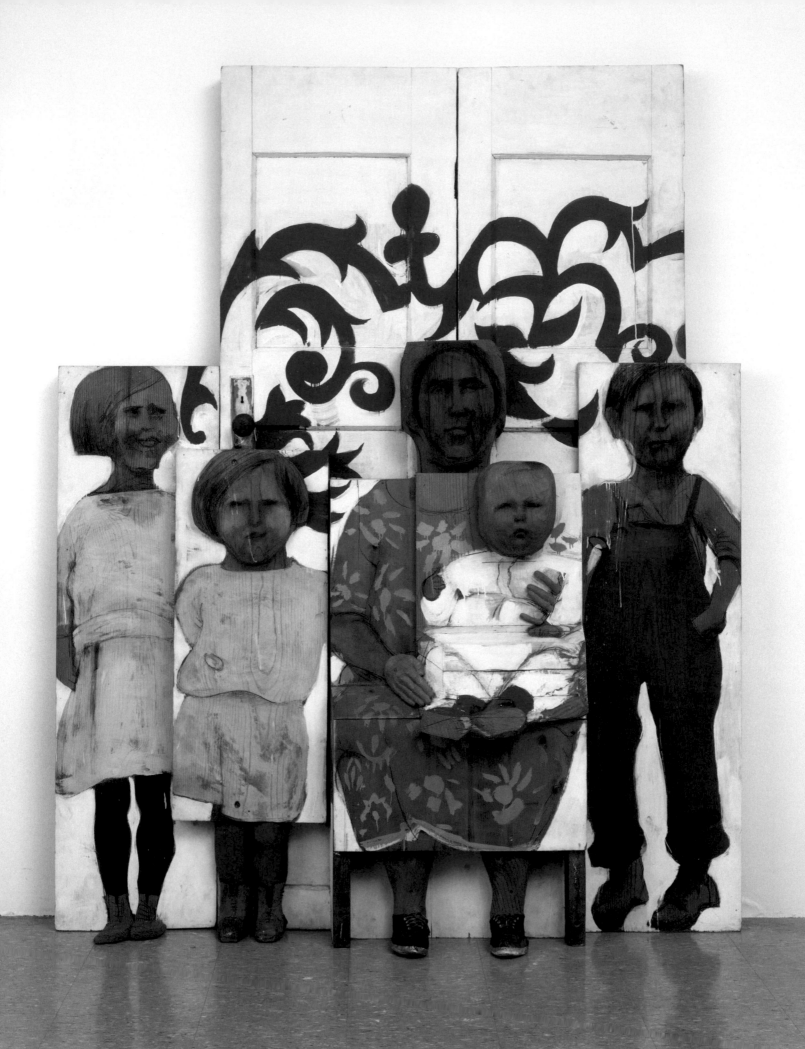

Opposite:
marisol (marisol escobar) | Venezuelan, born
France, 1930
THE FAMILY. 1962
Painted wood and other materials in three sections,
overall 6' 10⅝" x 65½ x 15½"
(209.8 x 166.3 x 39.3 cm)
Advisory Committee Fund

robert indiana | American, born 1928
THE AMERICAN DREAM, I. 1961
Oil on canvas, 6' x 60⅛" (183 x 152.7 cm)
Larry Aldrich Foundation Fund

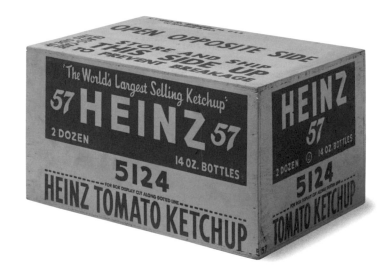

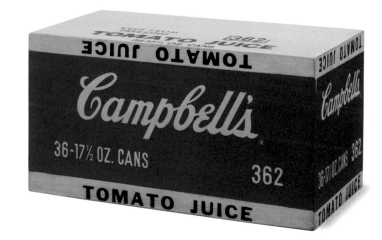

andy warhol | American, 1928–1987
HEINZ BOX (TOMATO KETCHUP). 1963
Synthetic polymer paint and silkscreen ink on wood,
10½ x 15½ x 10½" (26.7 x 39.4 x 26.7 cm)
Gift of Jasper Johns

andy warhol
CAMPBELL'S BOX (TOMATO JUICE). 1964
Synthetic polymer paint and silkscreen ink on wood,
10 x 19 x 9½" (25.4 x 48.3 x 24.1 cm)
Gift of Douglas S. Cramer Foundation

robert indiana | American, born 1928
LOVE. 1967
Screenprint, comp. and sheet: 34 x 34"
(86.4 x 86.4 cm)
Publisher: Multiples, New York
Printer: Sirocco Screenprinters, North Haven, Conn.
Edition: 250
Riva Castleman Fund

claes oldenburg | American, born Sweden, 1929
PASTRY CASE, I. 1961–62
Enamel paint on nine plaster sculptures in glass
showcase, 20¾ x 30⅛ x 14¾"
(52.7 x 76.5 x 37.3 cm)
The Sidney and Harriet Janis Collection

roy lichtenstein | American, 1923–1997
BAKED POTATO. 1962
Ink and synthetic polymer paint on paper,
22¼ x 30⅛" (56.6 x 76.5 cm)
Gift of Abby Aldrich Rockefeller (by exchange)

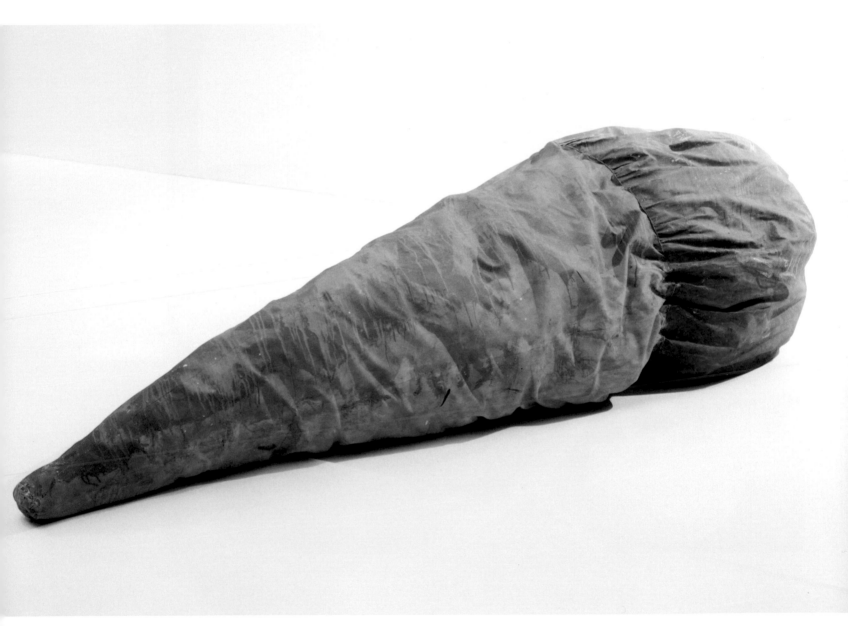

claes oldenburg
FLOOR CONE (GIANT ICE-CREAM CONE). 1962
Synthetic polymer paint on canvas filled with foam
rubber and cardboard boxes, 53¾" x 11' 4" x 56"
(136.5 x 345.4 x 142 cm)
Gift of Philip Johnson

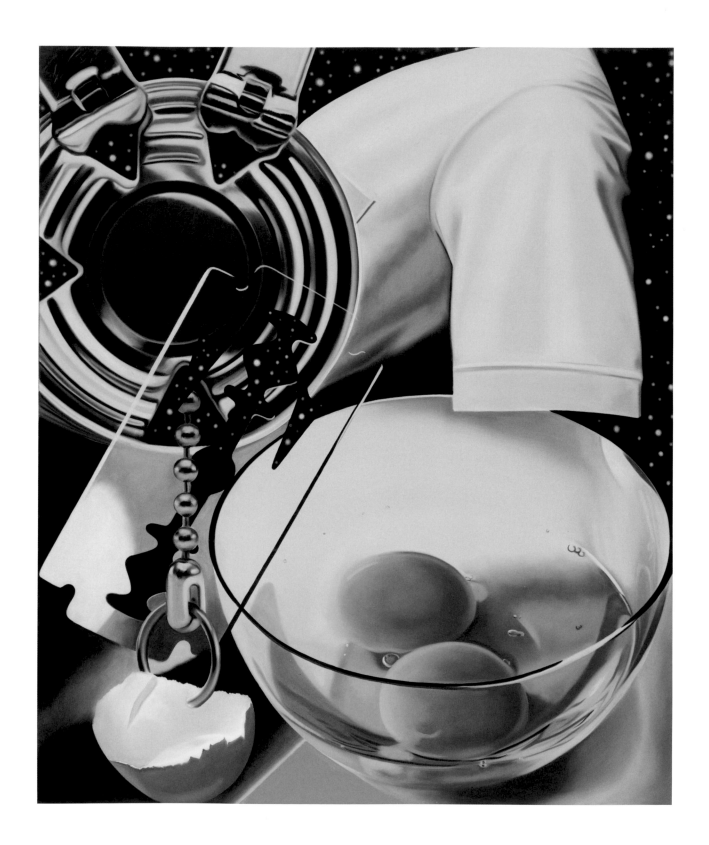

james rosenquist | American, born 1933
UNTITLED. 1980
Oil on canvas, 6' 6⅛" x 66" (198.4 x 167.6 cm)
Gift of Philip Johnson

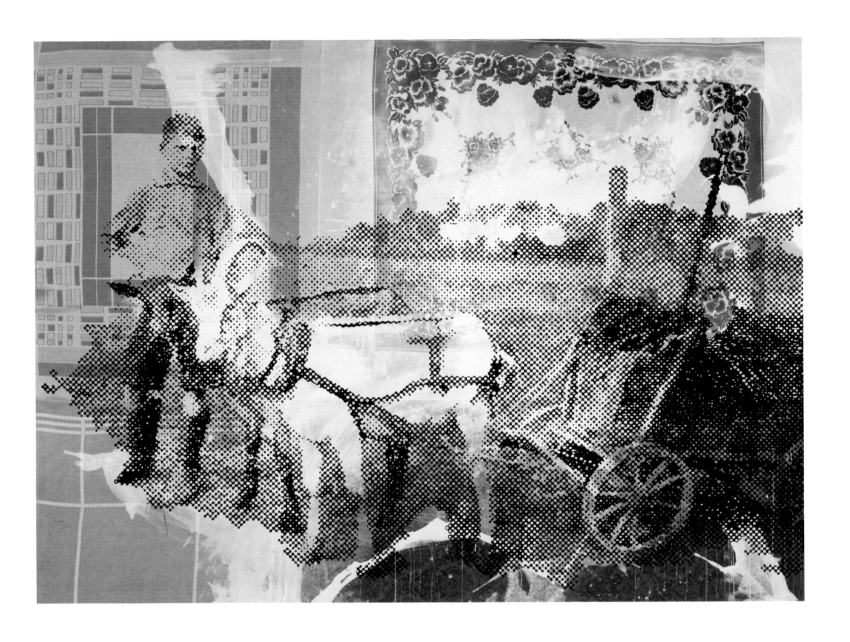

siqmar polke | German, born 1941
THE GOAT WAGON. 1992
Synthetic polymer paint on printed fabric,
7' 2" x 9' 10" (218.4 x 299.7 cm)
Gift of Werner and Elaine Dannheisser

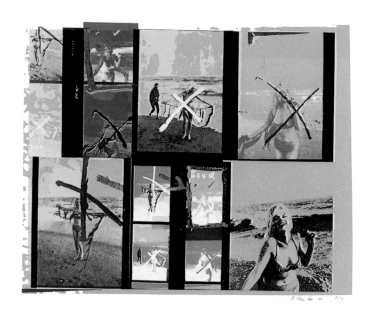

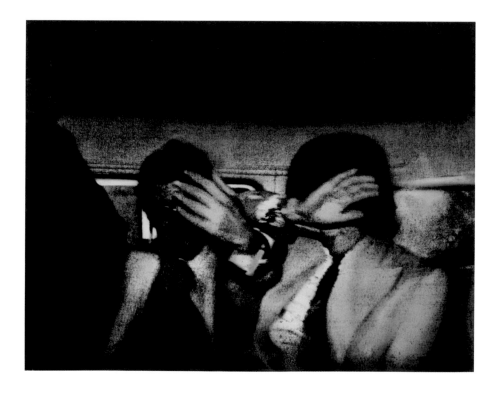

richard hamilton | British, born 1922
MY MARILYN. 1966
Screenprint, comp.: 20¼ x 25" (51.5 x 63.3 cm)
Publisher: Editions Alecto, London. Printer: Kelpra
Studio, London. Edition: 75
Joseph G. Mayer Foundation Fund

richard hamilton
SWINGEING LONDON 67. c. 1968–69
Oil on canvas and screenprint, 26½ x 33½"
(67.3 x 85.1 cm)
Purchase and Donald L. Bryant, Jr., Douglas S.
Cramer, Ronald S. Lauder and John Angelo Funds

Opposite:
michelangelo pistoletto | Italian, born 1933
MAN WITH YELLOW PANTS. 1964
Collage with oil and pencil on polished stainless
steel, 6' 6⅞" x 39⅜" (200.3 x 100 cm)
Blanchette Rockefeller Fund

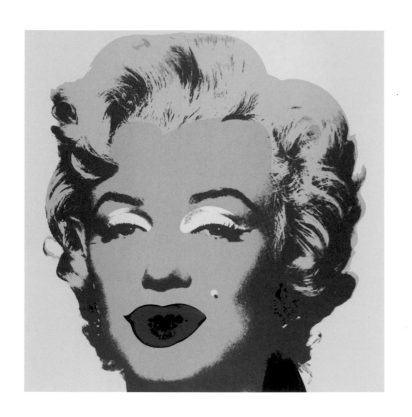 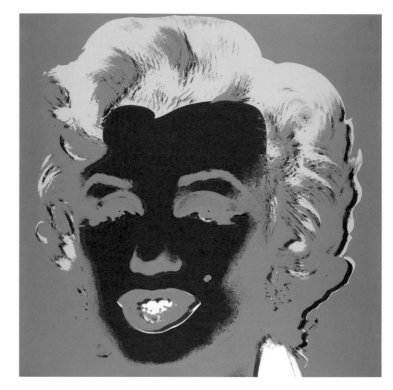

This page and opposite:
andy warhol | American, 1928–1987
Four plates from **MARILYN MONROE (MARILYN)**. 1967
Four from a portfolio of ten screenprints,
comp. and sheet, each: 36 x 36" (91.5 x 91.5 cm)
Publisher: Factory Additions, New York
Printer: Aetna Silkscreen Products, New York
Edition: 250
Gift of Mr. David Whitney

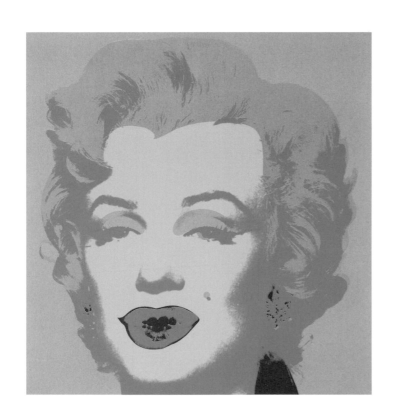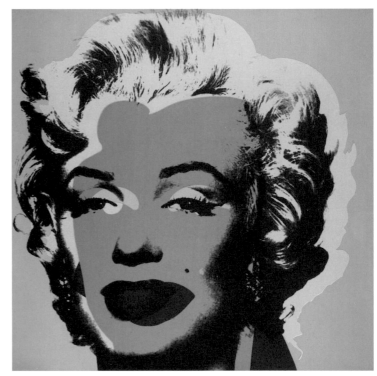

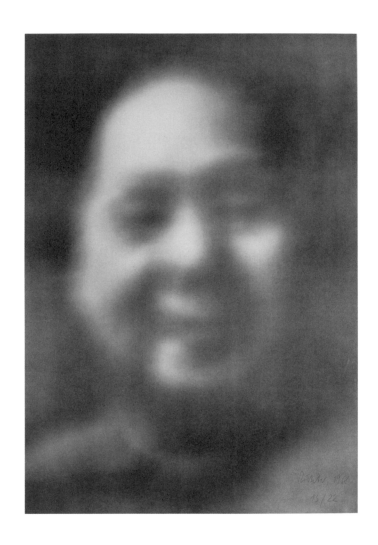

gerhard richter | German, born 1932
MAO. 1968
Collotype, comp. and sheet: 33 x 23⅜"
(83.9 x 59.4 cm)
Publisher: Galerie h (August Haseke), Hannover,
Germany. Printer: unknown. Edition: 500
Jeanne C. Thayer Fund

gerhard richter
ELISABETH II. 1966.
Photolithograph, comp. and sheet:
27⁹⁄₁₆ x 23⅜" (70 x 59.4 cm)
Publisher: Galerie h (August Haseke), Hannover,
Germany. Printer: unknown. Edition: 50
Gift of the Cosmopolitan Arts Foundation

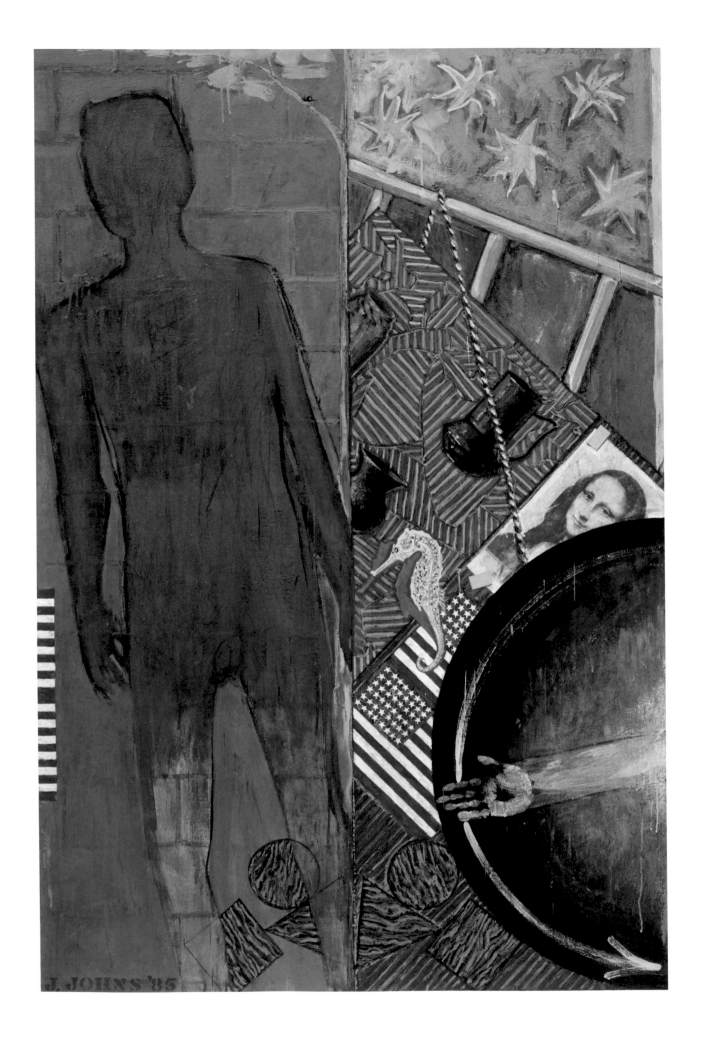

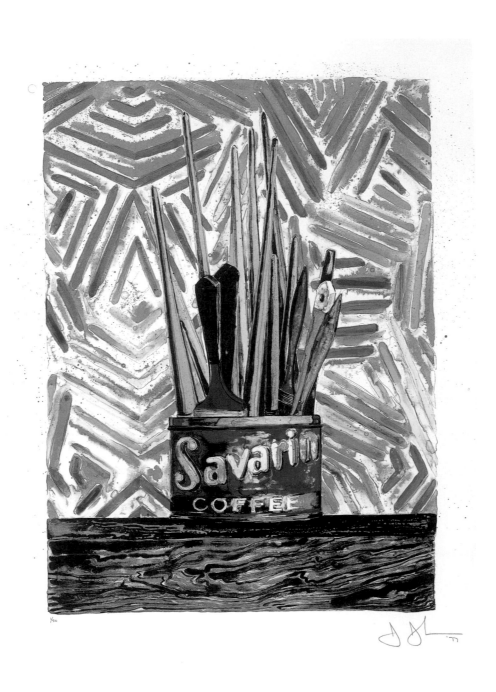

Opposite:

jasper johns | American, born 1930
SUMMER. 1985
Encaustic on canvas, 6' 3" x 50" (190.5 x 127 cm)
Gift of Philip Johnson

jasper johns
SAVARIN. 1977
Lithograph, sheet: 45½ x 34⅝" (115.6 x 87.9 cm)
Publisher and printer: Universal Limited Art Editions,
West Islip, N.Y. Edition: 50
Gift of Celeste Bartos

william eggleston | American, born 1939
MEMPHIS. 1971
Dye transfer print, 12¹⁵⁄₁₆ x 19¼" (32.9 x 48.9 cm)
Gilman Foundation Fund

william eggleston
MEMPHIS. c. 1972
Dye transfer print, 12⁹⁄₁₆ x 19⅛" (32 x 48.9 cm)
Purchased as the gift of the John E. Galvin
Charitable Trust on behalf of the Crouse Family

william eggleston
UNTITLED. Before 1980
Dye transfer print, 11½ x 17⅜" (29.4 x 44.3 cm)
Gift of Caldecot Chubb

william eggleston
SUMNER, MISSISSIPPI. c. 1972
Dye transfer print,13⅝ x 20¹³⁄₁₆" (34.5 x 53.3 cm)
Purchased as the gift of the John E. Galvin
Charitable Trust on behalf of the Crouse Family

tina barney | American, born 1945
SUNDAY NEW YORK TIMES. 1982
Chromogenic color print (Ektacolor), 47½ x 60⅞"
(120.7 x 154.8 cm)
Anonymous gift

katharina fritsch | German, born 1956
BLACK TABLE WITH TABLE WARE. 1985
Wood, paint, and plastic, overall 35⅞6"
(90 cm) x 59⅛" (150 cm) diam.
Acquisition from Werner and Elaine Dannheisser

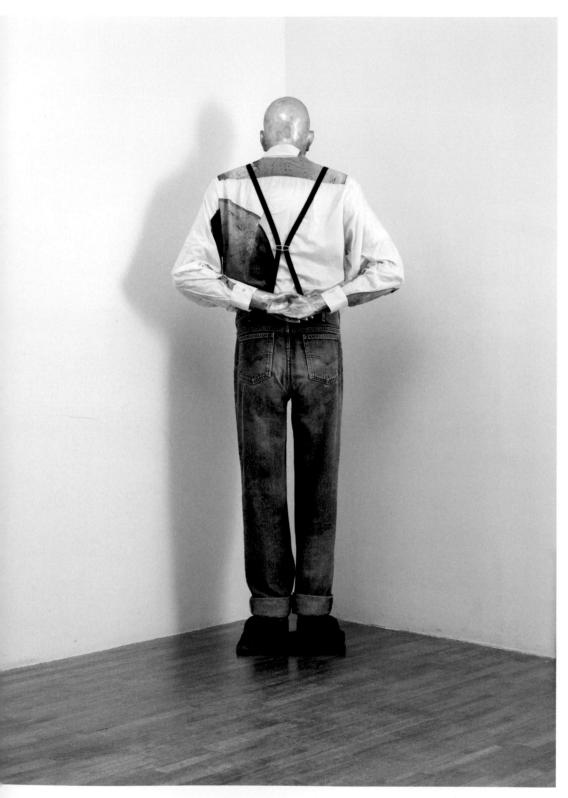

martin Kippenberger | German, 1953–1997
MARTIN, STAND IN THE CORNER AND
BE ASHAMED OF YOURSELF. 1990
Cast aluminum, clothing, and iron plate,
71½ x 29½ x 13½" (181.6 x 74.9 x 34.3 cm)
Blanchette Hooker Rockefeller Fund Bequest,
Anna Marie and Robert F. Shapiro, Jerry I. Speyer,
and Michael and Judy Ovitz Funds

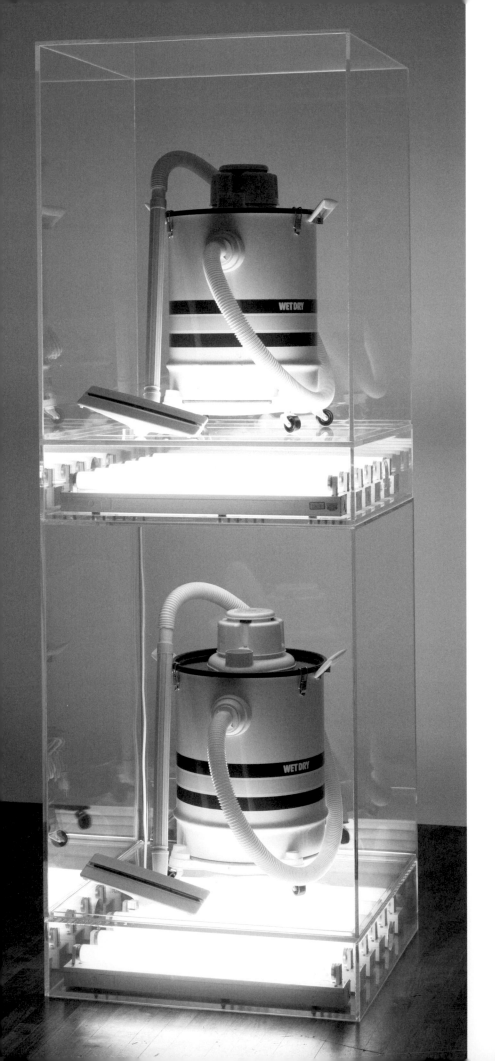

jeff koons | American, born 1955
NEW SHELTON WET/DRY DOUBLEDECKER. 1981
Two vacuum cleaners, plexiglass, and flourescent
lights, 6' 10½" x 28 x 28" (209.5 x 71.1 x 71.1 cm)
Gift of Werner and Elaine Dannheisser

robert gober | American, born 1954
CAT LITTER. 1989
Plaster, ink, and latex paint, 17 x 8 x 5"
(43.2 x 20.3 x 12.7 cm)
Acquisition from the Werner Dannheisser
Testamentary Trust

robert gober
NEWSPAPER. 1992
Photolithographs, 6 x 16¾ x 13¼"
(15 x 42.5 x 33.6 cm)
Publisher: the artist, New York. Printer: Derrière
L'Étoile Studios, New York. Edition: 10
Gift of the Associates in honor of Deborah Wye

Opposite:
felix gonzalez-torres | American, born Cuba.
1957–1996
"UNTITLED" (USA TODAY). 1990
Candies, individually wrapped in red, silver, and
blue cellophane (endless supply),
dimensions vary with installation
Gift of the Dannheisser Foundation

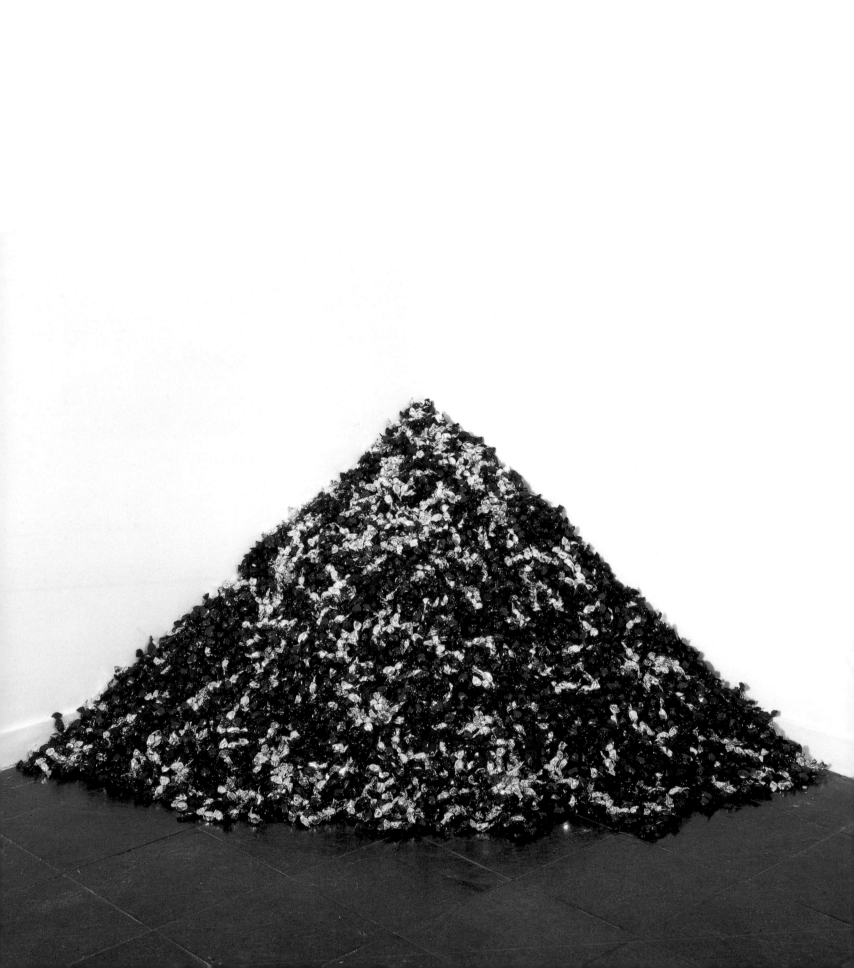

julian opie | British, born 1958
LANDSCAPE?, IMAGINE YOU ARE DRIVING,
IMAGINE YOU ARE WALKING, and CARS?, from an
untitled series. 1998–99.
Four of six screenprints, comp. and sheet (left to right):
24 x 34⅝" (61 x 88 cm), 24 x 33⅞" (61 x 86 cm)
24 x 31⅛" (61 x 79 cm), 24 x 41⁵⁄₁₆" (61 x 105 cm)

Publisher: Alan Cristea Gallery, London
Printer: Advanced Graphics, London. Edition: 40
Acquired through the generosity of Andrew Shapiro,
in honor of his mother, Anna Marie Shapiro

andreas gursky | German, born 1955
TOYS "Я" US. 1999
Chromogenic color print, 6' 9½" x 11' ⅝"
(207 x 336.9 cm)
Gift of Jo Carole and Ronald S. Lauder

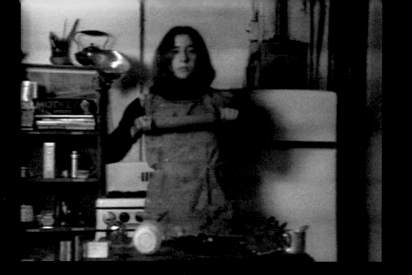 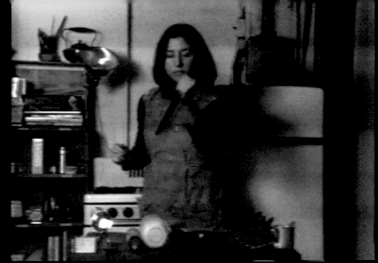

Opposite:
zhang peili | Chinese, born 1957
EATING. 1997
Three-channel video installation, color, sound
Gift of the Junior Associates

martha rosler | American, born 1943
SEMIOTICS OF THE KITCHEN. 1975
DVD, color, sound, 6 minutes
Purchase

kiki smith | American, born Germany, 1954
A MAN. 1990
Printed ink on torn and pasted handmade paper,
6' 6" x 16' 8" (198.1 x 508 cm)
Gift of Patricia and Morris Orden

mutable

The contemporary period is characterized by shifting perspectives, unexpected transformations, and unnerving impermanence. Political monoliths have disintegrated; fatal illnesses have emerged without warning; environmental disasters have threatened. Even without these destabilizing forces, however, the art of the last few decades might independently have embraced and reflected the kind of uncertainty apparent in previous fins de siècle, as artists questioned constancies from political structures to sexual identities. They also sought out new, pliable materials—from felt and latex to Vaseline and video—to convey mutating forms and a sense of perpetual flux, as they addressed poignant issues of memory, mortality, and the transient nature of life that have flourished in contemporary artistic dialogue.

Joseph Beuys of Germany and Matthew Barney of the United States come from different generations and continents but succinctly illustrate these themes of mutability and inconstancy. A sculptor, social activist, performance artist, and teacher, Beuys believed in the transformative and restorative powers of art; his signature materials, such as felt and fat, for him were symbolic of regeneration and rebirth. His performances and lectures often produced enigmatic works of art, such as the blackboard drawing UNTITLED (SUN STATE) (1974), in which he sought to liberate humanity's innate healing energies and powers of understanding. Here, while speaking at The Art Institute of Chicago, he drew a kind of chart of his ideal social state, marking the conduits between politics and culture necessary for a harmonious existence. Beuys's performances, and the sculptures and other artworks that they generated, signaled an inclusive, holistic approach to artmaking that expanded the role of the artist to that of performer, instigator, and philosopher, and that of art to instrument of social transformation.

Barney captured the zeitgeist of the 1990s. His complex, some would say mystifying art incorporates installation, performance, sculpture, and video or film, and examines the athletic and sexual potentials of the human body. Many of his sculptures first appeared as film props in his exegeses of unfixed gender, physical endurance, and mutating entities. His themes are underscored by his equally unusual and unstable materials, ranging from viscose Vaseline and self-lubricating plastics to tapioca pudding. He also makes his own body a site of metamorphosis, shifting in performance between genders, and between animal and human. The sculpture PACE CAR FOR THE HUBRIS PILL (1991) simultaneously evokes some strange albino vehicle, an exercise machine, and a Murphy bed composed of pliable substances that might melt or disintegrate if touched.

Barney's work is often called surreal, and indeed the Surrealists of the 1920s and 1930s are precursors of our preoccupation with amorphous identity. They tried to pull their imagery directly

from the unconscious, exemplified by the mutating forms seen in work ranging from the elastic-bodied nudes of André Kertész's 1930s photographs to the art of Max Ernst, whose painting THE NYMPH ECHO (1936) explores the theme of metamorphosis through a hallucinatory vision of the natural world.

Themes of flux and instability persisted through the mid-century. After the horrors of World War II, many artists turned to nature and its intrinsic themes of growth and regeneration. The so-called TEXTUROLOGIES of the French painter Jean Dubuffet, for example, often included bits of sand, pebbles, and leaves in their lush, dense, overall fields. These literal borrowings from nature evoke organic matter, erupting with fecundity and decay.

The performance art that flowered in the 1960s incorporated concepts of change and movement into its essential format. Whether in Happenings and Fluxus concerts in New York and Europe, Nouveau Réaliste events in Paris, German Aktionen, or the work of Japan's Gutai group, the inherently temporal nature of performance renders it antithetical to that of the conventional art object. Yet artists such as Yves Klein and Jean Tinguely, in Paris, managed to create objects embracing time and motion. In Tinguely's renowned HOMAGE TO NEW YORK, a mammoth self-destructing machine brought itself to a dramatic end in the Sculpture Garden of The Museum of Modern Art, in 1960. Tinguely believed that the value of art, and of life, lies in constant change. FRAGMENT FROM HOMAGE TO NEW YORK is a relic of a kinetic event. Klein too used performance to make art objects, but

worked with people instead of machines to make not sculpture but paintings, in his signature color, a blue he called "International Klein Blue." For ANTHROPOMETRY: PRINCESS HELENA (1960), for example, Klein dragged a nude woman covered in blue paint across a large sheet of paper, creating a dynamic work invoking chance, movement, and transference.

In the late 1960s sculptors Eva Hesse, Robert Morris, and Lynda Benglis were among the American artists who reacted against the austerity and exactitude of Minimalism, adopting a fresh approach to materials that imbued their work with a sense of dynamic fluidity. Morris's felt pieces and Benglis's works in foam, as well as their bronze and aluminum counterparts, suggest gestating matter in their undulating and biomorphic forms. Hesse used pliant substances such as papier-mâché, latex, and string to create flexible forms that evoke mutable organic objects and whose own impermanence comes built into them. Her sensitive untitled sculpture of 1966 varies with each installation, since it responds to, indeed requires, the force of gravity to generate its shape.

European artists of the 1960s and 1970s also explored new materials, while focusing on the continuous flux of nature. The work of the Arte Povera artist Giuseppe Penone and the British land artist Richard Long reflect the evolving states inherent in

the landscape. Penone's monumental **DOUBLE VEGETAL GESTURE/AX** (1982) fuses a tree branch with a vice of iron and bronze, pitting the natural forces of growth against the immobility of metal. Long's work documents walks that he takes in the country, and the humble markers he may leave in the landscape; indoor sculptures such as **KILKENNY CIRCLE** (1984) are equally the results of these temporal adventures, and parallel the variability of nature in their differing installations, which follow the artist's guidelines while reflecting the participation of the installer.

A preoccupation with unsettling fin de siècle themes of disequilibrium and instability characterized much of the art of the 1980s and 1990s, often embedded in explorations of the human body and identity. Fascinated with disguise and makeup, Cindy Sherman parodied society's accepted female stereotypes by metamorphosing before her camera from one stock character cliché to the next, transforming her persona with each new image. In an unusual body of work from 1988–89, instead of modeling herself she photographed inflatable female dolls, posed in scenes of horror and decay. The buxom, red-lipsticked blonde who appears in **UNTITLED #188** (1989) is dismembered and reduced to detritus—a fragmented, expendable creature of contemporary society.

Many contemporary artists directly addressed the fragility and impermanence of life using the fragmented body. Robert Gober, in an untitled work of 1991 that can be read as a memento mori to those lost to AIDS, abruptly severs the lower half of a man's body and poses it as if it were disappearing into the wall. In a fusion of violence, death, and sexuality, phallic candles emerge from the corpselike figure's wax flesh. Frenchman Christian Boltanski first gained recognition in the 1960s for his short films and notebooks reassessing his childhood; in the mid-1980s, confronting memory and the passage of time, he began a series of altar-like installations, such as **THE STOREHOUSE** (1988), comprising stacks of tin boxes topped with portrait photographs of children. Lights further the evocation of a memorial, and allusions to the horror of the Holocaust are unavoidable and intentional.

Perhaps the work of Felix Gonzalez-Torres best exemplifies the threads of inconstancy, disequilibrium, and flux that so resonate today. It embodies mutability both formally and conceptually. Essentially interactive, Gonzalez-Torres's pieces are always changing, whether through their variable installation or their slow disintegration as viewers remove their individual elements. But themes of renewal underlie these works as well; piles of prints are depleted by viewers only to be reprinted and restacked, heaps of candies dwindle only to be restocked, and light bulbs burn out only to be replaced, as in **"UNTITLED" (TORONTO)** (1992). Despite the underlying optimism of this piece, however, its materials and their qualities— the limpness of the electrical wire, the bareness of the bulbs—suggest a memorial, whether installed vertically, as a cascading waterfall of light puddling on the floor, or horizontally, as a stream of flickering votives. Perhaps it is impossible to interpret these pieces otherwise, in light of Gonzalez-Torres's early death—a tragic manifestation of the instability of contemporary life.

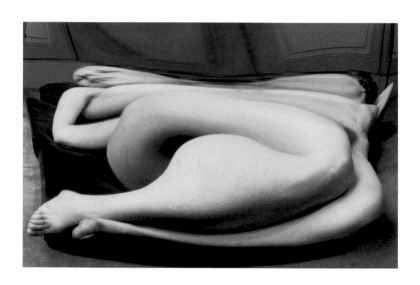

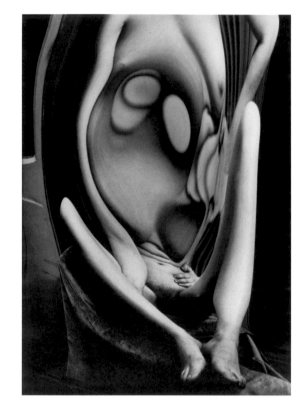

andré ĸertész | American, born Hungary.
1894–1985
DISTORTION #34. 1933
Gelatin silver print, 8⅞ x 13½" (22.6 x 34.4 cm)
Purchased as the gift of Harriette and Noel Levine

andré ĸertész
DISTORTION #117. 1933
Gelatin silver print, 12¹¹⁄₁₆ x 9¼" (32.2 x 23.5 cm)
Purchased as the gift of Mrs. John D. Rockefeller 3rd

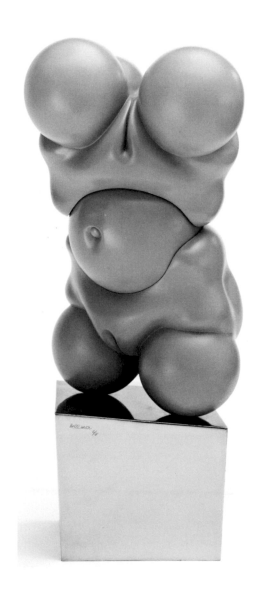

hans bellmer | German, born Upper Silesia
(now Poland). 1902–1975
DOLL. 1936 (cast 1965)
Painted aluminum, 19⅛ x 10⅝ x 14⅞"
(48.5 x 26.9 x 37.6 cm) on bronze base
The Sidney and Harriet Janis Collection

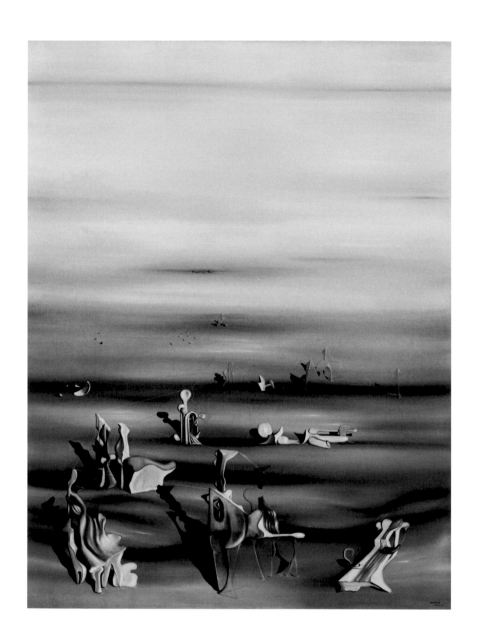

yves tanguy | American, born France.
1900–1955
THE FURNITURE OF TIME. 1939
Oil on canvas, 46 x 35 ¼" (116.7 x 89.4 cm)
James Thrall Soby Bequest

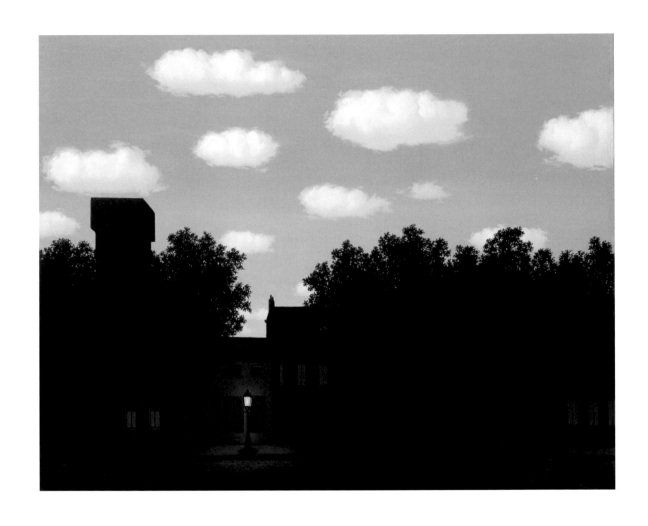

rené magritte | Belgian, 1898–1967
THE EMPIRE OF LIGHT, II. 1950
Oil on canvas, 31 x 39" (78.8 x 99.1 cm)
Gift of D. and J. de Menil

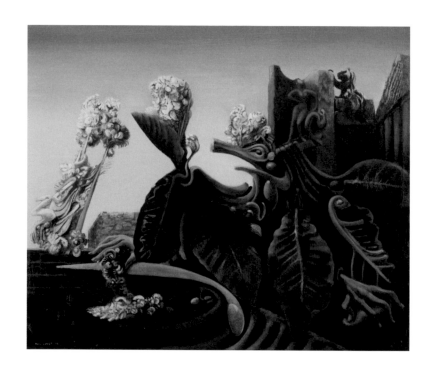

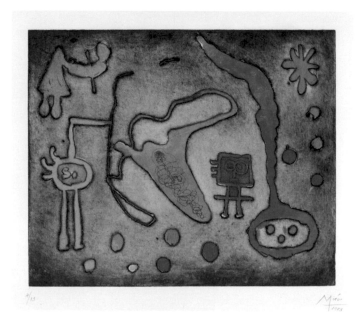

max ernst | French, born Germany. 1891–1976
THE NYMPH ECHO. 1936
Oil on canvas, 18¼ x 21¾" (46.3 x 55.2 cm)
Purchase

joan miró | Spanish, 1893–1983
Untitled from SERIES II. 1947, published 1952–53
One from a series of five etching and aquatints,
plate: 14¹³⁄₁₆ x 17¹⁵⁄₁₆" (37.7 x 45.5 cm)
Publisher: Maeght Éditeur, Paris
Printer: the artist at Atelier 17, New York, and
Atelier Lacourière, Paris. Edition: 13
The Associates Fund

man ray (emmanuel rudnitsky) | American,
1890–1976
RAYOGRAPH. 1922
Gelatin silver print, 9⅜ x 7¹⁄₁₆" (23.9 x 17.9 cm)
Gift of James Thrall Soby

man ray
RAYOGRAPH. 1927
Gelatin silver print, 12 x 10" (30.5 x 25.4 cm)
Abby Aldrich Rockefeller Fund

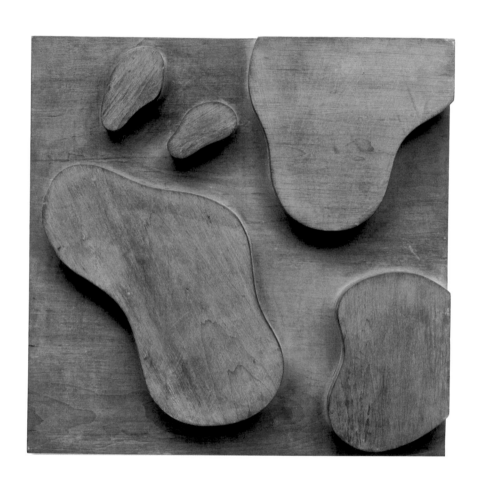

jean (originally **hans**) **arp** | French, born
Germany (Alsace). 1887–1966
RELIEF. 1938–39, after a relief of 1934–35
Wood, 19½ x 19⅝ x 2¾" (49.5 x 49.8 x 7 cm)
Gift of the Advisory Committee (by exchange)

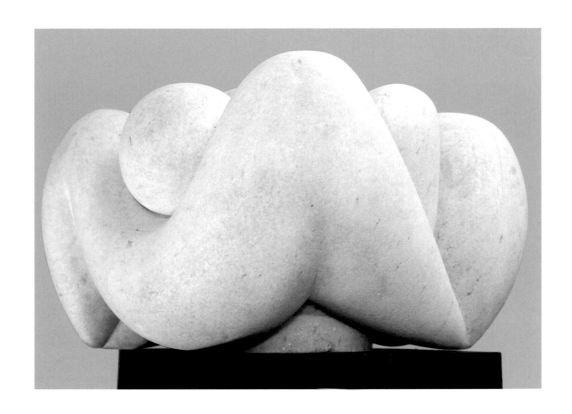

isamu noguchi | American, 1904–1988
CAPITAL. 1939
Georgia marble, 16 x 24 x 24" (40.7 x 61 x 61 cm)
Gift of Miss Jeanne Reynal

jean dubuffet | French, 1901–1985
BOTANICAL ELEMENT: BAPTISM OF FIRE
September 1959
Assemblage of leaves with oil on paper,
21⅝ x 27⅛" (54.9 x 68.9 cm)
The Sidney and Harriet Janis Collection

jean dubuffet
PLACE FOR AWAKENINGS from the
MATERIOLOGIES series. 1960
Pebbles, sand, and plastic paste on composition
board, 34⅞ x 45⅜" (88.4 x 115.2 cm)
Gift of the artist in honor of
Mr. and Mrs. Ralph F. Colin

jean dubuffet
SOUL OF THE UNDERGROUND. 1959
Oil on aluminum foil on composition board,
58⅞" x 6' 4¾" (149.6 x 195 cm)
Mary Sisler Bequest

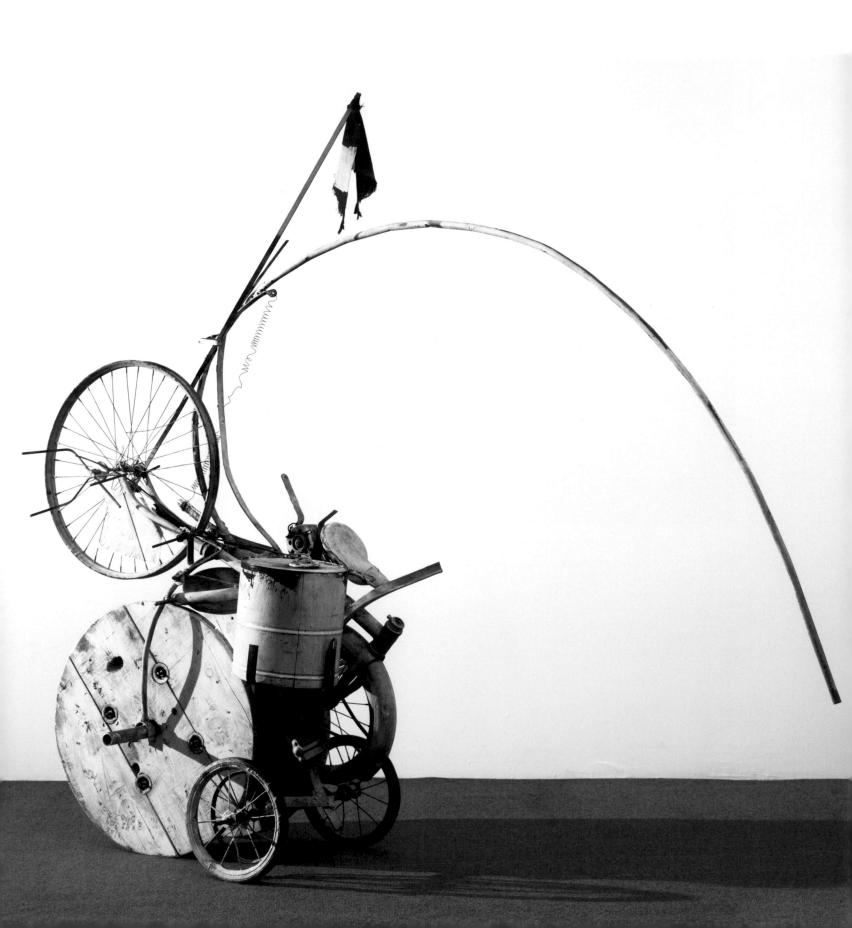

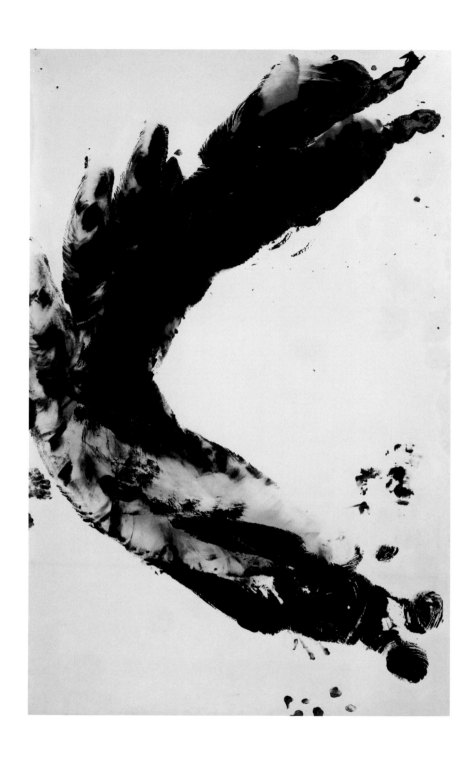

Opposite:
jean tinguely | Swiss, 1925–1991
FRAGMENT FROM HOMAGE TO NEW YORK. 1960
Painted metal, fabric, tape, wood, and rubber tires,
6' 8¼" x 29⅝" x 7' 3⅞" (203.7 x 75.1 x 223.2 cm)
Gift of the artist

yves klein | French, 1928–1962
ANTHROPOMETRY: PRINCESS HELENA. 1960
Oil on paper on wood, 6' 6" x 50½"
(198 x 128.2 cm)
Gift of Mr. and Mrs. Arthur Wiesenberger

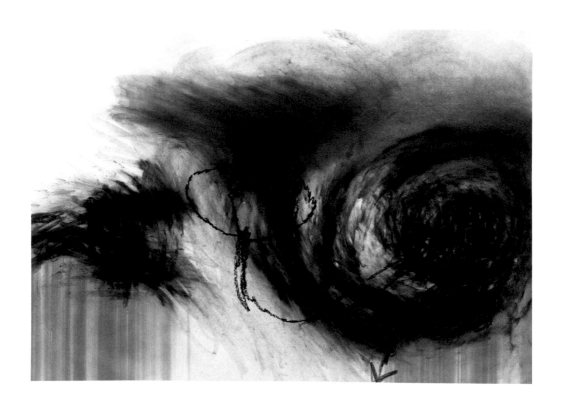

robert morris | American, born 1931
BLIND TIME III. 1985
Graphite on paper, 38 x 50" (96.5 x 127 cm)
Acquired with matching funds from Michael
Blankfort and the National Endowment for the Arts
and purchase (by exchange)

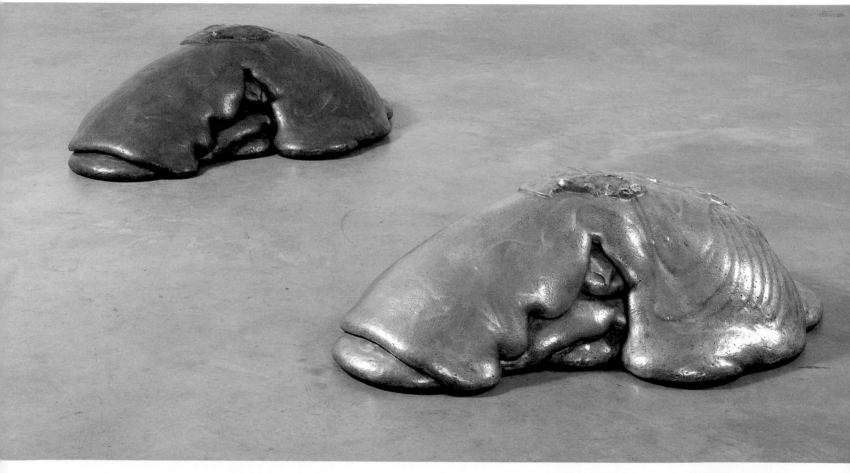

lynda benglis | American, born 1941
MODERN ART NUMBER 1. 1970–74
Bronze and aluminum (cast 1973–74) in two parts,
each: 12 x 42¾ x 30" (30.5 x 108.6 x 76.2 cm)
Gift of J. Frederic Byers III

joseph beuys | German, 1921–1986
FELT SUIT. 1970
Felt, 69⅞ x 28⅛ x 5⁵⁄₁₆" (177.5 x 71.5 x 13.5 cm)
Publisher: Galerie René Block, Berlin
Fabricator: unknown. Edition: 100
The Associates Fund

joseph beuys
UNTITLED (SUN STATE). 1974
Chalk on painted board with wood frame,
47 ½" x 6' ¹⁄₁₆" (120.7 x 183 cm)
Gift of Abby Aldrich Rockefeller and acquired
through the Lillie P. Bliss Bequest (by exchange)

ʏaʏoi кusama | Japanese, born 1929
NO. F. 1959
Oil on canvas, 41½ x 52" (105.4 x 132.1 cm)
Sid R. Bass Fund

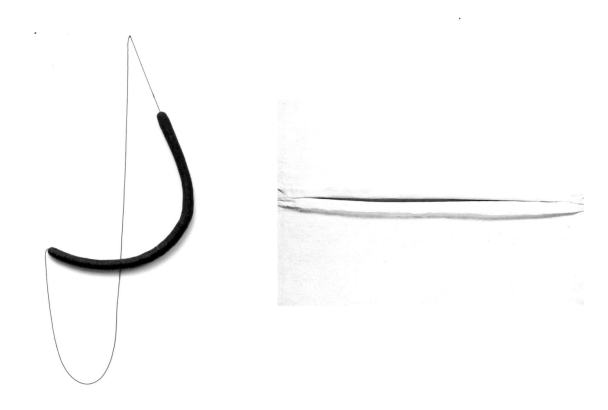

eva hesse | American, born Germany. 1936–1970
UNTITLED. 1966
Enamel paint and string over papier mâché with
elastic cord, 33½ x 26 x 2½" (85 x 65.9 x 6.4 cm)
Ruth Vollmer Bequest

piero manzoni | Italian, 1933–1963
ACHROME. 1960
Kaolin on canvas, 16⅛ x 24" (41 x 61 cm)
Thomas W. Weisel, Marcia Riklis, Emily and Jerry
Spiegel, Barbara Jakobson, and Ronald S. Lauder
Funds

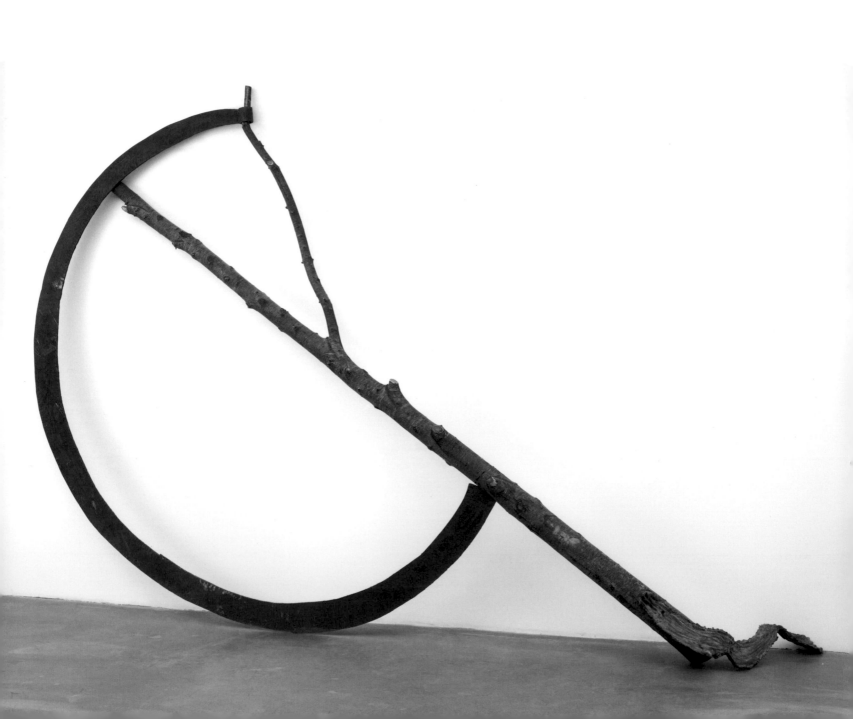

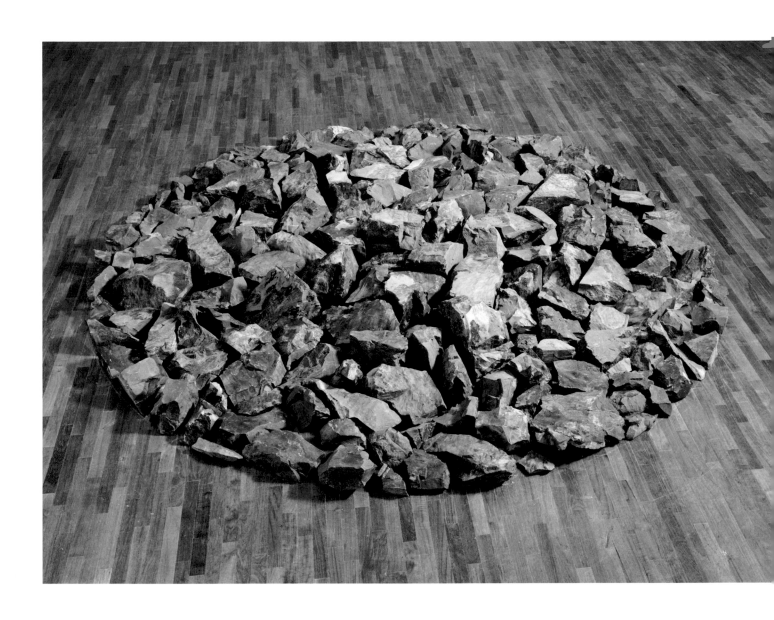

Opposite:
giuseppe penone | Italian, born 1947
DOUBLE VEGETAL GESTURE/AX. 1982
Wood, tree branch, iron, and bronze, approx.
9' 5¼" x 13' 5" x 9¾" (287.6 x 409 x 24.8 cm)
Gift of Agnes Gund and purchase

richard long | British, born 1945
KILKENNY CIRCLE. 1984
195 stones, overall diam.
ranging from 8' 3½" to 8' 8" (252.7 to 264.2 cm)
Gift of the Dannheisser Foundation

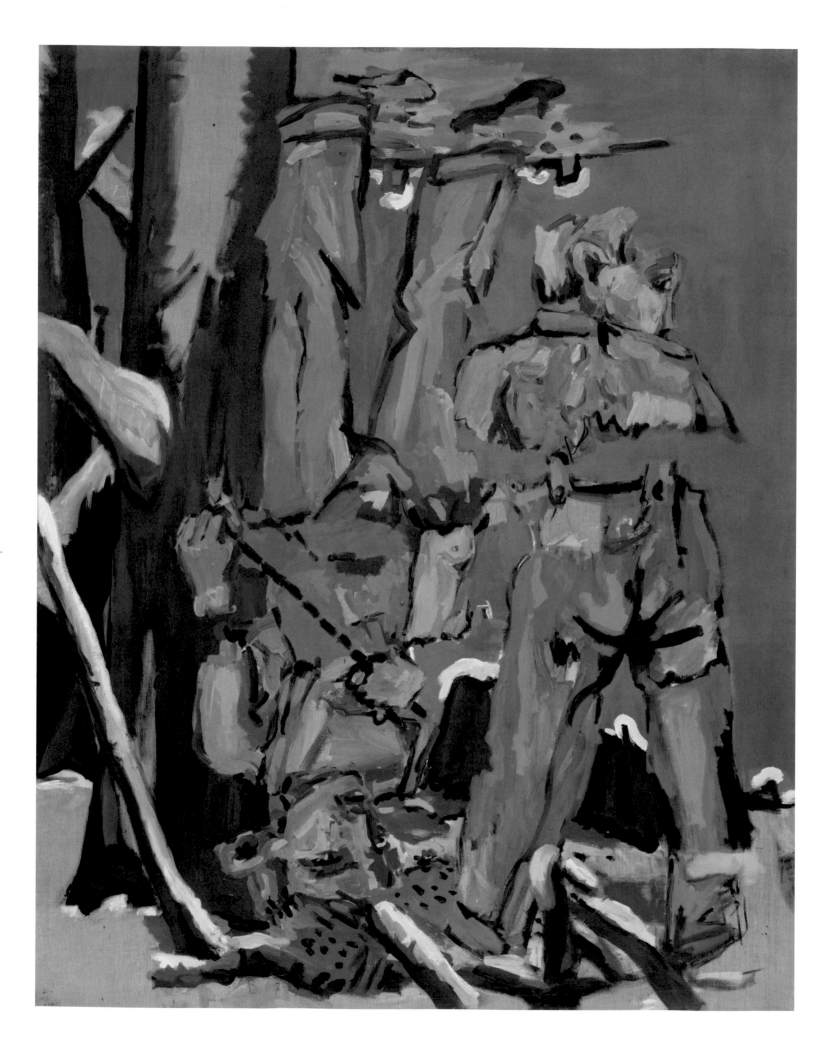

Opposite:

georg baselitz | German, born 1938
WOODMEN. 1968
Charcoal and synthetic resin on unprimed canvas,
8' 2" x 6' 6¾" (248.7 x 200 cm)
Gift of Ronald S. Lauder, Leon Black, Donald L.
Bryant, Jr., Thomas W. Weisel, Doris and Donald
Fisher, Mimi and Peter Haas, Enid A. Haupt Fund
and purchase

cindy sherman | American, born 1954
UNTITLED #188. 1989
Chromogenic color print, 43½ x 65½"
(110.5 x 166.4 cm)
Gift of the Dannheisser Foundation

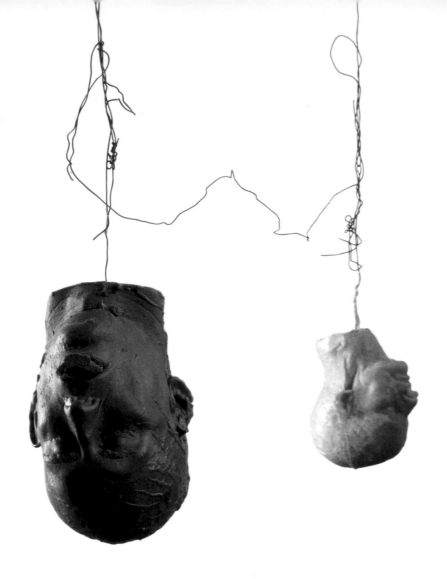

bruce nauman | American, born 1941
HANGING HEADS #2 (BLUE ANDREW WITH
PLUG/WHITE JULIE, MOUTH CLOSED). 1989
Wax and wire, two heads, 10¾ x 9½ x 7¾"
(27.3 x 24.2 x 19.7 cm) and 10½ x 8¾ x 7¼"
(26.7 x 22.2 x 18.4 cm)
Acquisition from the Werner Dannheisser
Testamentary Trust

Opposite:
robert gober | American, born 1954
UNTITLED. 1991
Wax, fabric, leather, human hair, and wood,
13¼ x 16½ x 46⅛" (33.6 x 41.9 x 117.2 cm)
Gift of Werner and Elaine Dannheisser

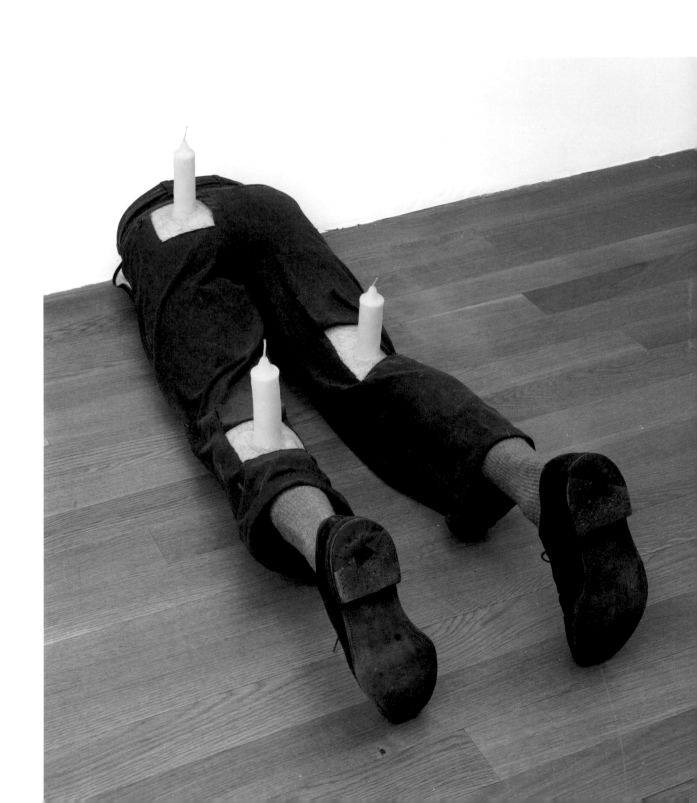

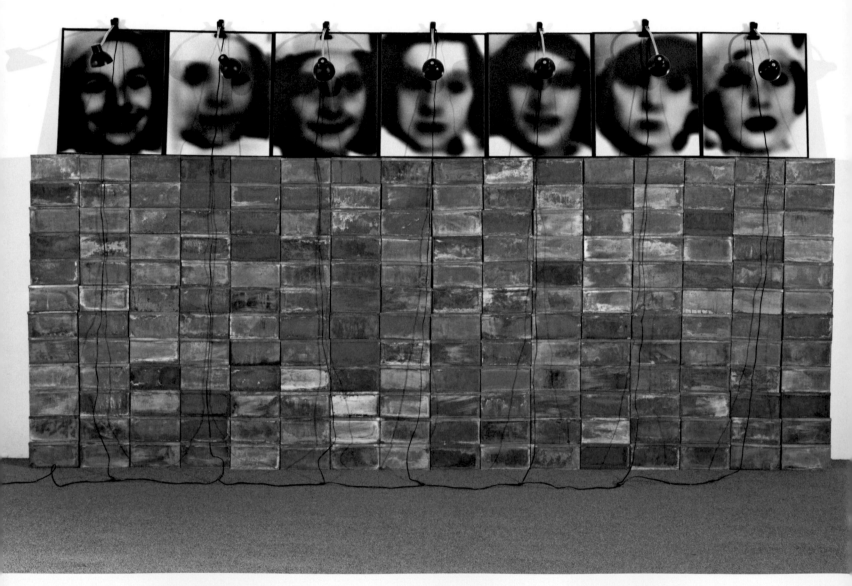

christian boltanski | French, born 1944
THE STOREHOUSE. 1988
Seven photographs with seven electric lamps and
one hundred ninety-two tin biscuit boxes containing
cloth fragments, overall 6' 11⅛" x 12' 4" x 8½"
(211.2 x 375.8 x 21.6 cm)
Jerry I. Speyer, Mr. and Mrs. Gifford Phillips, Barbara
Jakobson, Arnold A. Saltzman Funds, and purchase

Opposite:
guillermo kuitca | Argentine, born 1961
UNTITLED. 1992
Mixed media on canvas, 8' 4½" x 6' 1¼"
(255.7 x 186.1 cm)
Gift of Patricia Phelps de Cisneros in memory of
Thomas Ammann

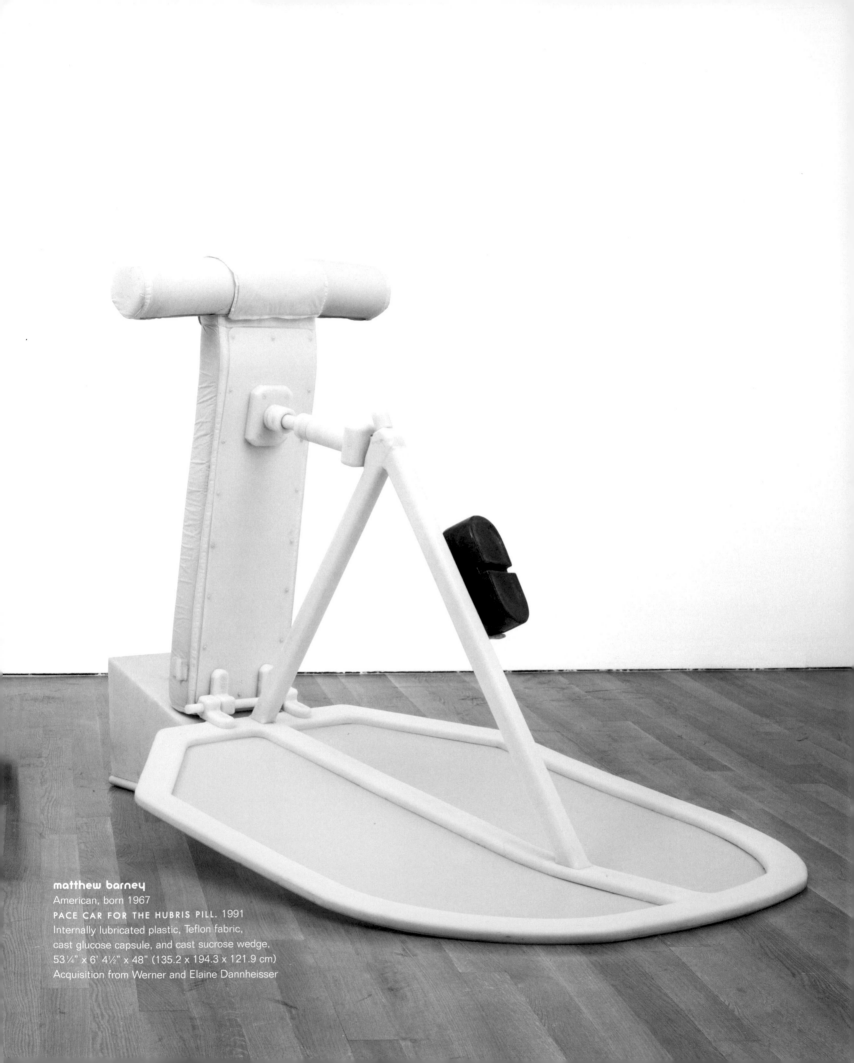

matthew barney
American, born 1967
PACE CAR FOR THE HUBRIS PILL. 1991
Internally lubricated plastic, Teflon fabric,
cast glucose capsule, and cast sucrose wedge,
53¼" x 6' 4½" x 48" (135.2 x 194.3 x 121.9 cm)
Acquisition from Werner and Elaine Dannheisser

david hammons | American, born 1943
HIGH FALUTIN'. 1990
Metal (some parts painted with oil), oil on wood,
glass, rubber, velvet, plastic, and electric light bulbs,
13' 2" x 48" x 30½" (396 x 122 x 77.5 cm)
Robert and Meryl Meltzer Fund and purchase

dieter appelt | German, born 1935
THE FIELD. 1991
Thirty gelatin silver prints, each panel:
19 ½ x 14 ¼" (49.5 x 36.2 cm)
Joel and Anne Ehrenkranz Fund, John Parkinson III
Fund, and The Fellows of Photography Fund

180 mutable

Opposite:
felix gonzalez-torres | American,
born Cuba. 1957–1996
"UNTITLED" (TORONTO). 1992
42 twenty-five-watt light bulbs, extension cord,
and porcelain light sockets, dimensions vary
with installation 42' (12.8 m) long, with 20'
(6 m) extra cord
Gift of Emily and Jerry Spiegel

li yongbin | Chinese, born 1963
FACE 1. 1996
DVD, color, silent, 36 minutes
Gift of Sylvia de Cuevas

182 mutable

peter campus | American, born 1937
THREE TRANSITIONS. 1973
DVD, color, sound, 5 minutes
Barbara Pine Fund

mako idemitsu | Japanese, born 1940
HIDEO: IT'S ME, MAMA. 1983
DVD, color, sound, 27 minutes
Purchase

kristin lucas | American, born 1968
5 MINUTE BREAK. 2001
Two-channel video installation, color,
sound, 4:35 minutes
Gift of Bobbie Foshay-Miller, Margot Ernst, Shining
Sung, Lisa A. Applebaum, the Contemporary Arts
Council, and Lois Plehn and Richard Plehn

185

tony oursler | American, born 1957
THE LONER. 1980
DVD, color, sound, 30 minutes
Purchase

john pilson | American, born 1968
INTERREGNA. 1999–2000
DVD, color, sound, 10 minutes
Fractional and promised gift of David Teiger

artists' biographies

Researched by
Raimond Livasgani,
Mara Sprafkin,
and Amy Gordon.
Written by Amy Gordon.

berenice abbott | American, 1898–1991 | American photographer Berenice Abbott befriended Man Ray and worked as his studio assistant while she was studying photography in Paris. She later set up her own portrait studio, where she became known for her photographs of famous writers, artists, aristocrats, and collectors. On a trip back to the United States in 1929, Abbott decided to move to New York permanently. It was then that she began photographing the city, a project that was to continue for more than a decade. Abbott was determined to push the medium's documentary nature to its limits, and she has since been considered one of America's great photographers.

marina abramovic | Yugoslavian, born 1946 | Marina Abramovic is a Yugoslavian-born artist whose highly personal, intensely physical works obliterate the line between life and art. In performances throughout the 1960s and 1970s, for live audiences or video productions, she engaged in activities designed to test her own endurance, sometimes sitting for days without moving, confronting danger, or inflicting pain upon herself. She collaborated with fellow artist Ulay from 1976 to 1988. Joint works focused upon their binary relationship and, later, the Eastern belief in transcendence. From 1988 Abramovic's solo performances and videos have been largely autobiographical and increasingly theatrical, addressing her personal history and cultural background.

josef albers | American, born Germany. 1888–1976 | The German-born American artist and theorist Josef Albers was a forerunner of Color Field and Op art. While teaching at the Bauhaus, Albers, who also worked in the school's metal shops, became fascinated by the optical effects of color, and he created extensive series of geometric compositions in various color combinations, observing the changes produced by the subtlest alterations. Albers emigrated to America in 1933 and taught at Black Mountain College and at Yale University, where he disseminated his ideas to a new generation of artists. He began his defining color series, **HOMAGE TO THE SQUARE**, in 1950, and had completed more than one thousand variations at the time of his death.

dieter appelt | German, born 1935 | Initially a singer with the Berlin Opera, German photographer and performance artist Dieter Appelt did not devote himself fully to the visual arts until 1976. His early photographs and performances, in which he often incorporated site-specific structures, smeared himself with dust, or rolled in dirt, explored the artist's relation to nature and showed his indebtedness to Joseph Beuys. Appelt composes nearly all his images in series that evidence the passage of time or decay. His **FIELDS** series comprises multiple, discrete views of flowing water, stones, and the artist's head. From the late 1980s he has experimented with new technologies, focused on environmental site studies, and has continued his tortured self-portraits.

armand p. arman | American, born France, 1928 | A founding member of the Nouveau Réalisme movement, French-born American sculptor Armand P. Arman uses functional objects as inspiration for his

art. His first works were created by throwing ink-covered objects at or across a canvas. He later explored the potential of objects themselves with his **ACCUMULATIONS**, in which he stockpiled multiple, identical entities—from guns to glasses to paintbrushes— depriving them of their practical meaning through repetition and static arrangement. Such objects-based work strove to represent the rampant excessiveness of consumer society. Later series included **RAGES**, in which he publicly destroyed objects; **COMBUSTIONS**, in which he burned them; and **INVISIBLES**, which were objects cast in concrete.

jean (originally, **hans**) **arp** French, born Germany (Alsace). 1887–1966 | The Alsatian-born French artist and poet Jean Arp was a founding member of the iconoclastic Dada movement. Intermittently an adherent of Surrealism as well, he invented abstract series of droll, humanized objects and used techniques of accidental composition in collages, reliefs, and drawings. In the 1930s he was associated with Cercle et Carré, de Stijl, and Abstraction-Création. Allegiance with the Surrealist movement spurred his best-known work, which consists of biomorphic, fluid sculptures that were nonrepresentational and typically had no base or predetermined orientation. In his late career, he received major public commissions and won widespread acclaim.

charles atlas | American, born 1958 | Charles Atlas is the central American figure working in "video-dance," a contemporary art form that examines the relationships between video, performance, storytelling, and design. His media work

has ranged from feature-length narrative pieces and documentaries to short comic films and provocative video installations, the majority of which incorporate music and choreographed movement. Atlas has also designed sets, costumes, and lighting for numerous productions in the United States and abroad. He has frequently collaborated with such notable performers as choreographer and dancer Merce Cunningham and the performance artists Marina Abramovic and Leigh Bowery.

francis bacon | British, born Ireland. 1909–1992 | An Irish-born British painter and draftsman, Francis Bacon was famous in London for his ostentatious public persona and throughout the world for his nightmarish oil paintings and drawings. In the years following World War II, he painted bold figurative works, often based on photographic imagery ranging from newspaper snapshots to the motion studies of Eadweard Muybridge. These tortured figures in surreal settings were meant to illustrate human vulnerability. His work drew heavily on many artists, from the Spanish painter Diego Velázquez to the Russian filmmaker Sergei Eisenstein. While the self-taught Bacon did not identify with any particular movement or style, the influences of both Cubism and Surrealism can be clearly seen in his deformed portraits and unearthly settings.

giacomo balla | Italian, 1871–1958 | Italian painter Giacomo Balla was a founding father of the Futurist movement, which urged artists to revitalize their work by harnessing the power of modern science and technology. He was devoted to the concept of light and movement as the essence of all form, a tenet clearly influenced and informed by Neo-Impressionist painting and the advent of photography. His most archetypal work used abstract color planes to convey the powerful forces of speed and motion that he felt evoked the dynamism of modern life. After World War I an interest in theater and graphic design paralleled his continuing preoccupation with the rendering of light and its various effects. Late in his career he turned to a more conventional figurative style.

matthew barney | American, born 1967 | The work of the enigmatic American artist Matthew Barney reveals an alternate universe filled with gender anxiety, rigorous athleticism, and Barney's own expansive personal mythology of cryptic symbolism. Petroleum jelly, sports equipment, and prosthetic body attachments all feature prominently in his work. He often blurs the distinction among mediums, creating sculptures, drawings, and photography to accompany his films and building installations that integrate performance and video. Barney's most celebrated works are the recent CREMASTER cycle of films, five lavish, theatrical, epic meditations on sexual differentiation.

tina barney | American, born 1945 | Since the early 1980s, American photographer Tina Barney has captured intimate and intriguing images of the suburban upper class. Expansive dimensions, vivid colors, and apparent candidness give drama to her staged photographs of wealthy families at seemingly endless leisure. Yet far from judging or fetishizing this world in which she herself was raised, Barney strives to convey an empathy and psychological depth in her images of friends and family. Even so, her work emits an isolation and anxiety that makes it as complex as it is compelling. In recent years, Barney has moved away from monumental family scenes toward simpler single portraits.

georg baselitz | German, born 1938 | German painter, sculptor, and printmaker Georg Baselitz emigrated to West Berlin from East Germany in 1956 and has created masterful figure studies that informed a generation of representational artists. In a 1961 manifesto entitled PANDEMONIUM, he advocated an expressive figural art inspired by the raw emotion and disquieting symbolism found in *art brut* and the psychotic art of deviants, rejecting *tachisme* and other abstract painting modes dominant at the time. His work addresses themes of heroism and history and typically features strong coloration and choppy, unrestrained brushwork. Despite his representational emphasis, Baselitz believes the medium and pictorial structure to be his tools of expression. He draws attention to formal elements by defamiliarizing his subjects, portraying them dismembered, dissolving, and, from 1969 on, exclusively upside down.

hans bellmer | German, born Upper Silesia (now Poland). 1902–1975 | Though associated with the Surrealists, German sculptor, photographer, and draftsman Hans Bellmer was a singular artist whose body of work drew on nostalgia, erotic fantasy, and his own personal preoccupations. Inspired by George Grosz and Dadaist nonconformity, he began to sculpt life-size, anatomically correct dolls in 1933, and eventually equipped them with a system of interchangeable joints, facilitating endless permutations of deformity. Bellmer considered his dolls physical manifestations of fetishistic desires and social taboo, and they were acclaimed by Parisian Surrealists for their combination of desire and disgust. Beginning in the late 1930s, he focused on exquisitely painstaking drawings and prints, many of which accompanied erotic texts.

lynda benglis | American, born 1941 | The provocative sculpture of American artist Lynda Benglis employs extreme tactility and curvilinear, draped, or folded forms to examine traditional femininity. From her early poured latex sculptures and projecting foam pieces to her more recent metallized fabric knots, Benglis conceives much of her sculpted work by manipulating unconventional materials and technologies. She is particularly fond of molding one substance to suggest the appearance of another. In the 1970s, she produced several video pieces that pointedly address female sexuality. Her outspoken feminism brought her international fame in 1974 when she ran a defiant advertisement in ARTFORUM magazine featuring a suggestive nude photograph of herself.

lucian bernhard | American, born Germany. 1883–1972 Among the most influential graphic designers of the twentieth century, German-born American artist Lucian Bernhard helped to introduce a compact, bold aesthetic into mainstream advertising. His career began auspiciously when he won a commercial poster contest with an unconventional design of a solid background, eye-catching product image, and prominent, though minimal, text. This formula was in radical contrast to the wordy and decorative posters of the day, and it became his trademark. The success he enjoyed with subsequent similar advertisements and logos allowed him to follow other design pursuits, and he went on to conceive many notable, now-standard typefaces. He later designed interiors, packaging, and furniture.

joseph beuys | German, 1921–1986 | Equally an artist and a social activist, German-born Joseph Beuys advocated and practiced an "extended concept of art," which radically expanded the hegemony of distinct mediums and traditional

artworks into his idea of "social sculpture." All actions and elements of life were proclaimed artistic creations. His holistic philosophy manifested itself in a body of conceptual work that included sculptures, drawings, multiples, and performances. His discrete artworks incorporated recurrent materials, such as fat, felt, vitrines, or honey, that resonated with personal symbolism. He was an instrumental member of Fluxus and, in the 1970s and 1980s, he belonged to many political and ecological organizations. Teaching and public involvement were paramount in his art.

christian boltanski | French, born 1944
Frenchman Christian Boltanski is a self-taught filmmaker and installation artist whose work explores themes of remembrance, death, and the passage of time. Though often presented as documentary, his art, as well as his public persona, admittedly combine elements of truth and invention. His early films and notebooks, in which he revisited his childhood, reflect Boltanski's interest in forms of commemoration, and from 1968 on photography featured prominently in his work. His installations integrate photographs, dramatic lighting, mementos, and altarlike constructions, which powerfully evoke memorials or shrines. Into the late 1980s his environments increasingly, though intuitively, recalled the Holocaust.

louise bourgeois | American, born France, 1911
Louise Bourgeois is a French-born American sculptor and printmaker whose work is prized for its treatment of gender issues and its poignant expression of personal experience. Since the 1960s her sculpture has grown both in size and scope, incorporating myriad materials, such as stone, wood, and latex, and fusing elements of realism and geometric abstraction to create a highly varied oeuvre. Her sculpture, which is frequently large or in the form of an environment, often alludes to male and female anatomy with organic shapes. Like her sculptures, Bourgeois's prints are stylistically and thematically diverse. At times narrative or autobiographical, they may also use intuitive symbols to evoke a viscerally powerful response.

margaret bourke-white | American, 1904–1971
A pioneer of the photo essay, American photographer Margaret Bourke-White captured her subjects with a mixture of poignant compassion and documentary precision. She began her career as an industrial and architectural photographer, emphasizing the abstract and linear beauty of mechanical structures. She soon became interested in photography as a tool of social commentary and, on excursions to Germany, Russia, India, and the American Southwest, used her camera to document living conditions and political conflict. Between 1929 and 1945 she defined the role of photojournalist while on staff at several notable magazines. During World War II, she worked abroad, becoming the first female photographer attached to the U.S. Armed Forces.

constantin brancusi | French, born Romania. 1876–1957
The streamlined, abstract work of Romanian-born French sculptor Constantin Brancusi reduces its subject to the most elemental forms. Inspired by African sculpture early in his career, he developed a passion for carving that remained lifelong. Carved wooden prototypes were often followed by renderings in bronze or marble. Brancusi was especially interested in constructing individualized wooden bases for his work. Around 1909 he introduced the ovoid into his sculpture, believing it to be the essence of form. Most of his mature works followed this practice of eliminating all detail.

marianne brandt | German, 1893–1983
An influential metalworker, German designer Marianne Brandt created a body of work that roughly parallels the stylistic evolution, from arts-and-crafts to industrial functionality, of the Bauhaus, where she was one of very few female students. Brandt is best known for her early silver and bronze tea and coffee services, which she constructed from simple geometrical forms, at times stressing aesthetics over functionality. In her late career, she designed practical lighting fixtures, the most innovative of which were mass-produced. Realizing both consumer needs and industrial practicality, Brandt created mature designs that show the influence of her mentor, Bauhaus artist László Moholy-Nagy.

marcel breuer | American, born Hungary. 1902–1981
Arguably the most celebrated student at the Bauhaus, Hungarian-born American architect and designer Marcel Breuer was a champion of the International Style, experimenting with new technology and putting functionality first in all his designs. His initial breakthrough came in 1925, when he began using tubular steel to construct lightweight furniture that was ingeniously versatile: chairs doubled as tables and vice versa. He went on to design, and subsequently universalize, modular furniture and interiors, which were mass-producible and could be rearranged according to need or desire. Breuer eventually settled in America, where he taught architecture and designed numerous groundbreaking structures, notably the Whitney Museum of American Art in New York and the UNESCO building in Paris.

alexander calder | American, 1898–1976
Applying his engineering background, American sculptor Alexander Calder created abstract, fluid mobile forms that moved with the turn of a crank or shift of a breeze, making him a forerunner of Kinetic art. He first gained fame with a whimsical circus of animated toys, which he constructed from bits of wire, cork, and wood. His work remained independently idiosyncratic until 1930, when a visit to Piet Mondrian aroused his interest in abstraction. He began to assemble nonobjective, locomotive sculptures with constantly shifting parts. These constructions were labeled "mobiles" by Marcel Duchamp; brightly colored "stabiles" (stationary sculptures) followed. In his late career Calder made jewelry, illustrations, paintings, and stage designs.

peter campus | American, born 1937
American artist Peter Campus was among the first to explore the technological capability of video and manipulate its properties to create provocative works of art. The first videos he made, shortly after consumer cameras came on the market in the late 1960s, were focused on the individual and on self-perception. Using simple effects and optical illusion, Campus altered or obliterated his own image in diverse ways. Similarly, his closed-circuit video installations confront viewers with various distorted projections of themselves. Campus abandoned video art in 1978 to develop his interest in computer processes and still photography, and has only recently returned to the medium.

giorgio de chirico | Italian, born Greece. 1888–1978
The first practitioner of metaphysical art, Greek-born Italian painter, sculptor, and theorist Giorgio de Chirico

gained early admiration for his transcendent vision, and was an indomitable inspiration to the Surrealists. He is best known for his paintings of empty city spaces, with frozen cast shadows or statues that inhabit brightly lit piazzas, creating a mood of anxious desolation. Along with fellow artist Carlo Carrà, de Chirico declared this dreamlike, psychologically dense work *pittura metafisica* (metaphysical painting), and with it strove to reveal the universal enigmas that lurk beneath the world of tangible objects. His later career encompassed a wide variety of styles and mediums, including forays into set design and literature.

christo (christo javacheff)
American, born Bulgaria, 1935
American artist Christo Javacheff was born in Bulgaria and fled to Vienna during the Hungarian Revolution of 1956. He moved to Paris in 1958, where he gained recognition with the Nouveaux Réalistes. That year he began his signature practice of wrapping everyday objects in plastic or fabric, raising questions about the nature of art and artistic authorship. In 1961, with his wife Jeanne-Claude, he began to "wrap" public buildings and monuments, altering urban environments while drawing attention to the obscured edifice. The scope of their work continued to expand and typically involves large-scale intervention in natural spaces requiring teams of assistants, such as their 1991 project UMBRELLAS, which took place jointly in Japan and the United States.

imogen cunningham | American,
1883–1976 | American photographer Imogen Cunningham is famous for her astute portraiture and abstract plant and animal photography. She began working in the romantic pictorial tradition, staging costumed individuals in idyllic settings, but gradually moved in the opposite direction, favoring sharply

detailed pictures of natural forms. In 1932 Cunningham helped to found the f.64 Group, which endorsed straightforward photography and sharp focus, yet she never settled into that or any other convention. She constantly pushed the limits of the medium, framing extreme closeups to create abstractions and exploring double exposures and the effects of pure light. In her late career she refined her integrative portraiture, which poetically merged setting and sitter.

stuart davis | American,
1892–1964 | In pursuit of a distinctly American aesthetic, painter Stuart Davis incorporated elements of Cubism, Expressionism, and everyday life to convey the sensory experience of urban excitement. He was profoundly affected by the 1913 Armory Show, where he first encountered the shallow compositions, collage technique, and imaginative color of European avant-garde art. Believing that the essence of a city lay in its commonplace sights, he depicted store facades, advertisements, and mundane objects decades before the Pop artists would discover the same subjects. His paintings displayed a highly idiosyncratic technique, using robust planes of color, text, and catchy, advertisement-inspired graphic design.

andré derain | French,
1880–1954 | French artist André Derain, whose diverse work included prints, illustrations, and costume design, was nonetheless best known for his painted landscapes and figure studies. He was inspired and informed by the colorful, expressive techniques of Vincent van Gogh and Paul Cézanne, and by Nietzchean philosophy. With his fellow visionary Henri Matisse, he cultivated the Fauvist style, which incorporated spontaneous lines and brushwork and bold, often pure col-

ors. Derain devoted himself to this unconstrained, instinctive style of painting through the first decade of the century, when, after a brief but significant experimentation with Cubism, he settled into a sequence of Neoclassical and historicist styles that epitomized his late work. Near the end of his career, he achieved financial success for his numerous set designs and book illustrations.

jim dine | American, born 1935
American painter and printmaker Jim Dine was an influential precursor of the Pop art movement. He first ventured into the art world with his Happenings of 1959–60, and quickly began to develop a style in which everyday objects were attached to the canvas or were represented as a painted series of images. Certain motifs, including hearts, robes, tools, and ties, recur so frequently in his work as to be personal icons. In the 1970s he showed a marked interest in printmaking, exploiting the medium's versatility in extensive thematic variations.

jean dubuffet | French,
1901–1985 | Inspired by the unaffected art of children and of the mentally ill, French painter, sculptor, and printmaker Jean Dubuffet originated and promoted *art brut*, a mode of expression that eschewed traditional academic conventions and relied instead on immediacy and raw emotion. His work had a crude, unsophisticated appearance, often utilizing organic or found materials and barbaric imagery. He created his expansive output almost entirely in series; among the most famous were his PHÉNOMÈNES and MATÉRIOLOGIES, textured relief pictures that incorporated natural substances, his CORPS DE DAMES, shockingly crude female nudes, and L'HOURLOUPE, an invented aesthetic of bold black-and-white outlines that attempted the representation of objects as they exist in the mind.

william eggleston | American,
born 1939 | Mainly self-taught, the American photographer William Eggleston is one of the leading pioneers of color photography. Eggleston's first prints were made from slides, which contributes to their intense hues and hyperreal effects. His photographs document the vernacular Southern landscape in which he grew up and are characterized by the seemingly casual feel of snapshots. With dazzling color, he creates looming iconic images from commonplace objects of everyday life.

james ensor | Belgian,
1860–1949 | Belgian Symbolist painter, printmaker, and draftsman James Ensor was an instrumental member of the progressive group *Les Vingts*. After an early realist period, he assimilated the loose brushwork popularized by the Impressionists. His subject matter, however, with its dark fantasy and enigmatic, often masked figures, was in stark contrast to Impressionist ideals. Ensor cast his ostensibly religious tableaux with phantoms, skeletons, and other symbolic images, imbuing them with biting social commentary or personal references. As critics increasingly denounced him, he likened himself to the suffering Christ. Despite this criticism, he inspired a rising generation of Expressionists and Surrealists with his dramatic coloring and psychological apparitions.

max ernst | French, born
Germany. 1891–1976 | German-born French painter and sculptor Max Ernst was a leading proponent of Surrealist art who was best known for his vividly colored, fantastic compositions. Disillusioned after military service during World War I, he initially joined the nihilistic Dada movement and became known for his innovative collages. He moved to Paris in 1922, aligning himself with

André Breton and Surrealism. There, experiments with pencil rubbing and other transfer techniques led to a style of freely imagined, mystical landscapes, many of which feature menacing birds or inanimate forms sprung to life. From the 1930s on, he concentrated increasingly on sculpture.

walker evans | American, 1903–1975 | A preeminent figure in American photography, Walker Evans is responsible for many iconic images of the United States during the era of the Depression. Throughout his career he believed passionately in the power and beauty of untouched, simply composed images, and his body of realist work helped to define the American tradition of "straight photography." He strove to document America through its people and places, often using commercial signage to evoke the texture of a specific locale. His best-known works are his compassionate portraits of poor Southern sharecroppers, which were taken both independently and while working for the Farm Security Administration during the Depression. After World War II, he was extremely prolific and influential as a photographer for FORTUNE magazine.

lucian freud | British, born Germany. 1922 | Lush surfaces, expressionist strokes, and classically balanced compositions distinguish the work of German-born British painter, draftsman, and printmaker Lucian Freud. His early paintings depict nudes and dingy cityscapes, which he imbued with somber moods and painstaking realism. Each work is the result of many months of toil. After 1950 he continued to render nudes and interiors in this same manner, but adopted a freer brushstroke and more interpretive colors. He eventually became an adept and prolific

printmaker, translating his nude sitters and signature choppy brushwork into precise, masterful lines with the etching needle.

katharina fritsch | German, born 1956 | German sculptor Katharina Fritsch begins with ordinary subjects—a rat, an elephant, a kitchen table—and creates a sense of the surreal with altered scale, striking color, strong silhouettes, pristine details, and unlikely juxtapositions. She generally casts her plaster, aluminum, or polyester sculptures from molds that she carefully conceives herself; those that are not actually mass-produced in this way artfully simulate an impersonal, machine-made aesthetic. Though her works are frequently likened to Jeff Koons's satirical readymades, Fritsch is not interested in social criticism or provocation, but in giving exaggerated physical form to unconscious imagery. In recent years her art has drawn on mythic or folkloric sources.

paul gauguin | French, 1848–1903 | Sometimes described as a Post-Impressionist, a Symbolist, or a Synthetist, French painter, sculptor, and printmaker Paul Gauguin made highly individualistic work that is indeed difficult to classify. He devised his characteristic compressed pictorial space and expressive blocks of color while working with Émile Bernard in Brittany. Gauguin considered his simple, puzzlelike compositions the ideal unity of visual form and emotional content. He first exhibited successfully with the Impressionists, but soon began to seek a more authentic, primal art and a fuller, more uninhibited lifestyle, which he found during several trips to Tahiti. Escaping what he considered the decadence of Western society, he settled in French Polynesia and exploited the island's tropical palette and Oceanic imagery, synthesizing motifs from many different artistic traditions.

gego (gertrude goldschmidt) Venezuelan, born Germany. 1912–1994 | Though a trained architect, German-born Venezuelan artist Gego worked as a sculptor, draftsman, and printmaker throughout her career, applying her profound structural sensibility and appreciation of geometry equally to all mediums. She began as an industrial designer and architect, and dabbled in sculpture until her acquaintance with Bauhaus artists Josef and Anni Albers inspired her to experiment with graphic art. Gego's continuing interest in geometric, yet expressive abstraction can be seen in her pristinely linear sculptures, prints, and drawings, which often include gossamerlike entanglements, systematic patterns, or rigid meshes of line. Her later career focused mainly on large-scale, seamlessly integrated sculpture for architectural settings.

alberto giacometti | Swiss, 1901–1966 | Growing up in a celebrated artistic family, Swiss-born painter and sculptor Alberto Giacometti began refining his own skill at an early age. His first notable sculptures, which resembled tribal male or female idols, were inspired by the simple forms and primal nature of African art. After attaining success as a Surrealist painter and sculptor, Giacometti began, in the 1940s, to work in what became his mature style of figural sculpture. These spindly, attenuated figures are isolated in space—emphasizing their alienation and anonymity—and remain his signature works. Such compositions were a poignant visualization of postwar European desolation and are some of the most powerful emblems of that era.

robert gober | American, born 1954 | American sculptor Robert Gober draws on everyday objects for subject material, integrating meticu-

lously detailed renderings with subtle mutations to imbue the mundane with psychological tension. After working commercially in carpentry, including making dollhouses, he began in 1984 to fashion a series of everyday objects such as beds, sinks, newspapers, and human body parts, frequently adding, subtracting, or morphing certain elements to create a poignant sense of the surreal. Though such meticulously re-created objects recall Marcel Duchamp and his Readymades, Gober's are unique, dexterously modeled objects that express a personal and intuitive symbolism and address issues of homosexuality, gender, loss, memory, and perception.

felix gonzalez-torres American, born Cuba. 1957–1996 The radical art of Cuban-born American sculptor Felix Gonzalez-Torres employs commonplace materials in ever-changing manifestations. In his early paper stacks and candy piles, he adopted a Minimalist vocabulary but, consciously reacting against the finiteness of those forms, he invited viewers to take pieces of his installations, making their participation and consumption inherent to the artistic process. Other installations, such as light strings and synchronized clocks, were poignantly and personally expressive. To Gonzalez-Torres, a victim of AIDS, such deeply intuitive symbols of love and intimacy were the most effective and affecting weapons against ignorance.

arshile gorky (vosdanig manoog adoian) | American, born Armenia. 1904–1948 Armenian-born American painter and draftsman Arshile Gorky worked tirelessly to develop his craft, eventually

arriving at a distinctive personal style that is widely recognized as a precursor of Abstract Expressionism. As a young painter, he methodically applied himself to a series of self-imposed "apprenticeships," in which he adopted the technique and aesthetic philosophy of an artist he greatly admired and then moved on to successive artists after mastery had been achieved. Gorky developed his own stylistic approach only eight years before his death. Influenced by the Surrealists, he painted highly personal, yet ostensibly abstract works, which feature protozoan-like forms on diffusive colored backgrounds. In his critical years as an artist, Gorky was struck by personal tragedy and committed suicide before his full achievements could be recognized.

eileen gray | British, born Ireland. 1879–1976 | Throughout her career, Irish-born British designer and architect Eileen Gray was at the vanguard of contemporaneous style. Born into an aristocratic family, she studied fine arts abroad, ultimately training extensively in the Japanese art of lacquer. Her early furniture, which showed a technical mastery of the craft, was luxuriously lacquered in an individualistic, abstracted Art Deco style. As early as 1920 she rejected such adornment, turning instead to utilitarian, distinctly modern textiles, furniture, and interiors, which showcased industrial materials and ascetic forms. Gray later worked as an architect, designing few but noteworthy buildings, which emphasized multifunctional space and comfort.

juan gris | Spanish, 1887–1927 Spanish painter, sculptor, graphic artist, and theorist Juan Gris began his career in Paris, where many influ-

ential Cubist artists were working. After a brief period as an illustrator for a newspaper, he began to paint in a Cubist style. His interest in the ideas behind the dominant Synthetic Cubism led to the creation of paintings that were systemic and intellectually rigorous. Gris consciously interjected everyday objects, bright colors, and methodical compositions into his traditionally instinctive, sometimes cryptic Cubist canvases. By standardizing the spontaneous, intuitive techniques of Pablo Picasso and Georges Braque, he made Cubism accessible and gained public and critical acclaim. With success achieved, he became a prolific sculptor, set designer, and illustrator in his late career.

hector guimard | French, 1867–1942 | The architect and furniture designer Hector Guimard was the chief proponent of Art Nouveau in France. He assured the movement's ubiquity and esteem with his designs for the Paris Métro stations, notable for their stemlike, cast-iron arches and vermilion bud-shaped lamps. During the height of his career, he designed numerous town houses and entire blocks of apartment buildings. His comprehensive approach to all aspects of a living space, from its exterior to its interior, led to the creation of floridly embellished buildings, furniture, and lighting fixtures. After World War I, Guimard was unwilling to assimilate emerging styles, and his late career was relatively dormant.

andreas gursky | German, born 1955 | German photographer Andreas Gursky studied at the Kunstakademie in Düsseldorf with the influential Bernd and Hilla Becher. Gursky's dramatic color photographs of vast interior and exterior spaces are often characterized by an emphasis on formal properties and abstract arrangements. In 1986 he began increasing the size of his images, which now often rival the

scale of contemporary paintings. Since 1992 he has taken to digitally manipulating his photographs, resulting in hyperreal invented scenes in saturated colors.

richard hamilton | British, born 1922 | British painter and printmaker Richard Hamilton was the pioneering figure in London's Pop art scene. In a highly diverse and inventive career, he has consistently endeavored to eliminate the divide between high and low art. Drawing on early experience as a commercial artist and the influence of Marcel Duchamp, he appropriated popular culture and consumer-oriented images while simultaneously quoting classical references from art history, achieving a mode of expression that is both common and refined. His key works examine the manipulative tactics and omnipresent imagery of the mass media. Since the 1960s Hamilton has remained an active and experimental printmaker, continually exploring the aesthetic potential of new techniques.

david hammons | American, born 1943 | American installation artist and sculptor David Hammons creates poignant, satirical pieces that are a caustic challenge to racial stereotypes and prejudice. His eclectic body of work often uses gritty, nonart materials, visual puns, appropriated vocabulary, and provocative imagery, confronting delicate social issues head-on. His SPADE series of the 1970s, for example, makes a repeated physical allusion to a derogatory term for African-Americans. In his most recognizable work, inspired by Dada and Arte Povera, Hammons assembled bottles, bottle caps, hair, chicken bones, greasy bags, and other refuse from the streets of

Harlem, creating installations that are simultaneously quasi-historical artifacts and a confrontation of clichés.

erich heckel | German, 1883–1970 | German painter and printmaker Erich Heckel was a founding member of BRÜCKE (BRIDGE), a group formed in 1905 with the common goal of a simplified, powerfully emotive art. In keeping with these ideals, he painted bold, angular forms with a striking, yet muted palette, and his compositions are invested with a primal spiritual energy. His early works were chiefly landscapes and nudes. After World War I his subjects became darker, reflecting a newfound understanding of human torment. With its capacity for robust lines and flat color, the woodcut was an opportune medium for Heckel, whose extraordinary prints helped to revitalize German interest in printmaking.

eva hesse | American, born Germany. 1936–1970 | Though a tragically early death shortened her career, German-born American painter and sculptor Eva Hesse created an influential body of work, which brought ambiguity, playfulness, and fluidity to Minimalist form. Her first works comprised expressive, semiautobiographical drawings and paintings, executed with a delicate appreciation for both rationality and the absurd. After 1965 she dedicated herself to increasingly monumental sculpture that emphasized contrasting elements and her own intuitive feminism. Although she consciously refused any stylistic allegiances, Hesse worked in a post-Minimalist milieu, creating organic, abstract forms out of experimental and malleable synthetic materials that contrasted with the impenetrable austerity of male-dominated Minimalist sculpture.

mako idemitsu | Japanese, born 1940 | A pioneer of feminist art since the late 1960s, Mako Idemitsu first embraced video when confusion between Japanese and English, her husband's language, made other forms of storytelling difficult. As a woman working within a male-oriented society, she initially experienced difficulty and frustration exploring the unwieldy and expensive medium of video, and compromised by shooting her first works in her home, her children underfoot. Since then she has made films that focus on the mother-child relationship, particularly her perception of Japanese women as defined and limited by the caretaker role. Also addressing Japanese media-obsessed culture, her video vignettes characteristically incorporate television monitors displaying metaphoric reminders of desire or propriety.

robert indiana | American, born 1928 | Born in New Castle, Indiana, American Pop artist Robert Indiana (born Robert Clark) is best known for his legendary LOVE images done in the mid-1960s, which were initially based on a holiday card he designed for The Museum of Modern Art. Indiana's compositions use bold, bright colors and graphic elements such as numerals and letters in tight, formal arrangements. He takes his inspiration from signs and billboards that are typically seen along highways or in bars, cafés, or restaurants.

jasper johns | American, born 1930 | A seminal precursor of the Pop movement, American painter, sculptor, and printmaker Jasper Johns reintroduced representational painting in the 1950s by appropriating familiar images as motifs: targets, maps, and the American flag were all trademarks in his often-serial art. He continued to emphasize the everyday through assemblage, affixing commonplace objects to his canvases. His work has persistently questioned the fundamentals of perception and the nature of the art object. He has repeatedly reinvented his work, as he did in the early 1970s, when he turned to abstract designs and again in the 1980s with enigmatic, more autobiographical motifs. Printmaking's possibilities for experimentation with serial imagery in different contexts have captivated Johns throughout his career, and he has made the medium a pivotal component of his art.

donald judd | American, 1928–1994 | Both artist and art theorist, American sculptor Donald Judd eschewed traditional craftsmanship and decoration and promoted rigorous conceptualization. While an art critic for a major journal, he began to develop his aesthetic philosophy, manifesting it in abstract paintings and sculpture. In the mid-1960s, he devoted himself to creating objects, frequently boxes or geometric solids, which were placed on the floor or mounted on the wall. His aim was to remove all context and individuality from objects. Usually made of industrial metals, wood, or concrete, his pieces were produced in a factory to eliminate any sign of workmanship. The set of ideals Judd originated in his writings and art became the exemplar and standard for Minimalism.

vasily kandinsky | French, born Russia. 1866–1944 | Russian-born French painter and theorist Vasily Kandinsky was a pivotal figure in the birth of an abstract visual language. His stylistic innovations and theoretical texts reflect an ongoing fascination with the effects of pure color and nonrepresentational art, piqued by his early exposure to Fauvism and the art of Paul Gauguin. Kandinsky personally strove for a new aesthetic vocabulary that, like music, could evoke emotion unconsciously, one which, by 1910–11, resulted in some of the earliest nonfigurative works of the century. His paintings of the 1920s and early 1930s achieved this expressive quality through the merging of simple geometric shapes and brilliant color, after which he developed a more biomorphic style. He circulated his philosophy widely and taught at the Bauhaus from 1922 to 1933.

ellsworth kelly | American, born 1923 | American painter Ellsworth Kelly has been alternately deemed an adherent of Minimalism, hard-edge painting, and geometric abstraction. He initially studied the human figure in Paris, but by 1949 had turned to an abstract mode that would characterize his signature works: clearly defined, brightly colored canvases in dramatic shapes that emphasize color and contour. Kelly based his abstractions on forms from nature and observations of light and shadow, distinguishing himself from other contemporaneous abstract painters whose works were purely cerebral. After the 1970s, he began making sculptures that parallel his graphic achievements.

andré kertész | American, born Hungary. 1894–1985 | Hungarian-born American photographer André Kertész's creativity with the camera forever expanded its range of aesthetic possibilities. He photographed the people of his native country before moving to Paris in 1926, where he was profoundly influenced by many international art movements, including Constructivism and Surrealism. His compositions from this era fittingly explore geometric and abstract forms and the distorting effects of mirrors and perspective. He purchased his first hand-held camera in 1928, and subsequently produced spontaneous, candid photographs that freely recorded the everyday scenes and influential figures of Paris. In 1936 Kertész immigrated to America, where he continued to garner acclaim as a magazine and independent photographer until his death.

anselm kiefer | German, born 1945 | A leading exponent of Neo-Expressionism in Germany during the 1970s and 1980s, Anselm Kiefer is known for colossal compositions that scrutinize German history through irony and symbolism. His mentor, Conceptual artist Joseph Beuys, encouraged Kiefer's use of performance and photography in his attempts to understand the past. Photography is also an important element in his early canvases, which borrow mythic and Nazi-related imagery to confront historic themes. Later in his career, Kiefer broadened his content to include Hebrew and Egyptian history, and his paintings became more subjective, employing symbolic materials and elusive subjects. Kiefer is also a skilled printmaker who exploits the rough qualities inherent in the medium of woodcut to create prints that feel at once raw and refined.

mokuma kikuhata | Japanese, born 1935 | Mokuma Kikuhata is a painter and sculptor based in Kyushu, southern Japan, who between 1957 and 1960 was a leading member of the Kyushu-ha artists' group. His earlier work related to French *art informel* painting but this soon evolved into a strong "anti-art" and regionalist "anti-Tokyo" statement. His colorful assemblages and performances incorporated refuse and mundane articles of everyday life, such as tin cans, wooden logs, coins, ropes, baseballs, and dolls' heads and evoked a strong interest in sexuality, politics, and, notably, the folk customs of Kyushu. Though little known to Western audiences, Kikuhata was an integral figure in the seminal

annual Yomiuri Independents open exhibitions held in Tokyo. His works of the 1960s, in particular his ROULETTE series of painted assemblages on wood started in 1963, showed a marked inclination toward Pop art.

martin kippenberger

German, 1953–1997 | During his short but eclectic career, painter and sculptor Martin Kippenberger was the rebel of contemporary German art, producing a wide-ranging body of work that draws heavily on visual and verbal puns, shocking scenarios, and ribald self-loathing. Rejuvenating aspects of Pop art and the ready-made, he created hodgepodge concoctions using everyday materials and found objects that were saturated with an irreverence and witticism reminiscent of Joseph Beuys. Kippenberger's creations frequently address the hypothetical value and social function of original art objects. For example, he executed many estimable drawings on hotel stationery, and once converted a Gerhard Richter painting into a functional coffee table.

ernst ludwig kirchner

German, 1880–1938 | German painter, printmaker, and sculptor Ernst Ludwig Kirchner was the driving force behind the revolutionary BRÜCKE (BRIDGE) group of artists, whose progressive ideas were the cornerstone of German Expressionism. Inspired by African and Polynesian art, Kirchner strove for a raw, unrefined art that incorporated bright colors and simple forms. His signature paintings of urban scenes, with their thick outlines and jagged figures, are palpably charged with a sense of carnal lust lurking beneath pomp and protocol. Like the other BRÜCKE members, Kirchner was a zealous printmaker, harnessing the unique aspects of woodcut, lithography, and etching to produce some of the most important prints of the twentieth century.

yves klein | French, 1928–1962

French painter, sculptor, and performance artist Yves Klein is most noted for smooth, monochromatic blue paintings in his own patented shade, International Klein Blue (IKB). These works, however, represent only one achievement of a lifelong experimentation with the power of pure color. Klein's Color Field paintings were based on the artist's belief that pure color was a profound, spiritual force. He experimented with different methods of applying paint, using sponges, relief maps, and, in one of his famous performance series entitled ANTHROPOMETRIES, the human body. This and other performances—he once exhibited an empty gallery space—suggest Klein as a forerunner of Conceptual art.

oskar kokoschka | British, born Austria. 1886–1980

A resolute humanist in all facets of his life, Austrian-born painter, graphic artist, and author Oskar Kokoschka pursued an art that would make visible the inner essence of humankind. He focused a considerable part of his career on portraiture, striving to represent the sitter's spiritual and emotional disposition rather than his or her physical constitution, using gesture and interpretive color to convey character. His complex and capricious career embraced numerous subjects—from scandalous young nudes to the Bible—and formats—from sparse sketches to large-format Expressionist landscapes. He was most prolific as a draftsman, with an output of five thousand or more drawings.

käthe kollwitz | German, 1867–1945

A quietly determined social activist, German printmaker and sculptor Käthe Kollwitz gave voice to suffering with her exquisitely poignant art. Inspired by graphic artist Max Klinger, she began to work almost exclusively in the print medium in 1890, at first portraying historical injustices and the poverty she witnessed in her poor Berlin neighborhood. After her youngest son was killed in World War I, she channeled her sense of loss into her prints and sculptures, which largely focus on the inhumanity of war and anguished, grieving family members. A more active political stance reappeared in her work of the 1930s, triggered by the rise of National Socialism and the impending war. Her sensibility for monumental sculpture manifests itself in her printed imagery, which is characterized by dark, condensed forms in compressed space.

willem de kooning | American, born The Netherlands. 1904–1997

Dashingly handsome and indomitably witty, Dutch-born American painter Willem de Kooning was a highly salient and central figure of Abstract Expressionism in America. In his early work he sampled a variety of established techniques before stumbling upon the rough, spontaneous Action painting that would become his trademark and a cornerstone of the Abstract Expressionist movement. He caused a stir in the 1950s art world with his WOMAN series of canvases, rendered with slashing brushstrokes that featured savage, grotesquely sexual women, with all the accoutrements of the idealized modern female exaggerated to produce a nightmarish vision. In his later years, de Kooning turned to lushly colored landscapes in a more lyrical style.

jeff koons | American, born 1955

American artist Jeff Koons first worked as a stockbroker on Wall Street, and his success there helped him to finance his initial artistic career. Koons is highly controversial due to his appropriation of mass-produced objects into the realm of the fine arts. In the tradition of Marcel Duchamp's Readymades, he encased household electronics and fluorescent lights under Plexiglas in his early works. More recently he created a series of stainless-steel and porcelain figures ranging from an inflatable rabbit to one of Michael Jackson and pet chimpanzee Bubbles. The blunt commodity-oriented nature of his work reflects the media-saturated milieu of contemporary American society.

guillermo kuitca | Argentine, born 1961

The grandson of Russian immigrants to Argentina, painter Guillermo Kuitca uses his art to analyze perspective, geography, and the personal and private spaces between humans. He had his first solo exhibition at the age of thirteen and grew up simultaneously pursuing experimental theater and painting. Early on he was recognized for his theatrical paintings, in which a low perspective implied the viewers' presence among miniature figurines in eerie interiors. In the 1980s Kuitca created monochromatic paintings in a style that incorporated systematic, anonymous plotting devices, such as maps, genealogical trees, architectural blueprints, and floor plans. It is through these devices that he evoked themes of dislocation and alienation.

yayoi kusama | Japanese, born 1929

The work of Japanese sculptor, painter, installation artist, and performance artist Yayoi Kusama reveals strains of Minimalism, feminism, Pop, and a personal struggle with mental illness. As a child she experienced bizarre hallucinations, seeing spotty auras that she subsequently translated into polka dots and psychedelic patterns in her art. In the 1960s she created installations that frequently incorporated soft phallic protuberances, mirrors,

or food. An early participant in Happenings, she also staged flamboyant public performances as a form of political activism.

fernand léger | French, 1881–1955 | French painter Fernand Léger considered maximal contrast—of color, solid and planar forms, and straight and curved lines—the key to powerful compositions. He was initially associated with avant-garde artists in Paris, helping to found the Section d'Or Cubist group. During World War I, he served in an engineers' regiment, where his exposure to military machines and his contact with French soldiers and workers inspired him to seek a relevant, futuristic art that was accessible to the masses. His idiosyncratic style, recognized as prototypical Machine art, utilizes bold, tubular forms, fragmented subjects, and a bright patchwork of colors. He favored series of object-based or character-based paintings. In his later years, he produced ceramics, set designs, and stained-glass windows.

sol lewitt | American, born 1928 With his cerebral, systems-based art, American sculptor and graphic artist Sol LeWitt is considered the "inventor" of Conceptual art. Often linked with the tenets of Minimalism, he is best known for serial and modular structures, which he organizes into geometric units using calculated, mathematical formulas. Addressing the mind rather than the emotions, he eschews the art-historical tradition of craftsmanship, placing creative value in the conception, rather than the execution, of a work. Augmenting the artistic anonymity of his work is LeWitt's use of neutral materials, such as white enamel or wood. His impressive body of prints, books, drawings, and photographs are thematically analogous to his sculpture.

li yongbin | Chinese, born 1963 Self-taught painter and media artist Li Yongbin lives and works in Beijing, where he creates haunting and illusionary self-portraits using the simplest of means. Since 1996 he has recorded his own face in various transmogrifications, from its reflection in a dark pool of ink to one in a heat-distorted Perspex mirror, entitling each video, simply, FACE. Li uses a straightforward process and, in most cases, a single camera angle. The mesmerizing and mysterious visages in his videos are achieved without technological manipulation or effects. By transforming his image without altering reality, he poses questions of representation and elusive identity.

roy lichtenstein | American, 1923–1997 | Incorporating comic-strip motifs and the visual vocabulary of commercial art, American painter and printmaker Roy Lichtenstein was a pioneer of the Pop art movement. By 1960 he had arrived at his mature style, which imitated the heavy outlines, campy melodrama, and catchy colors of mass-media illustrations, and even included the Benday dots associated with color printing in newspapers. He later diversified beyond comic-strip scenes, using his generic mass-media style to depict landscapes, monumental sculptures, and farcical "Abstract Expressionist" brushstroke paintings.

el lissitzky (lazar markovich lissitzky) | Russian, 1890–1941 El Lissitzky was an influential Russian painter, exhibition and graphic designer, photographer, and art theorist. Inspired by Kazimir Malevich and Suprematism, he sought rational, systematic forms that would integrate geometry, architecture, and the arts, believing such constructs would be universally understood and politically potent. Various experiments led to perhaps his most important contribution, a series of geometric abstractions entitled *Proun* that were precursors of Constructivism. In addition to his immense artistic output, Lissitzky was a well-respected professor and the founder of several revolutionary art periodicals.

richard long | British, born 1945 Inspired by an abiding respect for nature, British sculptor and installation artist Richard Long became an innovator of Land art in the 1960s. Connecting spiritually with the earth during lengthy hikes, he made earthworks in remote locales from Peru to Nepal. His "sculptures" commonly comprise ephemeral, geometrically simple compositions in nature, such as a trail tread in soft grass or a circle of stone shards. Its minimal interference with the earth differentiates Long's work from that of other Land artists. Usually conceived outside the gallery environment, his work is either transported or photographed for exhibitions. In the late 1970s he began composing interior works comprised of natural elements found on his walks.

kristin lucas | American, born 1968 | Coming from a generation marked by technological savvy, American artist Kristin Lucas makes works that incorporate video, installation, performance, animation, and the Internet and that defy any easy characterizations of medium or movement. Fascinated by currently relevant themes, she composes her media productions to highlight the anxiety and isolation of modern societies bombarded with television, computers, electronic media, and automated devices. Her work often expresses the depth of this void by initiating a virtual interaction between viewer and machine, offering a disturbing contemporary substitute for personal relationships. Lucas has received numerous awards, grants, and fellowships and has had several recent solo shows.

allan mccollum | American, born 1944 | American artist Allan McCollum creates works with roots in Conceptual art that defy the ideas of a rare and inherently valuable object. Throughout the 1980s and 1990s he worked in plaster of Paris, making mass-produced casts in unlimited editions, assigning value to the conglomeration of objects rather than to a single object itself. Repetition and accumulation are paramount in his installations of these casts, which most notably depict framed black pictures, dinosaur bones, or cryptic vase-shaped vessels. His diverse work has been interpreted as a sardonic parody of consumer culture, an expression of mindless repetition, and a critique of the market-based obsession with rarity.

charles rennie mackintosh British, 1868–1928 Scottish-born British architect and designer Charles Rennie Mackintosh was the foremost practitioner of Art Nouveau in Great Britain, and a member of a highly original Glasgow design quartet known as the Four. The stark simplicity of Mackintosh's designs, most notably for furniture, textiles, tearooms, and posters, emphasized alternately rigid and curving lines in stylized foliate patterns and streamlined geometric forms. After World War I, he focused on textile design, and near the end of his life, he devoted himself entirely to the medium of watercolor.

rené magritte | Belgian, 1898–1967 | Belgian painter and draftsman René Magritte was a leading Surrealist artist. Influenced by Giorgio de Chirico and *pittura metafisica*, he developed his signature style—realistically rendered depictions

of imaginary scenes—while working in Paris among the Surrealists. Many of his works combine images and text or juxtapose unlikely elements, to uncanny effect. Certain recurrent subjects, such as a female torso, a bowler hat, birds, castles, apples, or a pipe, have made his work highly recognizable. In his late career he painted murals, illustrated poems, and experimented with a number of styles, eventually settling into a classic technique reminiscent of the Old Masters.

kazimir malevich | Russian, born Ukraine. 1878–1935 | Russian painter and theorist Kazimir Malevich was an adherent of several avant-garde movements, most notably Russian Cubo-Futurism, before channeling his own ideas about geometric painting into the founding of Suprematism. This movement advocated the intuitive arrangement of color and geometric shapes to achieve the expression of pure energy. Malevich later translated these theories into three-dimensional architectonic sculpture. His Suprematist creations, along with his writings and teachings, led to the application of Suprematist design principles to functional objects. In his late career, he returned to a figurative style reminiscent of his early, pre-Suprematist imagery.

man ray (emmanuel rudnitsky) American, 1890–1976 | A highly original photographer, painter, and filmmaker, American artist Man Ray was successively a forerunner of both the Dada and Surrealist movements. He painted in styles ranging from Cubism to *tachiste*, but was best known for his photographs, which integrate artful cropping, embellished negatives, and surpris-

ing juxtapositions of people, props, and environments to achieve a dramatic or illusory effect. Perhaps his greatest contribution to both photography and Surrealism was his Rayograph, a version of the photogram in which objects placed on photographic paper are exposed to light, leaving a photographic shadow. He used this technique to create abstract, ostensibly chance compositions of commonplace objects, ingeniously gleaning fortuitous results from mechanical means.

piero manzoni | Italian, 1933–1963 | Italian artist Piero Manzoni began his career auspiciously as a painter but quickly denounced traditional motives and methods of art, thereafter devoting himself to nihilistic experiments that radically presaged 1980s Conceptual art. His most noteworthy early paintings, known as ACHROMES, were entirely white compositions in which scratched gesso, pleated or sliced canvas, and textile additions achieved a sculptural relief devoid of imagery. He signed a 1957 manifesto against style, advocating total aesthetic freedom and unity of art and life, and consequently began an esoteric vein, exhibiting such works as LIVING SCULPTURES (nude models bearing his signature), ARTIST'S SHIT, and his own breath inside a balloon.

brice marden | American, born 1938 | In the 1960s American painter Brice Marden emerged as an important Minimalist with his multi-sectioned monochromatic paintings. An avid student of art-historical precedents, he revived the tradition of geometric abstraction in a rejection of the gestural aspects of Abstract Expressionism. Instead, he drew attention to the surface of his paintings, emphasizing their flatness and understated color. He was known to heighten this effect by adding beeswax to his paint. Inspired by Chinese ideograms, his recent

paintings have abandoned his multi-panel concept, featuring instead a calligraphic web of lines that intersect upon their surfaces.

marisol (marisol escobar) Venezuelan, born France, 1930 A Venezuelan sculptor living in the United States, Marisol is best known for her darkly humorous portrait sculpture. Inspired by pre-Columbian and American folk art, her early work comprised figurines in bronze, terra-cotta, and wood, sometimes trapped in glass boxes. In the 1960s she composed large figural assemblages of painted wooden figures, body casts, and found appendages and objects, blending handcrafted artistry with a vivid, satirical Pop aesthetic. Portrayed with a striking blend of boxy forms, comical protrusions, and flat images, her subjects range from famous Pop-culture icons and political figures to gargantuan babies and poor migrant families, her own self-portrait appearing frequently among the ranks.

agnes martin | American, born Canada, 1912 | The Canadian-born American painter Agnes Martin creates abstract paintings that exhibit significant elements of Minimalism but are also deeply emotive. Despite their systematic methodology, they remain philosophically aligned with earlier expressionist abstraction. Her key works, which incorporate a grid of faint pencil lines and washes of muted, almost transparent color, evolved over a period of nearly two decades. She began in the 1940s in the realist mode, progressed to a type of biomorphic abstraction, and eventually distilled her compositions down to the most basic, evocative elements. Martin's recent work favors geometric color bands and stresses the horizontal constituent of her grids.

henri matisse | French, 1869–1954 | A prolific French painter, sculptor, and printmaker, Henri Matisse is among the most significant artists of the twentieth century. His artistic career, though highly varied, was unified in its quest for comprehensive harmony of color and composition. Fascinated by the inherent qualities of color, he published theoretical writings on the subject. The consequence of this interest was the birth of Fauvism. His paintings and drawings are marked by great attention to the interplay of contour with form, and perspective is often eliminated to emphasize surface equilibrium. Whether his subjects are domestic scenes or human figures, they are rendered as harmonious, decorative, abstracted forms. His largely figural sculptures owe their origins to Auguste Rodin.

ludwig mies van der rohe American, born Germany. 1886–1969 | With his sublimely simple, technologically advanced structures, German-born American architect Ludwig Mies van der Rohe epitomized the International Style, and, as professor and subsequently director of the Bauhaus, was a tireless advocate of its philosophy. His buildings, renowned for their structural honesty, ennoble rather than conceal their infrastructures. Mies pioneered the now-ubiquitous glass-and-steel skyscraper, which, like his furniture, capitalized on sleek new materials such as tubular steel and chrome. A proportionately small number of his designs ever went beyond the blueprint stage. Of these, the most exemplary and famous is his German Pavilion, a masterful grid of steel columns and glass planes, erected for the 1929 Barcelona International Exhibition.

joan miró | Spanish, 1893–1983 Among the most important figures associated with Surrealist art, Spanish painter Joan Miró was best known for his abstracted landscapes

and depictions of a fanciful universe, which typically featured biomorphic shapes and curvilinear lines floating on muted backgrounds. Like the Surrealist poets, who were his friends and whose work served as inspiration for him, Miró drew on dream imagery and the realm of the unconscious, but distinctively imbued his work with a spectral playfulness. Miró was a prolific printmaker, often using the medium for book illustrations. In his late career, he translated his expressive imagery into new mediums, including tapestry, ceramics, stage designs, and murals.

piet mondrian | Dutch, 1872–1944 | By eliminating representational subject matter, Dutch painter and theorist Piet Mondrian had a profound effect upon the course of art. Early on he experimented with Neo-Impressionism, Symbolism, and Cubism, and consequently gained an appreciation of pure color and fragmented abstractions. During the teens, he helped to found de Stijl, a group of Dutch artists and designers who promoted geometric abstraction as a new language of expression. His belief in the equilibrium of the cosmos brought him to his signature style, deemed Neo-Plasticism. Incorporating black lines intersecting at right angles and serenely ordered blocks of flat, primary colors, this visionary approach reflected a universal harmony.

claude monet | French, 1840–1926 | French painter Claude Monet was a prime adherent of Impressionism, a radical movement of the late nineteenth century that many consider the foundation for modern art. Boldly diverging from the conventions of classically themed monumental works of the Paris Salon,

Monet painted everyday scenes of modern life, often outdoors, focusing on the ephemeral effects of light on his subjects. His fragmented brushstrokes, impromptu compositions, and penchant for mundane subject matter signaled a bold move toward abstraction and anticipated the artistic innovations of the twentieth century. As his eyesight failed in old age, Monet continued to paint scenes of his beloved garden and Japanese footbridge, producing canvases that were increasingly expressionist in style.

robert morris | American, born 1931 | An extremely versatile American painter, draftsman, sculptor, and installation artist, Robert Morris has worked in myriad mediums and styles while constantly exploring the possibilities of artistic self-expression. He began producing Minimalist art in the 1960s, accompanying his largely geometric pieces with rigorously intellectual writings. In later sculptures he opted for ephemeral materials and mutable forms, as seen in his hanging or recumbent felt sculptures, monumental earthworks, and amorphous installations of dirt or steam. Also an art historian, Morris generally stresses the expressive and scholarly content of his art more than the visual. Since the 1980s he has focused on paintings and drawings that express visions of the Apocalypse and other symbolic themes.

edvard munch | Norwegian, 1863–1944 | An ingenious Norwegian painter and printmaker, Edvard Munch channeled his difficult childhood into a deeply moving, personally emotive art, making him a precursor of Expressionism. He adopted the vivid palette and loose brushstroke of Post-Impressionism, but his compositions dealt with the universal concerns of sexuality, love, death, as well as a distinctly modern loneliness and anxiety. Munch's

work was met with wildly contrasting reception; the outraged scandal surrounding his 1892 exhibition at the Berlin Kunstverein was a rallying cry to young, radical artists everywhere. Some of his most significant innovations were in the realm of printmaking, a medium of constant experimentation for him.

bruce nauman | American, born 1941 | Placing equal value in conceptual exploration and its formal outcome, American sculptor, installation, and video artist Bruce Nauman produces idea-based art, refusing any singular characterization of style, medium, or interpretation. Much of his work, from casts of body parts to videos displaying corporeal activity, deals with the human body, particularly his own, and its tactility. In installations he frequently incorporates contradictory or provocative words and phrases—sometimes composing with neon tubing and flashing lights—to evoke concerns about alienation and other disturbing psychological themes. Among the first significant video artists, Nauman has produced Conceptual films and film installations that intuitively provoke powerful viewer reactions of anxiety, frustration, and agitation.

isamu noguchi | American, 1904–1988 | American sculptor and designer Isamu Noguchi used abstract organic forms in his work, believing they possessed a transcendent capacity for expression. After spending the period from 1906 to 1918 in Japan, and most of the next decade in the United States, he worked as an assistant in Constantin Brancusi's Paris studio, where he was influenced by the sculptor's smooth and streamlined abstractions. His own signature works are

similarly elegant, monumental in stature, and largely carved in stone, a material with which he felt a spiritual connection. He also conceived quintessentially modern furniture and interior appliances in metal, wood, plastic, and paper. Noguchi's talent for altering environments with sleek architectural forms is also apparent in his sculpture gardens, stage sets, fountains, and playground designs.

emil nolde | German, 1867–1956 | Fiercely independent throughout his career, Emil Nolde, who was born near the border of Germany and Denmark, was associated with many movements, but aligned with none. His subject matter ranged from landscapes and cityscapes to biblical scenes, but vibrant color and Expressionist brushwork were consistently at the heart of his work. Nolde's richly hued early paintings and prints attracted the attention of the BRÜCKE (BRIDGE), and his brief affiliation with the group led to an extraordinary range of printmaking. A 1913 voyage to New Guinea piqued Nolde's interest in native art, and his late works were characterized by organic forms and subject matter that reflected a certain pessimism toward urban civilization.

georgia o'keeffe | American, 1887–1986 | Georgia O'Keeffe was a distinctly American, supremely unconventional painter and draftsman. She worked as a teacher and commercial artist for years, simultaneously educating herself in modernist innovation, and eventually began her own independent work with abstract, curvilinear charcoal drawings. These works fascinated photographer and gallery owner Alfred Stieglitz, who became her benefactor, mentor, and husband. Her subsequent exposure to photography invigorated her paintings, as she mimicked in her compositions the extreme close-ups, blurry focus, and double exposures of a camera. O'Keeffe's mature work, which

ranges from sensual, lushly colored organic abstractions to geometric cityscapes, reflects the influence of the abstract paintings of Vasily Kandinsky, the organic forms of Art Nouveau, and the radical configurations of Japanese prints.

claes oldenburg | American, born Sweden, 1929 | Swedish-born American artist Claes Oldenburg was the leading sculptor of the Pop art movement, known for his often humorous depictions of everyday objects. His move to New York in 1956 first aroused his interest in consumer items and advertisements, a fascination reflected in his early whimsical plaster casts and colorful renderings of material goods. In a provocative blurring of art and commerce, he sold these sculptures in 1961 in a converted storefront he called "The Store," an event that coincided with his interest in Happenings. Oldenburg pioneered the medium of soft sculpture with his jumbo-sized interpretations of food, furniture, and other objects. Since the late 1970s Oldenburg has increasingly focused on monumental outdoor public commissions.

julian opie | British, born 1958 Using manmade materials and a streamlined style, British painter, sculptor, and printmaker Julian Opie is one of many contemporary artists who shows a strong indebtedness to 1960s Pop art. He emerged in the 1980s with boxy paintings and bright folded-steel sculptures of mundane, often domestic objects. Since the late 1980s his work has approximated an anonymous, computer-simulated universe, with minimal detail, simple perspective, hard-edged and brightly colored blocks, and stark, childlike forms. The suggestive titles of Opie's most recent works invite the viewer to project himself or herself into these colorfully sterile landscapes, creating a humorous, yet compelling simulation of contemporary alienation.

tony oursler | American, born 1957 | Tony Oursler has been a preeminent presence in American video art since the 1980s, when he began exhibiting unusual narratives featuring bizarre sets and puppets. His early videos address postmodern alienation and mass-media culture with a dark, ironic humor that anticipated his later work. In the 1990s he created video sculpture and installations, using tiny projectors to animate amorphous dummies or to project images into space. His "talking heads" appear to confront or interact directly with the viewer. Video effigies, fragmentary spoken narrative, and sculptural objects that create disconcerting dioramas are often combined in his installations and are meant to examine popular response to virtual animation.

eduardo paolozzi | British, born 1924 | British sculptor and printmaker Eduardo Paolozzi reflects modern life through the merging of machine aesthetics and mundane materials. In 1952 he was a founding member of London's Independent Group, and in a lecture-demonstration entitled "Bunk," he showed slides of magazine and pulp-fiction images, showcasing the newfound importance of the mass media and prophesying the Pop-art aesthetic of the 1960s. Often drawing analogies between the human figure and engineered machinery, Paolozzi's sculptures juxtapose scraps and found objects with an architectural framework of industrial metals. Similarly, his landmark screenprints of the 1960s are amalgams, integrating mass media, text, and mechanistic design to create seemingly random syntheses from contemporary society.

giuseppe penone | Italian, born 1947 | Associated with the artists' group Arte Povera, which advocated the use of humble materials, Italian sculptor Giuseppe Penone creates work that metaphorically represents man's harmony with, and sometimes harnessing of, nature. His first works involved interventions in a secluded forest, and subsequent sculptures, though shown in galleries, were closely associated with the environment. Many of his installations contain tree branches, leaves, vegetables, earth, or bronze castings of these elements. The human body also figures prominently, especially in the form of fingerprints, meaningful to Penone as concrete evidence of human presence. From the 1980s on, he has cleverly integrated gardening tools into his sculpture, offering them as physical links between man and the earth.

pablo picasso | Spanish, 1881–1973 | In a career that spanned eighty years, Spanish painter, sculptor, printmaker, and draftsman Pablo Picasso produced an enormous body of work in a wide variety of styles. In the early 1900s, he was influenced by the angularity of African masks and the fragmented planes of Paul Cézanne's compositions, and he began to paint in an innovative style that culminated in the birth of Cubism. His tireless experimentation in countless mediums, coupled with his vibrant personality and public persona, enabled him to influence the course of modern art until his death in the early 1970s. Picasso was, arguably, the most significant artist of the twentieth century.

john pilson | American, born 1968 | Despite his relative youth, American artist John Pilson has taken photographs and made videos for nearly a decade, exploring the theme of urban and corporate interiors. He first approached this theme after working as a multimedia designer for several Wall Street investment firms. Subsequent videos addressed the anonymity and rigidity of urban work environments, underlining the tension between individual creativity and institutional regulation. Often described as having Minimalist tendencies, Pilson's work is rife with eventless voids and unsettling bare space. His black-and-white photographs treat similar urban themes, but lavish more attention on formal aestheticism.

michelangelo pistoletto Italian, born 1933 | As a young man, the self-taught Italian artist Michelangelo Pistoletto worked for his father as an art restorer. Strongly influenced by Francis Bacon's expressive figurative paintings, Pistoletto turned to photography as a tool. His early works comprised photographic portraits transferred onto highly varnished surfaces or mirrors, thereby creating interactive compositions that involve the passing viewer. In the late 1960s, Pistoletto turned to sculptural works and performance art and became associated with the Arte Povera group. More recently his work has made ironic comment on the academic canon of figurative sculpture.

sigmar polke | German, born 1941 | The artistic oeuvre of the enigmatic German painter Sigmar Polke defies generalizations. With fellow German artist Gerhard Richter, he originated the style termed Capitalist Realism, which mimicked Pop-art methods but embraced a darker view of consumerism and media omnipresence found in postwar Germany. His art often incorporates the clichéd and the conventional, at times placing transparent images over kitschy

patterns or appropriating art-historical techniques in ironic, often irreverent commentaries on artistic tradition. A constant innovator, since the 1980s Polke has worked with chemically experimental paintings that change appearance over time.

jackson pollock | American, 1912–1956 | Jackson Pollock was among the progenitors of American Abstract Expressionism. His signature "drip" paintings, in which sticks or brushes were used to pour paint across a canvas from all sides, epitomized the new spirit in American art: they were heroically scaled, spontaneous, and focused on the process of painting itself. Before this critical, yet relatively short phase of his career, Pollock was influenced by the Surrealists' study of the unconscious and by the work of Pablo Picasso and Joan Miró. Debilitated by alcoholism, he undertook extensive therapy and self-exploration, with his discoveries fueling his art. The resultant works were semiabstract and highly personal, showing a free association of motifs and dreamlike imagery. Later his work evolved into total abstraction, built from skeins of layered paint.

robert rauschenberg American, born 1925 | Seminal American artist Robert Rauschenberg is most renowned for his early COMBINE paintings, which, in their synthesis of free, gestural brushwork and actual found objects, established a major bridge between Abstract Expressionism and Pop art. Throughout the 1960s, he also appropriated clippings from the media, transferring everyday images from current events directly onto his canvases. In his innovative series of the 1970s, his material included translucent veils of silk, cotton, and cheesecloth. Photography and installation art have increasingly

marked his career in recent decades. He has also been a strong supporter of progressive cultural and artistic causes and has traveled worldwide to collaborate with artists and artisans of diverse cultures and backgrounds.

odilon redon | French, 1840–1916 | The French nineteenth-century Symbolist artist Odilon Redon depicted the world of his imagination in paintings, prints, and drawings of a fantastic universe. His first dreamlike charcoal drawings were produced after he moved to Paris, where he grew disdainful of realist subject matter and the then-dominant Impressionist style. Ranging from macabre to mystical, his own work frequently made literary allusions and incorporated imaginative imagery such as floating eyes and severed heads. His prints tended to be darker and more chimerical than his paintings, which were frequently colorful depictions of flowers or spiritual subjects. Redon's striking palette served as inspiration for the later Fauvists, while his fanciful imagery anticipated that of the Surrealists.

gerhard richter | German, born 1932 | Gerhard Richter was one of the founders of Capitalist Realism, a German strain of Pop art with a more potent critical edge than its American and British counterparts. He used photography as a starting point for these compositions, often appropriating familiar newspaper images of prominent individuals. With large-format, blurred renderings, usually in black, white, and gray, he raised questions about the nature of representation. Refusing association with any one style of expression, Richter, in the late 1970s, began working in an abstract mode, creating brilliantly colored expressive compositions. He continues to work in these disparate modes as an intentional conceptual statement.

gerrit rietveld | Dutch, 1888–1964 | Dutch architect and designer Gerrit Rietveld was one of the first to apply the rudiments of de Stijl, with which he was long associated, to architecture. After opening a furniture shop in 1918, he won immediate fame for his angular, geometric armchair, which, with its intersecting, rigidly straight planes and a later application of primary colors, was archetypically de Stijl, and would become his hallmark example of furniture. His subsequent large-scale architecture projects were distinguished by exteriors of converging and overlapping gray and white planes and by horizontal and vertical appendages in primary colors or black. Such geometrically reduced designs helped define the standard of modern architecture. After 1930 he designed mass-produced furniture and private houses.

aleksandr rodchenko Russian, 1891–1956 | Aleksandr Rodchenko was a Russian painter, designer, and photographer whose views of art resulted in a constant challenge to conventional modes of expression. After art school and a brief involvement with Futurism, he worked in a style of geometric, abstract painting, using a compass and ruler to obviate any indication of subjectivity or emotion. In 1920 he became ideologically opposed to easel painting and began promoting Productivism, a form of Constructivism that advocated a union of art and industry. He became an avid photographer and typographer, taught art, and held art-related government positions.

auguste rodin | French, 1840–1917 | Sometimes called a modern-day Michelangelo, French sculptor Auguste Rodin had such extraordinary talent for rendering the

human figure that he was initially accused of having cast his sculptures from live models. He worked for commercial decorators and sculptors during his early career, and consequently did not develop his individual style for many years. His arguably most famous work, THE GATES OF HELL, which includes such iconic figures as THE THINKER and THE KISS, was never cast in bronze during his lifetime. Rodin's monumental, metaphorical sculptures of figures in dramatic poses express basic human conditions and desires.

james rosenquist | American, born 1933 | A prominent figure of the Pop art movement, American artist James Rosenquist initially supported himself as a billboard painter while in school in Minnesota and then later when he moved to New York. The influence of these years is visible in his paintings of bold and brightly colored, blown-up images of everyday objects arranged in often startling juxtapositions. His fusion of corporate logos, food, cars, and politics sought to encapsulate the American experience of the period.

martha rosler | American, born 1943 | American artist Martha Rosler produces feminist, socially conscious art, often juxtaposing unlikely or ironic images, text, and performance in a biting commentary on societal oppression. Searching for an alternate mode of expression, she renounced painting early in her career and focused on collage, installations, performance, video, and even serial postcard projects throughout the 1970s and 1980s. Some of her most significant projects reveal the historical, cultural, and linguistic hegemonies that constrain women. Her darkly humorous video SEMIOTICS OF THE KITCHEN, for example, transforms cooking appliances into domestic tools of rage. In the 1990s Rosler's work became increasingly global, addressing world crises and communication systems.

robert ryman | American, born 1930 | With its nonrepresentational systems and focus on white, the work of American painter Robert Ryman is often associated with Minimalism, as it addresses the fundamental act of painting and the physical presence of the medium. Since the early 1970s, he has worked almost exclusively with a square surface, often varying subtle elements as he composes extensive series. By drastically reducing and systematizing the formal elements of his compositions, he forces the viewer to draw meaning from what are conventionally disregarded incidentals, such as texture, framing, or how a painting is attached to the wall.

egon schiele | Austrian, 1890–1918 | Though his career lasted only ten years, painter and draftsman Egon Schiele developed a highly recognizable style and was a pivotal figure of Austrian Expressionism. Stylistically he was influenced by the linearity of the work of Gustav Klimt and the Viennese Secession, yet his erotically charged compositions were uniquely his own. Using black outlines and expressive colors, he rendered pinched and tortuous human figures, often using gesture to reveal a grotesquely voracious sexuality. His landscapes and other compositions were often similarly distorted and psychologically taut. Schiele's art was scandalous, as was his lifestyle. He never finished his studies at art school, instead founding the nonconformist Neukunstgruppe.

joost schmidt | German, 1893–1948 | Though one of the lesser-known members of the Bauhaus, German graphic artist and sculptor Joost Schmidt spent thirteen years as a student and teacher at that famous school, which is sometimes considered the birthplace of modernism. He was an adroit woodcarver whose decorative reliefs, with their geometric shapes and clear organization, were typical of the Bauhaus. His carvings decorated Sommerfeld House in Berlin, which was among the Bauhaus's most important architectural projects. Influential as a typographer, Schmidt devised a course on lettering that stressed clarity and effectiveness of communication over adornment. His own graphic designs were some of the earliest and most compelling works of modern typography.

kurt schwitters | British, born Germany. 1887–1948
Initially associated with Dada, German-born artist Kurt Schwitters cultivated an early taste for everyday objects, random detritus, and scraps of printed ephemera that culminated in series of collages and reliefs. He referred to his art, his philosophy, and even himself as "Merz," a nonsensical word derived from the German "Kommerz" (commerce). He published a journal entitled MERZ and deemed his collages MERZBILDEN (Merz pictures). Schwitters periodically identified with Constructivism and Abstraction-Création, but his beliefs were all but singular among his peers. Beginning in the early 1920s, Schwitters devoted himself to an ambitious and obsessional architectural venture comprised of found objects and rubbish that he referred to as MERZBAU. The first two versions are destroyed; the third was left unfinished in his final home in the English Lake District.

charles sheeler | American, 1883–1965 | American photographer and painter Charles Sheeler found abstract beauty in mundane venues. Inspired by early Analytic Cubism, his first paintings called attention to the angular contours of American farmhouses and tools. He began to take photographs as a commercial venture, but by 1915 had accepted the camera as a form of expression as valid as painting. His subsequent photographs rendered architectural or industrial subjects with linear clarity and minute detail, and, like his corresponding paintings, equated the geometry of urban and industrial America with Cubist representation. Sheeler's mature paintings mirrored his photographs, using rigid lines and sleek planes in a style deemed Precisionism.

cindy sherman | American, born 1954 | Cindy Sherman has been a seminal figure in the field of American photography since the creation of her UNTITLED FILM STILLS series of the late 1970s to early 1980s, in which she posed as prototypical female figures from storybook and cinema history. Her successive, mostly color-photo series depict stock female characters ranging from centerfolds to clowns. In these works she questions notions of femininity and identity through the conspicuous use of artifice and cliché. Featuring masks, prosthetic body parts, and artificial environments, Sherman's disquieting compositions are redolent with psychologically and sexually charged imagery. Her more recent work includes grotesque still lifes of food, erotic paraphernalia, prostheses, and dolls.

david smith | American, 1906–1965 | Though he initially studied painting and drawing, American sculptor David Smith truly learned his craft while working as a riveter in a Studebaker automobile factory. The welding skills he had gained at his summer job lay dormant until 1933, when Smith began to produce his first welded sculptures, which, by the 1950s, had evolved into his signature freestanding, abstract works of steel, iron, and other metals. He frequently used the technique of assemblage, combining found objects, pieces of machinery, and metal scraps into striking three-dimensional collages. Influences on his art include Cubism and Surrealism, which he combined with his own personal mythology.

kiki smith | American, born Germany, 1954 | Kiki Smith is an American sculptor and printmaker whose work gained recognition in the 1980s for its focus on the vulnerability and endurance of the human body, particularly the female form. She simultaneously questions classical reverence for the body and contemporary unease with it, conflating beautiful materials and forms with confrontational subject matter. She began printmaking in the 1980s and has become one of the most inventive and prolific printmakers of her generation, often bringing unconventional, physical approaches to her printed art. Smith's recent work has proven her versatility, as she delves into new motifs, such as animals or fairytales, and new mediums such as photography.

nancy spero | American, born 1926 | American painter, collagist, and printmaker Nancy Spero has been a trailblazer of feminist art since the 1970s. Equally artist and political activist, she unreservedly uses her art to expose the worldwide abuse of women, corrupt gender relations, and the miseries of war. Spero appropriates iconic images of women, from tribal totems to magazine covers, in an effort to recast woman as protagonist in a male-dominated history. Revolutionary in her life as well as her art, Spero has worked exclusively on paper since 1966, challenging restrictions of the commercial gallery system.

edward steichen | American, born Luxembourg. 1879–1973
The Luxembourg-born American photographer Edward Steichen's inventive work and tireless advocacy helped to define photography as a high art form at a time when its relative youth as a medium and its mechanical nature prompted skepticism. Trained as a painter, Steichen manipulated his negatives to produce painterly, impressionistic effects. In 1902 he founded the Photo-Secession group with Alfred Stieglitz, and was dedicated to promoting and exhibiting contemporary photography. After a foray into war subjects, Steichen's work became less pictorial, instead emphasizing precision and clarity of composition. Some of his most recognizable, iconographic images date from the 1940s. He was for a time a high-fashion photographer and also an early director of the department of photography at The Museum of Modern Art.

gustav stickley | American, 1858–1942 | Gustav Stickley was an American designer whose robust, uncluttered furniture originated the Mission style. The inspiration for his distinctive, sturdy, rectilinear constructions was gained while traveling abroad, where he was impressed by the materials and workmanship of the British arts-and-crafts movement. He returned to America and opened his Craftsman workshop and line of furniture in 1900. It was soon supplemented by a monthly periodical, THE CRAFTSMAN, which, in addition to articles about arts-and-crafts decor, contained functional designs for modest houses. Poor business sense left Stickley bankrupt at the pinnacle of his career, but his Mission style remains a standard of early American modernism.

paul strand | American, 1890–1976 | The sharply detailed, tonally rich pictures of American photographer Paul Strand emphasized the objectivity of the medium and established the camera as a tool of fine art. Encouraged by friendship with like-minded photographer Alfred Stieglitz, Strand rejected the preeminent pictorial style of photography early in his career, favoring instead candid, unplanned compositions and refusing to manipulate his images in the darkroom. His diverse subjects included New York cityscapes, portraiture, and still lifes, which he cropped and enlarged to the point of abstraction. Strand also explored filmmaking, periodically working exclusively in the medium, and established his own documentary film company.

nikolai suetin | Russian, 1897–1954 | Among Kazimir Malevich's most gifted protégés, Russian painter, graphic artist, and designer Nikolai Suetin was celebrated for his application of Suprematist goals to three-dimensional objects. Early in his career he joined with other Malevich disciples in a group called UNOVIS, which strove to adapt Suprematist ideologies to practical projects. In the 1920s he envisioned an expansion of Suprematist ideals and began designing interiors, exhibition spaces, tea services, and tableware in the nonrepresentational style. His interiors included those for the Soviet Pavilions at the World's Fair in Paris in 1937 and in New York in 1939. After Malevich's death, Suetin created art that was less explicitly Suprematist, yet continued to argue the relevance of a practical, rather than contemplative, art.

yves tanguy | American, born France. 1900–1955 | French-born American painter Yves Tanguy was among the most devoted adherents of Surrealism. A painting by Giorgio de Chirico inspired his first creations, which, though Expressionist, contained similar elements of fantasy. In 1925 he joined the Surrealist movement, and soon developed his mature style of indecipherable, yet solid forms placed in desolate, dreamlike landscapes. He embraced automatism, a Surrealist method of harnessing subconscious creativity, and painted with pure color, achieving a nebulous, molten effect. The fantastic worlds of his canvases are made increasingly eerie by their paradoxical realism, achieved with naturalistic conventions such as perspective and shadow.

jean tinguely | Swiss, 1925–1991 | The chief practitioner of Kinetic sculpture, Swiss-born Jean Tinguely was known for his robotic mechanisms that performed tasks, engaged in random movement, or self-destructed. His contraptions, many of which comprised found objects and metal miscellany, were deemed METAMECHANIQUES, and he intended them to counter ages of static, academic sculpture and pay homage to movement as the marrow of both life and art. After becoming a founding member of Nouveau Réalisme in 1960, Tinguely experimented with kinetic fountains, monumental assemblages for urban locales, and Happenings, often creating public installations that exploded. After the 1970s he produced colossal reliefs and sculptures that dealt with darker themes.

joaquín torres-garcía Uruguayan, 1874–1949
Uruguayan painter Joaquín Torres-García is esteemed for his individualistic style of geometric abstraction. He began by painting murals and composing designs for stained-glass windows. The formative influence of his fresco work can be seen in his mature paintings, which utilize a grid to divide the canvas into thematically diverse panels. Earthy in color and thickly painted, his linear imagery also recalls pre-Columbian art. While developing his technique in Paris, he helped to found the Cercle et Carré group of abstract artists, which was an important forerunner of Abstraction-Création. Torres-García returned to Uruguay in 1934 and devoted himself to education, promoting modern European movements, such as Cubism and Constructivism, throughout South America.

henry clemens van de velde Belgian, 1863–1957 | Belgian architect, designer, and art theorist Henry Clemens van de Velde was an originator and major proponent of the organic Art Nouveau style. Consequently, his graphic and architectural work was characterized by sinuous lines and naturalistic forms. He was an advocate of Gesamtkunstwerk, which stressed a harmonious unity of all the arts. His belief in the fusion of art with elements of everyday life had inevitable manifestations in architecture and interior design, which van de Velde considered among the fine arts. He founded the Weimar Kunstgewerbeschule, a forerunner of the first Weimar Bauhaus, and was actively involved in other institutions, making his legacy that of a teacher and innovator as much as an artist.

jacques de la villeglé French, born 1926 | French artist Jacques de la Villeglé found beauty and value in the discarded shreds of Parisian street posters, and, like his fellow Nouveaux Réalistes, used such ostensible junk to create radical, irreverent art. Beginning in 1949 he worked in *décollage*, a process of stripping away poster layers to create artworks from street ephemera. De la Villeglé's *décollages* resulted in a random assortment of familiar cinema and advertisement images,

in what the artist deemed the ideal alternative to postwar abstract art. His work was a testament to real life, unrefined materials, and popular imagery, making de la Villeglé an important precursor of Pop art.

kara walker | American, born 1969 | With her racially charged, dark vision of the antebellum South, American installation and graphic artist Kara Walker has been a constant source of both controversy and adulation since she began showing work in the mid-1990s. The majority of her work is executed in the technique of silhouette, historically a type of portraiture in which a figure's contour is presented without detail against a contrasting background. Her paper figures are grotesque caricatures, which flagrantly exploit the most injurious racial stereotypes of the plantation-era South. In narrative tableaux, they tell stories that are explicitly violent and shockingly perverse, brazenly attacking issues of racism.

andy warhol | American, 1928–1987 | Andy Warhol was the defining figure of American Pop art, embracing the ideas of mass production and commercialism in radical paintings, prints, sculptures, and films. He first worked as a commercial illustrator. He focused his early output on consumer goods, faithfully replicating products such as Campbell's soup in paintings and sculptures. Archetypical of the Pop movement, Warhol's art consistently imitated life, appropriating images so familiar to a media-bombarded culture as to be meaningless, and

emphasizing the manufacturability of an image through repetition. His chromatic series of screenprints of Marilyn Monroe is a well-known example. The years before his untimely death were occupied making experimental films.

tom wesselmann | American, born 1931 | The American Pop artist Tom Wesselmann is a painter and printmaker. He came to New York to study cartooning at Cooper Union, where he was encouraged to become a painter. Wesselmann is best known for his GREAT AMERICAN NUDE series and his STILL LIFE series—everyday imagery, often including three-dimensional objects, in a graphic, simplified style. His interest in cartooning is clearly visible in his work. The series of SMOKER MOUTHS is characteristic in its bright and bold colors, its aggressive and exaggerated compositions, and its erotic connotations.

edward weston | American, 1886–1958 | One of the most significant photographers of the twentieth century, Edward Weston originated an aesthetic of graphic precision that would define American photography for decades. After denouncing his early, more sentimental images, he developed a lasting commitment to realism, refusing to tamper with, crop, or even enlarge his negatives. Likewise, he shot his frequently common motifs straightforwardly, isolated and centered in the composition. The camera's ability to capture minute detail delighted Weston, and he used extremely close focus to reveal the abstract elements latent in nature. His monumental images of peppers are especially renowned, and his landscapes similarly revel in the striking artistry of natural forms and geological phenomena.

frank lloyd wright | American, 1867–1959 | Recognized as among America's most influential and innovative architects, Frank Lloyd Wright championed an architecture marked by absolute harmony between a building and its environment. Among his first creations was the quintessentially midwestern, extremely popular Prairie-style architecture, which mirrored the flat landscape with its strong horizontal emphasis and fluid organization of dynamic space. Equally celebrated were his Usonian houses, designed during the Depression to maximize efficiency and minimize cost. Wright valued absolute harmony in the private houses he built, often designing the furniture and fittings as well. Widespread acclaim brought him substantial commissions, his most daring and visionary being the spiral-shaped Guggenheim Museum in New York, completed in 1959.

zhang peili | Chinese, born 1957 | One of a growing number of contemporary Chinese artists to attract international attention, Zhang Peili creates evocative video installations distinguished by their straightforward simplicity and frequent satirical or absurd perspectives. He began as a painter but in the late 1980s he experimented with video, documenting single actions such as washing a chicken or breaking a mirror. In later works he adopted multiple perspectives that enabled him to record several realities of a single activity. Among the most renowned of these is his 1997 video installation entitled EATING, in which three awkward camera angles make the simple act of eating seem surreal.

acknowledgments

Organizing an exhibition on the scale and breadth of **MODERN MEANS** is an ambitious undertaking and requires the expertise of scores of people across every department of the Museum. We would first like to express our gratitude to Glenn D. Lowry, the Museum's Director, for his ongoing support throughout the preparation of this complex project. In addition, we want to extend our heartfelt appreciation to Jennifer Russell, Deputy Director for Exhibitions and Collections Support, whose tireless efforts, delicate diplomacy, and continued encouragement made the successful completion of this exhibition a reality.

For their cooperation and thoughtful responses to our numerous requests, our sincerest thanks go to the Chief Curators of each of the Museum's collections: Mary Lea Bandy, Film and Media; John Elderfield, Painting and Sculpture; Peter Galassi, Photography; Gary Garrels, Drawings; and Terence Riley, Architecture and Design. The staff of each of these departments advised us and repeatedly welcomed us into their vast storerooms, pulling and re-pulling countless works as we finalized the exhibition's checklist. We are indebted to Paola Antonelli, Curator; Dalia Azim, Curatorial Assistant; Kathleen Curry, Assistant Curator, Research and Collections; Jodi Hauptman, Associate Curator; Susan Kismaric, Curator; Christian Larsen, Senior Cataloguer; David Moreno, Preparator; Avril Peck, Curatorial Assistant, Research and Collections; Jennifer Roberts, Curatorial Assistant, Research and Collections; Cora Rosevear, Associate Curator; Fabienne Stephan, Intern; Lilian Tone, Assistant Curator; and Jeffrey White, Preparator.

The experienced and talented staff of the Museum's Publications Department, under the leadership of Michael Maegraith, Publisher, is responsible for the preparation of this catalogue and merits our genuine appreciation. Production Director Marc Sapir brought his unmatched skills and high standards to every facet of the book's production. Editor Joanne Greenspun and Senior Editor David Frankel worked under extreme pressure to meet difficult deadlines for translation. Senior Book Designer Amanda Washburn created the volume's beautiful design, which sensitively showcases the art on every spread. Our thanks also go to Editorial Director Harriet Bee, Associate Production Manager Elisa Frohlich, and Associate Editor Cassandra Heliczer. For the beautiful photography of the works in the plate section, we are grateful to Erik Landsberg, Head, Collections Imaging, and John Wronn, Collections Photographer. In addition we would like to thank fine art photographer David Allison for his timely and professional work. Special recognition must also be given to Stephen Clark, Associate General Counsel, and Jane Panetta, Manager, General Counsel, for deciphering the complicated copyright issues surrounding this exhibition and catalogue.

The meticulous examination and preparation of each individual artwork falls to the Museum's unparalleled conservation staff. We would like to thank Chief Conservator James Coddington, Senior Conservator Karl Buchberg, Conservator Anny Aviram, Conservator Lee Ann Daffner, Conservator Lynda Zycherman, Associate Conservator Roger Griffith, Associate Conservator Erika Mosier, Assistant Conservator Scott Gerson, and Conservator Martha Singer for their extensive input and considerable efforts.

To coordinate a traveling exhibition, an additional level of expertise is required. We would like to thank Maria DeMarco Beardsley, Coordinator of Exhibitions, who worked diligently on this project. Jennifer Wolfe, Senior Assistant Registrar, brought her uncompromising scrutiny to the daunting task of preparing and overseeing the packing and shipping of nearly three hundred works and deserves our deep appreciation. Thanks also go to Heidi O'Neill, Senior Assistant Registrar, for her help. In the Department of Exhibition Design and Production Jerome Neuner, Director, repeatedly offered his insightful comments on the installation, for which we are most grateful. Among his staff we would also like to thank Hope Cullinan, Department Coordinator, for her assistance in preparing the

exhibition's model. Our genuine gratitude goes to Peter Perez, Conservation Framer, and his entire staff for their outstanding work on the framing of the exhibition. We wish to express our thanks to countless others in the Museum including Jennifer Tobias, Librarian; Eliza Sparacino, Manager, Department of Collection and Exhibition Technologies; Gaël Anne LeLamer, Senior CEMS Assistant; Susanna Ivy, CEMS Assistant; Steven Wheeler, CEMS Assistant; Pete Omlor, Manager, and Rob Jung, Assistant Manager, Art Handling and Preparation; Stan Gregory, Preparator; and Jack Siman, Preparator.

We also owe our appreciation to the team that worked tirelessly on this project from its inception. Jay Levenson, Director, International Program, and Patricia Maloney, former Curatorial Assistant, Mori Art Museum, were essential to the formation of the project. For two years Research Assistant Mara Sprafkin has served as our collaborator, keeping the entire project on track, coordinating all of its myriad details across departments, as well as helping with the research. Her positive attitude and sense of humor contributed immeasurably, transforming every crisis into a mere wrinkle. For compiling the research on more than one hundred fifty artists and nearly three hundred individual objects credit also goes to Raimond Livasgani, Curatorial Assistant, Research and Collections, and Research Assistant Amy Gordon, who each worked steadfastly on this volume. Mr. Livasgani and Ms. Sprafkin also prepared and coordinated endless reports on the collection, as we winnowed thousands of works down to the final list of nearly three hundred. Ms. Gordon deserves recognition and tremendous gratitude for her fluid and efficient writing of the artists' biographies. Special mention must be given to Mari Shinagawa-Thanner, Production Manager, who brought her prodigious talents as a designer and a manager to this project. We feel exceptionally fortunate that she was a member of our team. We would also like to express our warm appreciation to Barbara London, Associate Curator, for selecting the video program for the **Mutable** section of the exhibition. And for the use of video equipment we are indebted to David Teiger and The Project, New York and Los Angeles. Reiko Tomii and Miwako Tezuka checked the Japanese translation of this catalogue, for which we are most grateful.

Our colleagues at the Mori Art Museum merit our sincerest appreciation for their collaboration at every phase of this project. We are indebted to Minoru and Yoshiko Mori for generously offering us this extraordinary opportunity to create a monumental exhibition for their important new museum. We would like to thank David Elliott, Director, not only for his thoughtful essay in this volume, but for his initial challenge to reassess the story of modern art through the unparalleled and synoptic collections of The Museum of Modern Art. Our gratitude also goes to several members of the Mori Art Museum staff including Fumio Nanjo, Deputy Director; Sunhee Kim, Curator; Mitsuyo Ogawa, Assistant Curator; Kenichi Kondo, Assistant Curator; Tamaki Koshida, Registrar; Shinya Takahashi, General Manager; Kunihiko Aizawa, Conservator; Misa Shin, Development Manager; Junko Suzuki, Press Officer; Sachiko Sugiura, Public Program Curator; Naotake Maeda, Exhibition Designer; and Natsumi Araki, Curator (editor). In addition we would like to thank the following people who assisted the Mori Art Museum with this enormous undertaking: Mami Hirose, Exhibition Coordinator; Masaaki Hiromura, Art Director; and Tetsuo Kinoshita, Translator, Keiko Hashimoto, Translator, and Shinichi Numabe, Translator.

The privilege of rethinking what *modern means*, paired with the task of looking at so much of the Museum's rich collections, has made this project immensely rewarding. We hope that the viewing public, many of whom may be seeing these works for the first time, will sense the inspiration we derived from the *continuity and change* of the extraordinary art presented here.

D. W. & W. W.

credits

index of illustrations